Precarious Dependencies

**GENDER, CLASS,
AND DOMESTIC SERVICE
IN BOLIVIA**

Precarious Dependencies

**GENDER, CLASS, AND
DOMESTIC SERVICE
IN BOLIVIA**

Lesley Gill

COLUMBIA UNIVERSITY PRESS ✳ NEW YORK

Columbia University Press
New York Chichester, West Sussex
Copyright (c) 1994 Columbia University Press
All rights reserved

Library of Congress Cataloging-in-Publication Data

Gill, Lesley.
 Precarious dependencies : gender, class, and domestic service in
Bolivia / Lesley Gill.
 p. cm.
 Includes bibliographical references and index.
 ISBN 0–231–09646–1
 ISBN 0–231–09647–X (pbk.)
 1. Women domestics—Bolivia—Social conditions. 2. Working
class women—Bolivia—Social conditions. 3. Social classes—
Bolivia. I. Title.
 HD6073.D52B514 1994
 331.4'8164046'0984—dc20 94–5948
 CIP

Printed in the United States of America

c 10 9 8 7 6 5 4 3 2 1
p 10 9 8 7 6 5 4 3 2 1

CONTENTS

ACKNOWLEDGMENTS

I would like to express my gratitude to a number of people who collaborated on this project. In particular, I thank the women of La Paz—servants and employers—who are the central figures of my account. Because of my conversations with them, I have a much deeper appreciation of the many facets of women's oppression. Their generosity and the warmth with which they received me will not be forgotten.

A number of people and organizations in Bolivia also facilitated my research in various ways. Xavier Albó, Cecilia Córdoba, Kevin Healy, Rosario León, and Marta Pantoja helped me make contact with women in the city. So, too, did individuals at Radio Fides, Opus Dei, the Centro de Promoción de la Mujer—Gregoria Apaza, and CEBIAE. The women of the Taller de Historia Popular de la Mujer (TAHIPAMU) taught me about the early union struggles of La Paz's cooks and the difficulties that plague contemporary organizational efforts. They generously shared archival information with me and were much appreciated friends. Mary Money of the La Paz archives assisted my search for documents and

shared her knowledge of local history. Last, but by no means least, Clara López Beltrán sustained me through thick and thin. She was a much needed friend and intellectual supporter, and her humor brightened my gloomier moments.

A number of people in the United States read the entire manuscript or portions of it. Sam Collins, Linda Kalgee, Maria Lagos, June Nash, Gerald Sider, Jill Whitmer, Brett Williams, and Ann Zulawski offered insightful criticisms and suggestions. I hope that the final product reflects their input, but I, of course, bear full responsibility for any remaining inadequacies.

Finally, I owe special thanks to my husband, Arthur Walters, who, figuratively speaking, kept me cooking. His love and support gave me the peace of mind to write this book.

Precarious Dependencies

GENDER, CLASS,
AND DOMESTIC SERVICE
IN BOLIVIA

INTRODUCTION

Antonieta Huanca stood on the edge of the Bolivian high plateau (*altiplano*) when she was ten years old and for the first time in her life looked down at the city of La Paz sprawling beneath her feet. "All the houses looked so tiny," she recalled, "and I was afraid to get on a bus to go down. There were so many people, and the smell of gasoline made me sick to my stomach. My aunt and I didn't speak Spanish, only Aymara, so it took a while to find our way around and to learn the names of things."

La Paz intimidates recent arrivals from the rural hinterlands like Huanca, where social life is attuned to the seasonal changes of the agricultural cycle, and the Aymara language is widely spoken. The city's grinding traffic, crowded streets, tall buildings, and aggressive residents overwhelm them, and the rapid tempo of urban life bewilders the uninitiated. Yet all immigrants do not confront the city as strangers. Some are welcomed by friends and kinfolk who preceded them by a number of years, and others have always made periodic visits to the city to buy, sell,

and work. For many people, La Paz, even as it overpowers, is an exciting place to be because it offers a wide range of pleasures. One can buy an ice cream cone near the Garita de Lima, listen to the beat of the latest huayños and Colombian cumbias pulsating from shops along the Avenida Buenos Aires, attend a double feature in a cinema, and marvel at an array of electronic gadgetry in the markets. Moreover, because La Paz is the nation's capital and a major commercial center, people from all over the country and the world rub shoulders in the city. The numerous parks and plazas provide young people with opportunities to court members of the opposite sex and to cultivate a sense of urban sophistication.

La Paz is without doubt one of the most remarkable cities in Latin America. It distinguishes itself as the highest capital city in the world and displays some of the most rugged and irregular geography of any urban metropolis on earth. From the sprawling satellite city of El Alto, located at nearly 13,500 feet above sea level on the broad expanses of the altiplano, the city extends downward through a series of canyons to the residential neighborhood of Calacoto, situated at an elevation of 10,500 feet. Although the actual distance between El Alto and Calacoto is scarcely eleven miles, the major roadway that connects these two urban extremes winds through a canyon in a sequence of bends and switchbacks for some twenty-two miles. It passes through the squatter settlements of immigrant Aymara Indians before entering the city center, where a number of high-rise office and apartment buildings reflect the intense sunshine and present a veneer of prosperity. The road then descends through a succession of affluent residential suburbs located at progressively lower elevations. Rising above the urban commotion and dwarfing the squatters' huts, skyscrapers, and suburban homes, the snow-capped peaks of the Andes present a majestic backdrop to this most unusual setting.

It can be stated without too much exaggeration that wealth and power in La Paz are inversely proportional to altitude. The residential neighborhoods in the lowest elevations contain individuals and families with the highest incomes in the city. These neighborhoods, which include Calacoto, San Miguel, Obrajes, and Achumani, shelter high-level government bureaucrats, newly rich merchants, mining entrepreneurs, and affluent professionals from the freezing nighttime temperatures and cold winds of the altiplano. Most, if not all, of these people define themselves as "white," or "criollo," a term that denotes European ancestry. Some even situate themselves in a direct line of descent from the Spanish con-

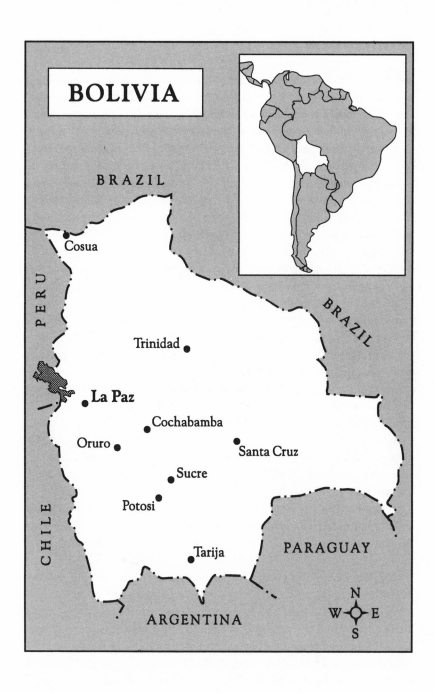

BOLIVIA

BRAZIL

PERU

• Cosua

Trinidad •

• La Paz

Cochabamba •

Oruro •

• Santa Cruz

Sucre •

Potosi •

Tarija •

BRAZIL

PARAGUAY

CHILE

ARGENTINA

N
W ✦ E
S

querors. They have gone to great lengths to create a comfortable, convenient urban lifestyle by building expensive homes that are equipped with a range of modern appliances, staffed with domestic servants, and surrounded by high walls to keep out intruders. The homes not only attest to the wealth of the occupants but also make conspicuous claims to social status, a cultural asset that is extremely important to the daily round of social life in La Paz.

At the city's other extreme, the highest neighborhoods in El Alto, and those perched atop the steep slopes overlooking the city center, contain the makeshift dwellings of the poor. These shantytowns watch over the metropolis below like a bad conscience. Most of the residents are rural-born Aymaras, referred to as "indios" (Indians) or "cholos" by the city's affluent inhabitants.

"Indio," in the parlance of the dominant society, refers to the people considered racially inferior who live in the countryside, cultivate the land, speak Aymara or Quechua, and labor in the service of others, and the term is considered an insult by those so defined.[1] "Cholo" is a much more complex category. It denotes individuals of mixed racial and cultural origins, who speak some Spanish and wear Western-style clothing. The category represents a vast social and cultural frontier between the racial divisions of "Indios" and "blancos" (whites); a classificatory schema that the descendants of the Spanish conquerors and other "whites" have struggled to maintain for hundreds of years. Because of its amorphous character, the boundaries that separate "cholos" from "Indios" and "whites" are constantly contested.

Many rural immigrants simply consider themselves to be *jaqi*, or people, and they come to La Paz in search of better living and working conditions. With considerable sacrifice and no help from the municipal government, the migrants have created neighborhoods such as Achachicala, Alto Chijini, Munaypata, and Villa Dolores. Even though these settlements have existed for a number of years, many are still bereft of most social services. They are also vulnerable to the heavy downpours of the November-March rainy season, when mudslides periodically wrench the homes from their tenuous moorings and sweep them down the hillsides.

The contrasts between the upper and lower reaches of La Paz could not be more striking, or severe. One's first impression is of a city divided into two separate worlds—a poor Indian majority and a prosperous white minority; indeed, many rural immigrants continue to refer to La Paz by its Aymara name—Chukiyawu. Upon closer inspection, however, the

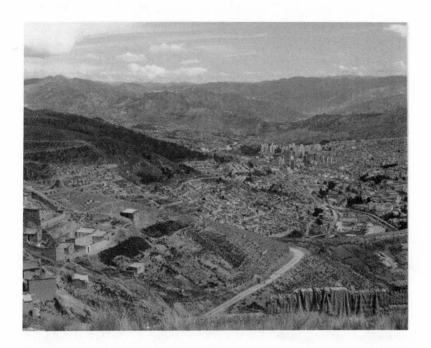

View of La Paz from the altiplano.

reality is considerably more complex. La Paz and Chukiyawu are connected in a number of ways, and a simple division between so-called whites and Indians conceals the social and economic connections between them.

For example, residents of the immigrant neighborhoods eke out a meager living by providing the labor that keeps La Paz running and the affluent residents contented. They work as street vendors, domestic servants, part-time construction workers, shoeshine boys, gardeners, doormen, and in a variety of other low-paid, insecure occupations. Their labor is indispensable to urban social life. Moreover, unlike the stark contrast between upper and lower La Paz, neighborhoods such as Miraflores and Los Pinos accommodate a number of "middling groups." Housewives, middle-level state bureaucrats, and small business people populate these areas. Similarly in Gran Poder and Tejar, a prosperous group of upwardly mobile Aymaras have carved out a space for themselves in commerce and, since the 1970s, they have acquired a considerable amount of wealth and social prominence in spite of the social stigma attached to their rural Indian origins.

Female domestic service connects all of the disparate groups that inhabit the city—rich, poor, middling whites, cholos, and Aymaras. Through the asymmetrical relations of domestic service women and men from different class and ethnic backgrounds are drawn together in the privacy of a home, where neither employers nor servants can remain entirely indifferent to the other's presence. As they struggle to control the work and accommodate each other, their daily encounters constantly strain and redefine the boundaries between family and non-family; Aymaras, cholos, and whites; and servants and those they serve.

Domestic service is an important arena in which to explore the changing class, gender, and ethnic relations that shape social life in La Paz. An exploration of domestic service allows us to ask questions about the way work is structured in homes, how this work is shaped by changes in the wider society, and how beliefs about gender are molded within and between classes and ethnicities. These considerations offer the possibility to move beyond the social dynamics of one particular city. They are issues that women from different social backgrounds face around the world as the changing international division of labor draws them into the labor force in different ways and restructures the relationships between men and women in households.

Well-educated professional women are increasingly entering the workforce to pursue careers, and they must find ways to reorganize domestic tasks to avoid a "double day." In a similar fashion, affluent women, who choose not to engage in waged employment outside the home and who have spouses willing to support them, want relief from the tedium of housework. Hiring a servant, who is usually another woman, is one solution to these problems (Susser 1991; Rollins 1985; Bossen 1988). Yet more and more poor women are taking jobs as paid domestic servants because agrarian transformations, deindustrialization, economic depression, and growing poverty are eroding their standard of living (Chaney and Castro 1989; Jelin 1977; Sanjek and Colen 1990). They, too, face problems with the organization of reproductive work in their households but are not able to hire other people to do it for them (Bunster and Chaney 1989). Taussig and Rubbo (1983) report that domestic service is increasing in Colombia, rather than disappearing as some predicted, and Hansen (1989) documents similar tendencies in Zambia.

Indeed, female domestic service is also expanding in the United States, where it all but disappeared after World War II. The restructuring of the U.S. economy has forced growing numbers of native-born Ameri-

6

cans and immigrant women to seek out work in the service sector, which expanded in the 1980s as other areas of the economy stagnated. Colen (1989) documents how West Indian women have left their families in the Caribbean to migrate to New York City, where they work long hours for affluent white families.

How, this study asks, is the general subordination of women to be understood when some women, who usually define themselves as members of a superior class or ethnic group, hire others to carry out the domestic duties that are typically assigned to women? The importance of this question is repeatedly brought home to me whenever I have lectured on my Bolivian research to student audiences at elite colleges in the United States. Many women, who would not be offended by the label "feminist," are insulted by my analysis of exploitative mistress-servant relationships in Bolivia because they feel that my description of Bolivian domestic service demonstrates uncomfortable parallels to their own experiences. Some may have encountered servants during periods of extended residence abroad, after the vagaries of a father's career in business, the foreign service, or international development forced their families to relocate. Others from affluent backgrounds have grown up with servants. Still others come from dual-career families, where hiring a servant is the only recourse that their mothers have to a double day. These young women typically rush to portray themselves as caring human beings and to defend their relationships with servants. Yet they entirely overlook the vast gulf created by race, class, and national origin that separates employers from servants, and the implications for the exercise of power are lost on them.

To better understand the manner in which gender is structured in the context of inequality, this book examines the relationships between Aymara domestic servants and their employers in La Paz over a span of almost sixty years, from 1930 to the late 1980s. The analysis encompasses a period when dramatic social and economic changes were reorganizing the lives of Bolivians and radically altering the physical appearance of La Paz. Between 1930 and 1988, Bolivians experienced a war (1932–1935), a major revolution (1952), eighteen years of nearly uninterrupted military dictatorship (1964–1982), and more recently, a foreign debt crisis and government austerity program that aggravated poverty, generated severe unemployment, and forced many people to make a living in the illegal, albeit highly lucrative, cocaine traffic. These upheavals and social transformations touched female domestic service only indirectly. Yet

they were crucial in shaping the beliefs that mistresses and servants held about each other and themselves and in demarcating the social boundaries within which people of different backgrounds lived their lives.

The principal concern is to examine the way in which changing power relationships sustain, alter, and recreate the social, cultural, and ethnic distinctions between employers and domestic workers. How, for example, are dominant and subordinate notions of gender and ethnicity created and manipulated in the process of class formation? How, too, do these notions come into conflict and contradict each other, and how is social status cultivated and maintained in the context of changing economic power? To answer these questions for La Paz, a city caught in the convulsions of late twentieth-century capitalism, the concept of class becomes a major conceptual tool. As the late E. P. Thompson has shown (1967), class is a historical relationship. It is shaped by the relations that men and women establish to the means of production, distribution, and associated cultural forms. I argue that class, gender, and ethnicity are inseparable and that consciousness of class is always articulated in gender- and ethnic-specific ways. In other words, beliefs about what constitutes "masculinity" and "femininity" or an ethnic identity are historically and culturally specific and express a particular relationship to power. They are molded into categories for inclusion and exclusion as contending social groups define themselves in opposition to others in the ongoing encounters of daily life.[2] Beliefs about gender and ethnicity then are continually contested, reworked, and redefined in the workplace and through the institutions of civil society—the family, church, media, etc.—even though at certain times differing interpretations may be obscured by a seemingly unified hegemony (Davidoff and Hall 1987).

Hegemony, according to Gramsci, refers to the historical moment when a dominant class or an alliance of class strata can frame alternatives and mold understandings of the world so as to legitimize their rule over subordinate groups in ways that appear natural. It is not only based on force and control of the state apparatus, but also requires the positive "consent" of subaltern groups (Gramsci 1971). Such hegemonic "moments" are historically specific and have varying degrees of success depending on the balance of contending forces at any particular time. They must be constantly manufactured and secured by regulating social life. The creation of hegemony is, then, always a process, one that is never total or complete and constantly threatened by antagonistic cultural expressions that challenge and arise from it.

Incorporating these concerns into an analysis of domestic service is not easy because of an assumed division of the world into *public* and *private* spheres.[3] Notions of public and private spheres are problematic concepts in domestic service, where the private sphere of the employer is the public sphere of the employee. They must therefore be understood as relative concepts that are related more to an ideology of power and control than to any actual existing division of social life (Di Leonardo 1991).

The associated theoretical concepts of production and reproduction developed by socialist feminist scholars revalue the activities assigned to women in the household (e.g., childrearing, cleaning, cooking, laundry, etc.) and demonstrate how these tasks are intimately linked to the production process.[4] Indeed, production and reproduction have been powerful theoretical tools in broadening traditional Marxist notions of class that were elaborated almost exclusively around the male workplace. It has become clear that the concept of class itself has to be reworked to encompass both productive and reproductive labor and that men and women often experience class in different ways (Lamphere 1987; Beneria and Roldan 1987). Increasingly, too, feminists recognize that white women and women of color experience class and gender in markedly distinctive manners (Sacks 1989; Simson 1983).

Yet to fully appreciate the interconnections between class, gender, and ethnicity in La Paz it is necessary to consider not only the wage nexus and the relationship between waged and unwaged labor, but also to understand how the changing economic relationships between men and women and among women themselves are culturally constituted and constitutive. Women are more than mothers and wives who provide reproductive labor for families in the private sphere, and workers who struggle to overcome the constraints of their reproductive responsibilities in the public sphere. They also participate in the vibrant social life of Bolivia's most cosmopolitan city by taking part in a broad array of activities that involve churches, schools, and numerous leisurely pursuits. It is in these arenas, as well as in the home and the workplace, where women—rich and poor, Aymara, chola, and white—create and refashion the images of ethnicity, class, and gender. By so doing, they convey a particular image of themselves and cultivate status, an aspect of class that encompasses continuous claims to honor and importance.[5] This is a crucial dimension of the struggle of groups and individuals for resources, and it is a form of competition that is pervasive in La Paz.

Women cultivate status, and they are also key conveyors of status symbols (Peiss 1985; Hall 1986; Davidoff and Hall 1987).

Dominant beliefs about class, gender, and ethnicity neither exist as a totalizing static form of hegemony, nor are they inclusive of all women. They must be constantly recreated and altered in accord with the shifting political and economic relationships of men and women and defended against alternative concepts that challenge the accepted dogma. These alternative beliefs are not only important in their own right, but they are indicative of what dominant groups must control, transform, or incorporate in order to maintain their position of dominance (Hall 1981; Williams 1977; Lagos 1993). Clearly, the relationship between servants and employers must be understood as part of an ongoing, historically structured process of class formation and struggle in which conflict and accommodation, incorporation and distancing, and imitation and innovation form an integral part.

Broadly conceived, then, this study is about the dialectics of class, culture, and power. In seeking to unravel these complex interrelations, it explores historical processes that are found in Latin America—and, indeed, in various forms, throughout the world. These processes incorporate women—particularly working class women—into the culture and practices of modern capitalism in ways that are often not of their own choosing and that differ from their male counterparts. Yet by examining their lives, we can learn more about broader patterns of domination and subordination, consciousness and representation.

As working-class women are subjected to new forms of repressive labor discipline, they often question the authority and integrity of the dominant order, seize upon its symbols, and reformulate them in their own image. Occasionally they do so in open defiance; unionized cooks in the 1930s, for example, briefly challenged employers and the municipal government (see chapter 1). At other times, or even simultaneously, they elaborate a unique version of femininity by appropriating styles from the dominant society (see chapter 5). Sometimes, too, they passively and obstinately defy the dictates of employers (see chapters 4 and 5).

Many times, however, they merely perpetuate extant patterns of subordination. Their cultural creations and social actions are often deeply implicated in the dominant cultural order. Like oppressed peoples elsewhere, separating from established structures of power and representation is often a very incomplete process (Comaroff and Comaroff 1992).

Thus we see working-class Aymara women flocking to evangelical Pro-
testant churches, which are simultaneously part of a vibrant immigrant
culture *and* instrumental in the continuing subjugation of these women.
Female churchgoers create a sense of "community" in the participatory
context of worship services, where they associate with other women like
themselves, and abusive male behavior is proscribed by strict, puritanical
rules. Yet at the same time, women adopt—often only temporarily—a
patriarchal religious ideology that advocates the natural inferiority of
women and promises individual salvation in the future, instead of sup-
porting collective political action in the present (see the conclusion).

Their contemporary struggles continue to unfold in unpredictable
ways. Young women move between inchoate awareness of their subjuga-
tion, the recognition of injustices, and, sometimes, conscious resistance.
In this way, they are similar to many other oppressed peoples who live in
the towns, cities, and villages of a rapidly changing world capitalist
society.

In order to understand the story of servants and employers in La Paz, I
have combined the traditional anthropological technique of participant
observation with the use of archival sources and oral histories. I draw on
court cases involving sixty-nine servants and their employers between
1930 and 1952 to document the period prior to the Bolivian revolution.
These data are further enriched by newspaper accounts and oral-history
interviews that I conducted between May 1987 and June 1988 with ser-
vants and employers who recalled the pre-revolutionary era.

I explore the post-revolutionary period through a related series of fo-
cused life histories with sixty-one former and current domestic workers
and thirty-five employers. The interviews do not represent a random
sample, nor can they be considered representative in a statistical sense.
Rather, they are an attempt to capture the diversity of experiences that
characterize the lives of servants and employers. For ethical reasons, I did
not select servants and employers from the same households, but located
them through a variety of different personal networks that included
friends, development organizations, churches, the marketplaces, and
embassies. These contacts proved enormously useful for explaining my-
self and my project to prospective interviewees, and they greatly facili-
tated the development of rapport during the interviews. To preserve in-
terviewees' confidentiality, I have used pseudonyms throughout this
study.

In my conversations with servants and employers, I wanted to collect a certain amount of information that would allow me to situate them in time and place, because there are no systematic data on domestic service for the city. I thus tried to choose women of different ages, educational levels, economic standing, marital backgrounds, and places of origin, but I did not want to structure the interviews around a questionnaire format that would automatically place information into my own preestablished categories. I needed to give women ample opportunity to express themselves at length so that they could better explain their theories of social life, express their hopes, fears, and problems, and depict their perceptions of the mistress-servant relationship in both the past and the present to me. I was thus faced with a tension between a need for basic sociological data and an interest in learning how my informants understood their experiences as servants, employers, women, and members of different classes and ethnic groups.

Although I elicited certain information from all servants (e.g., number of jobs, place of birth, etc.) and employers (number of servants, household size, etc.), I began my conversations by opening with a very broad, general question to encourage them to talk at length about themselves. When I was lucky, they spoke with considerable passion, humor, and anger about their lives and their relationships to each other, providing much of the quantitative information that I had chosen not to ask for directly, as well as a wealth of other details and insights that stimulated my own thinking in new ways. When they finished, I urged them to expand certain areas or to clarify others, and only then did I ask specific questions about points of information or topics of particular concern to me.

Yet despite the assistance that I received in arranging the interviews, I was not always fortunate enough to encounter loquacious domestic workers who were eager to tell me their stories. Sometimes, even though servants agreed to be interviewed, they were hesitant to expound at great length about themselves, especially to me—a seemingly rich, better-educated, North American stranger. This, however, was never a problem with employers, who were usually eager to talk about themselves and servants after a simple introduction and were more likely to see me as one of them.

Being a woman facilitated my interviews with servants, but it was not always enough to break the ice. I had to contend with the highly unequal

encounter between myself and my informants in which we met, with different interests, positions of power, and goals, to conduct an interview in which I was the interviewer and they were the interviewees. It became my task to discover the conditions under which domestic workers could speak most comfortably (see Gal 1991 and Keesing 1985); an employer's home was obviously not an appropriate setting. We talked in parks, on hillsides overlooking the city, in my home, and in their homes. There were times, too, when I spoke mostly about myself and left the interviews for other days, because the women wanted to know about my family, why I came to Bolivia, why I was interested in them, and if there were *cholitas*[6] in New York City, where I lived. Once they assessed my strengths and weaknesses, they could then decide how to present themselves to me, and the interviews proceeded more easily.

What I heard was not a clearly different "woman's voice," (cf. Gilligan 1982) nor did I discover a distinctive Aymara women's culture. Rather, aspects of their accounts were ambiguous, even contradictory. The stories reflected the disparate experiences of the urban- and rural-born, actual servants and former servants, young, single women and older, married mothers. They also portrayed a number of views about employers, the upper class, newly rich Aymaras, and foreigners that ranged from admiration to opposition, rejection, and the reformulation of dominant cultural concepts.

In addition to the interviews, I participated in the social life of La Paz in as many different ways as possible. This involvement was key to understanding the broader social and economic context that shaped, and was shaped by, my interviewees. I witnessed servant-employer interactions on both typical days and during special events, such as parties, weddings, holidays, and so forth. I followed servants on return visits to their home communities, met some of their relatives, attended worship services at evangelical Protestant churches with them, watched them court young men, and saw them slip off with each other to enjoy brief moments away from the watchful eyes of their employers. I also spent a lot of time socializing with employers. They invited me to lunches and afternoon tea parties, where I met their friends and family members. Sometimes I went on weekend retreats with them to the countryside. We also attended a number of "cultural" events, such as plays, concerts, and dance performances, and I participated in the social gatherings that usually followed these occasions. Finally, casual encounters with a wide range of people that I met

in the marketplaces, shops, streets, and buses of the city proved enormously insightful for understanding how different people perceive themselves and shape their relationships with others.

The book is organized in the following manner. Chapter 1 explores servant-employer relations within the rigidly defined social order of pre-1952 La Paz, in which the economic and political dominance of a white ruling class coincided with its superior social status and moral virtue. Paternalism was the ideological battleground on which the struggles between servants and their employers took place.

Chapters 2 and 3 discuss the emergence of a new social order in the three decades following the 1952 Bolivian national revolution; one in which superior class position no longer strictly coincided with ethnicity, moral rectitude, and privileged social status. They describe how social transformations and the commodification of the urban economy gradually altered relations among and between servants and their employers. Domestic service became a short-term, sporadic occupation.

Chapter 4 considers how the economic crisis of the 1970s and 1980s shaped servant-employer relations. As the involvement of mistresses in production and reproduction became more diverse, their interactions with servants grew more varied, and labor relations were renegotiated in novel ways.

The final chapters examine the perpetuation and transformation of dominant beliefs about class, gender, and ethnicity. Chapter 5 explores the private lives of servants away from the workplace in order to better understand how they experience domination and simultaneously create their own styles, practices, and conventions. Chapter 6 discusses the efforts of affluent mistresses to reform immigrant women *as* women, as well as discipline them as workers. It shows how these activities are crucial to the maintenance of a hegemonic cultural order.

Finally, chapter 7 examines the participation of domestic workers in broader social movements. It first discusses the efforts of domestic workers to establish a union in the midst of the growing disorganization of the Bolivian labor movement and then explores the greater effectiveness of evangelical Protestant sects in attracting domestic workers. The discussion considers why these relatively new organizations enjoy such apparent popularity among poor, immigrant women, but it also asks why the religious convictions of these women are not as great as the religious leaders desire.

SEÑORAS AND SIRVIENTAS,

1930-1952

During the late 1940s and early 1950s, an annual ceremony took place in the Ministry of Education in La Paz. Arranged by the Cruzada de Bien Social, a beneficent organization of upper-class white women, the ceremony honored several carefully selected domestic servants who had "dedicated their lives to the service of one family." In attendance were prominent public officials, representatives of several women's charitable associations, and the families whose servants received commendations. Following numerous speeches in which the loyalty and work spirit of the domestic workers was duly praised, the servants received silver medals and diplomas. Margarita Pastor, Marcela Carvajal, and Angela Calvimontes were among the award recipients in 1948 because they had served individual families for seventy, fifty, and forty-five years, respectively. Two years later, a seventy-eight-year-old medal winner proclaimed that "I will continue serving until the day of my death. I have worked since I was eight years old with no other purpose than to honorably carry out my obligations."[1]

Such paeans of servant-employer relationships appeared in La Paz's leading newspaper, *La Razón*, a right-wing, elitist publication that looked out for the interests of the Bolivian upper class and its owner, tin baron Carlos Aramayo. The image it painted of devoted domestic workers servicing upper-class families belied a harsher, more violent side of female domestic service. The rape and physical abuse of household workers were common. Moreover, domestic service constituted the principal form of employment for Indian women who were pushed out of rural communities by the expansion of the haciendas, fleeing the abuses of landlords, or lacking other means of economic support. It was also one way that rural women who had been incorporated into the hacienda system completed their personal service obligations (*mitanaje*) to the landlord. Poverty even obliged indigent peasants to give their children to rich families, who raised them as servants (*criadas*).

In 1950 La Paz had a population of 178,000 individuals fifteen years of age or older, and some 5,600 people labored in domestic service. Over 73 percent of these workers were women. They ranged from the very old to the very young, but female servants were most heavily represented by teenagers fifteen to nineteen years of age (27 percent) and women between twenty-five and forty-four (25 percent).[2] Many Aymara women like Pastor, Carvajal, and Calvimontes spent their lives as domestic workers. They did so not for love of the upper class, which was rapidly consolidating power at the expense of their communities, but because few other opportunities existed for Indian women. Many other Aymara women also moved in and out of domestic service in response to shifting personal fortunes, and they often felt neither admiration nor respect for their erstwhile patrons.

The ties that bound employers and servants varied by class, ethnicity, and household composition. Particularly among the upper class, servant-employer relationships were expressed in the paternalistic terms of duty, obligation, and the responsibilities that household members had for each other. The power of the male *patrón*, or master, overshadowed the affairs of the household, even though he did not take part in its daily management. Women understood his power, but the manner in which they coped with male domination reflected the different ways that class and ethnicity structured gender relations in the domestic sphere.

White women recognized the prerogatives gained from their ties to powerful men and therefore rarely contested male dominance, even though they resented the limits that it placed on them. Female servants,

however, embodied a complex mixture of collusion with and opposition to the power exercised by white employers—male and female. Although they undoubtedly objected to their subordinate position more than white women, the complaints of Aymara servants were most often voiced in the language of paternalism. They took employers to task for failing to act as "good" patron(a)s, without contesting the social relationships upon which employers' power was based. In this way, they used concepts that were acceptable to the oligarchy but infused them with new, or slightly different, meanings.

Paternalism, however, was not the only ideology that shaped servant-employer relationships. Particularly in the aftermath of the Chaco War (1932–35), rising discontent with the status quo generated increasing public debate on a range of social issues. New left-wing political parties organized, and workers and peasants grew more militant. Influenced by these trends, a small group of servants exposed to anarcho-syndicalism refused to abide by the paternalistic rules laid down by their employers. They organized a union and began to demand a series of new rights for domestic workers.

In order to understand the tensions and transformations of domestic service, we must examine the ways that class, gender, and ethnicity molded the social relations of domestic service during the years that led up to the 1952 Bolivian national revolution. Aymara servants and their employers participated in an ongoing pattern of domination, accommodation, and resistance that shaped the definitions of their respective obligations to each other. This process was structured by their daily interactions in the household and molded by broader forces that were reshaping Bolivian society.[3]

 ## THE CHANGING FACE OF LA PAZ

The rise of an export-oriented, tin-mining industry at the turn of the century stimulated a series of social transformations that restructured Bolivian society and established the parameters within which servants and employers negotiated their relations. The period from 1880 to 1930 marked the decline of silver and the rise of tin, which became Bolivia's primary export. The era also represented the second great expansion of the hacienda system, as railroad construction and population growth in mining and urban centers opened up new markets for agricultural pro-

duce. The dynamism of the tin industry facilitated the emergence of a powerful upper class of mining entrepreneurs, landlords, and urban professionals who were linked to each other by common economic interests and ties of kinship.

Members of this class lived in the cities, especially La Paz, even though they often maintained homes on rural estates. Despite a Bolivian upbringing, they modeled their cultural practices after European trends and strove to transform La Paz into a cosmopolitan urban center similar to the great cities of Europe. During the early twentieth century, they successfully pressured the government to invest in a series of urban construction, sanitation, and lighting projects (Klein 1982), including an elegant theater near the central plaza. They also built spacious mansions that they staffed with servants. These developments would have been impossible without major transformations among the rural and urban populations, overwhelmingly represented by Quechua- and Aymara-speaking Indians.

Corporate Indian communities represented the major obstacle to hacienda expansion in the late nineteenth century, but a revitalized attack on communal landownership was orchestrated by the government as early as 1860 under the dictatorship of Mariano Melgarejo. Known as the "liberal reforms," the new laws denied Indian communities the right to collective landownership and established a precedent for individual, private property. Indian resistance forestalled the enactment of the reforms for some twenty years, but by the 1880s the formation of new mining capital emboldened speculators who finally forced the Indians to accept individual ownership. It was then relatively easy for aspiring landlords to incorporate Indian land into large, private estates through purchases or blatant intimidation (Klein 1982).

By 1930, Indian communities held only one-third of the land and population that they had possessed in 1880. Disenfranchised Aymaras were incorporated into the labor forces of the great estates and the revitalized mining centers or were marginalized onto unproductive land. Those who became part of the hacienda system (*colonos*) were often obliged to reside in La Paz for a month or several weeks to complete personal-service obligations to the landlords. Many others migrated to the city in search of waged labor and to supplement the decreasing returns of subsistence agriculture by selling agricultural products and handicrafts. They not only worked as domestic servants, but also sold wood and llama dung (*takia*) for cooking fuel, engaged in small craft produc-

18

tion, and provided the labor for the construction projects that were re-shaping the face of the city (THOA 1986a).

While the number of rural Indian communities was seriously dimin-ished in the early part of the century, the plight of several semi-urban communities was equally disastrous. Residents of San Pedro, Santiago, and San Sebastian argued that they had lived on the perimeter of La Paz since "time immemorial." They had long combined subsistence agricul-ture with dairy and craft production for the urban market. Their move-ment among agriculture, commerce, and occasional urban waged labor, coupled with a sophisticated understanding of city life, tended to blur the distinctions between country and city.

Throughout the first three decades of the twentieth century, the lead-ers of these communities fought a long battle with the state to keep greedy landlords and speculators from seizing control of their land. In 1927 they petitioned the government to conduct a *revisita*, or survey, of communal lands because of "the numerous problems with boundaries and the incursions of outsiders." They also requested that the state recog-nize the authority of indigenous *caciques*, who claimed to be descendants of the Incas and enjoyed the support of a sympathetic local priest.[4]

The state responded to these efforts with contempt, and according to one government official frustrated with the persistence of the *comunaros*, "there have been innumerable petitions of the same sort presented in the same handwriting, in unintelligible language, asking strange things, and making the most unbelievable appointments . . . they invoke royal de-scent and the existence of ecclesiastical authorization to apply for a re-visita."[5] The communities lost their battles and the land was subsequently engulfed by urban sprawl, as La Paz filled with both disenfranchised peas-ants and newly rich entrepreneurs.

The city expanded from barely 79,000 inhabitants in 1900 to over 143,000 in 1930. This represented a rate of growth that superseded the addition of only 40,000 people to the city's population over the course of the entire nineteenth century (Klein 1982). In addition to the so-called whites, whose numbers never surpassed 15 percent of the urban popula-tion, and impoverished Indians, the cholo population of the city ex-panded in this period. Speaking both Aymara and Spanish, these urban-ites rejected their rural background. They engaged in petty commerce and various forms of craft production. Occasionally the cholas required the services of a domestic worker, but sometimes, too, the women worked as cooks in upper-class households. The upper class derided the

cholos, who they saw as closer to Indians than themselves, but the Indians tended to view cholos as more like whites.

By 1930 a relatively small group of white professionals, mining entrepreneurs, and landed oligarchs had constructed a highly coherent, yet grossly unequal social order. Members of this class subscribed to the social Darwinist views that had been common throughout Latin America since the mid-nineteenth century. They believed that "whites" were destined by nature to rule the country and the Indian masses. Indians, they thought, were biologically inferior and incapable of moral and economic development without white tutorship. They thus assumed the right to act as the final arbiters of social life and moral virtue. Newspapers and political parties represented their views, and the educational system restricted entry to a select urban elite. Indians and cholos, to a lesser extent, were excluded from the major institutions of national life, and Indians in particular were destined to labor in service of the more dominant groups.

The burden of these unyielding circumstances weighed heaviest on Aymara domestic servants. They experienced the deep-seated racial prejudices of the upper class in particularly personal ways, because they labored in close contact with wealthy employers in the private confines of a home. Such biases were extremely powerful in shaping the ways that Aymara women constructed and understood beliefs about their proper place in La Paz society. To understand the plight of Aymara servants, we must first consider for a moment the kinds of women who became servants and employers.

🔲 WOMEN AND DOMESTIC SERVICE

Female domestic service was not only crucial for the economic survival of Indian women, but also important for the self-styled "señoras," or ladies, of La Paz. These women were relatives of urban professionals, mining entrepreneurs, and large landlords. Sometimes, too, they owned land themselves. The women could not imagine running a household without servants because they had grown up with domestic workers attending to their every need. Their social position in the genteel circles of upper-class white society depended upon the presence of Indian women to carry out the domestic labor traditionally assigned to women. Despite contrasting positions in the household, both the señoras and their

Aymara servants answered ultimately to male household heads who had the power to intervene in domestic affairs and contradict the orders of the mistresses. The preeminence of male household heads was recognized by the legal code, which was established in 1829 and stated: "The señor is taken at his word with respect to the amount and payment of salaries . . . and honest accounting." The legal system further subordinated women to men by denying women the vote and requiring them to obtain prior approval from a spouse or male relative before engaging in legal transactions.

The *caballero*, or gentleman, represented the pinnacle of civility to which a man could aspire in La Paz. Ideally, the gentleman embodied two seemingly opposed qualities in a tenuous balance. On one hand, he symbolized power and dominance. He was a patriarch who demanded obedience and represented his family's authority and status in the city. The gentleman was also noted for the protection of women and children, if they did not question his right to command. On the other hand, a gentleman demonstrated refinement in his general behavior and use of language. Coarse language, bad table manners, public drunkenness, and sloppy dress were all anathema to him. Yet too much gentility could be interpreted as effeminate. Upper-class men, therefore, had to prove a vigorous manliness while simultaneously epitomizing personal refinement.

Swearing, for example, was associated with lower-class backwardness, but a gentleman had to understand uncouth expressions and even use them occasionally in the company of other men. Similarly, a gentleman might imbibe too much alcohol and associate too closely with women other than his wife, but as long as these shortcomings did not become indiscrete, they were excused, and even admired. Indians and cholos rarely, if ever, qualified for such bourgeois distinction because the oligarchy viewed them as uncivilized.

The señora was the feminine counterpart to the upper-class gentleman. She was meek, submissive, religiously devout, willing to bear all burdens, and a mother who was utterly devoted to her children. A woman was encouraged to have numerous children and held directly responsible for their upbringing, even though she delegated a considerable amount of the menial labor, especially diaper washing, to servants. Perhaps most importantly, a lady did not show any signs of sexual passion. Feminine sexuality was closely tied to notions of family honor, which was related to social class and the transmission of property.[6] Not surprisingly, the sexuality of women and their behavior in general was close-

21

ly guarded by both men and women. One woman who came of age in the 1940s described the plight of widows: "Widows who had daughters to raise could not remarry. They had to take care of their children, and there was always the risk that a stepfather would abuse the daughters. It was easier for widows with boys to remarry."

The ladies and gentlemen of the upper class cultivated an aristocratic lifestyle. To this end, servants were indispensable, not only because they carried out the most undesirable chores but also because servants symbolized the leisurely lifestyle that was so important to class position in La Paz. Men and women did not value hard work as an end in itself, and women did not consider household management to be work; nor did they labor outside the home, if at all possible. To do so would have been a denial of the lifestyle that they so assiduously cultivated. Those upper-class women who held jobs were restricted to a limited range of socially acceptable occupations that included giving music lessons, teaching a European language, or working in one of the few schools that were not operated by Catholic nuns.

Despite these restrictions, women of the oligarchy did not unequivocally embrace their subordinate position to male class peers. Many chafed at the patriarchal constraints imposed on their behavior.[7] In the first decades of the twentieth century, for example, author Adela Zamudio explored problems of sexual discrimination in her poetry and short stories, and beginning in the 1920s women sought legislative reforms that would allow them to vote. There were also a number of publications edited by women and directed to an urban, female readership that began to emerge at this time. These publications—*Femiflor, Eco Feminino, Venas de Plata*, and *Aspiración*—raised a number of issues of concern to upper-class women, including the right to higher education, female enfranchisement, and greater civil rights for them (Medinaceli 1989).

Dominant conceptions of ideal womanhood were also riven with contradictions. The ideal of chastity and sexual purity conflicted with marriage and motherhood, which publicly proclaimed sexuality. Dominant beliefs were constantly undermined by women who failed to marry, had illegitimate children, or suffered economic misfortune. In addition, they could be refashioned in new ways, as the case of Pilar Argueta illustrates. Pilar Argueta was born into a socially prominent La Paz family in the 1880s and in the early 1900s married a wealthy lawyer who rose to power in the Liberal Party. Over the next two decades, she gave birth to eleven

22

children who she raised with the help of servants in the family's urban mansion near the Plaza Murillo. Because diplomatic missions abroad and periods of forced exile took Pilar's husband away from the family for months and even years at a time, Pilar frequently assumed the burden of overseeing the family's rural estates in the Cochabamba Valley and the altiplano. At these times, she also managed all of the family's financial matters, sent her husband money wherever he happened to be, and continued to manage the daily affairs of a large household.

For all of this, the image of Pilar Argueta as an intelligent, strong, and authoritative woman was passed on to subsequent generations as a figure worthy of respect and emulation. Her grandchildren and great-grandchildren grew up listening to stories of a heroic woman who rode on horseback across the countryside, dealt swiftly with recalcitrant workers, and held her family together under adverse conditions. Yet she was also viewed as a loyal, devoted wife who quietly endured her husband's numerous extramarital affairs and recognized several children born to his mistresses. The apparent contradiction between the images of Pilar Argueta as the stalwart manager of the family's fortune and as a passive, deferential wife was really illusory: "unlady-like" behavior was acceptable as long as it advanced family interests at times when men were unable to fulfill their customary duties. Yet the appearance of too much self-interest or a direct challenge to the prerogatives of her husband could have jeopardized Argueta's ability to negotiate a dependent marital relationship, undermining her standing as a woman in upper-class society.

Pilar Argueta was not unusual among women of her class and generation. Dominant notions of appropriate female behavior were neither static nor homogeneous, but shifted in accord with the changing fortunes of men and women. Although the activities of upper-class women occasionally undermined misogynist beliefs, the women themselves rarely challenged the social relations that structured their own subordination to men. The ladies relied heavily on the privileges of social class and ties to powerful men to promote their own sense of dignity. In this way, they tried to shield themselves from the people of the lower orders. Although the cholas and other women who were not so well-to-do could not claim these class privileges, they were not bound by the same patriarchal restrictions as their upper-class counterparts. These women commonly established consensual unions with men, and some had no aversion to hard work. Indeed, they usually had to work in order to make ends

meet in their households. Many were merchants or small shop owners, and others belonged to an incipient group of white-collar workers. In contrast to the multi-servant households of the wealthy, these individuals typically utilized a single servant in their homes or businesses, which frequently shared a common premises, and the distinction between servants and kinfolk was not always clearly drawn.

Like women of the upper class, however, the cholas were very concerned with their honor as women. The preoccupation with reputation derived from an ambiguous desire for admission into the social life of the dominant white society and reflected a certain acceptance of prevailing beliefs about "civilization." These women often referred to their sisters in the countryside in the diminutive as "little Indians" (*indiecitas*), who, by definition, were uncivilized. The cholas, whose social roots often lay in the countryside, sought to distinguish themselves from the masses of despised rural people. Yet at the same time, they refused to abide by many of the rules that so constrained the behavior of the white señoras. The cholas were neither prudish nor demure. They often filed vigorous complaints with the police about alleged instances of slander. These cases, which were most common among chola women, demonstrate a worldly frankness that was rarely evident in the public behavior of women from the white oligarchy.

In 1933, for example, Calixta Zambrana accused two other cholas of repeatedly insulting her in public. According to Zambrana, they called her a "rotten bitch," screamed that she "slept with all the drivers, lieutenants, and other bastards from the police," and sneered that "during the absence of your lover, you got pregnant by another man and then aborted to escape the beating that [the lover] was going to give you." She told the court that the purpose of these insults was to "make me hated by the society in which I live, . . . and I cannot permit this because it results in the damage of my honor which is the most important."[8] Similarly, in 1937 Angelica de Portugal accused her estranged husband of jeopardizing her reputation as an "honorable and decent person." Portugal claimed that the husband and his two aunts accosted her on the streets, where they shouted insults and accused her of sleeping with her brother-in-law.[9]

These notions of female honor clashed with the beliefs about appropriate female behavior held by rural-born Aymaras. Aymara women encountered new concepts of appropriate behavior in the homes of upper-class urban employers, where most were employed. The racist attitudes of

the upper class traumatized them, and the señoras treated them as clumsy, misshapen beasts of burden who did not have the same physical and emotional needs as themselves. Similarly, those cholas who employed servants viewed rural-born Aymara women as country bumpkins and frequently overworked them.

The Aymaras emphasized the complementarity of men and women, although complete gender parity did not exist in rural Aymara communities, and even less on the haciendas where many worked. Yet both men and women participated in many aspects of production and reproduction that were extremely important to subsistence. They engaged in planting, harvesting, and herding, and although women tended to do more domestic work, men also carried out these chores when women were involved with something else.[10] Although the erosion of corporate communities undermined female control over productive resources, Aymara women were not relegated to a circumscribed "private" sphere like many of their urban counterparts.

Aymara marriage and inheritance patterns also differed from those of the urban upper class. Trial marriages (*sirwiñacu*) were still common in the mid-twentieth century. The final rituals of marriage only took place after a couple had lived together for a period of time and the respective kinfolk had amassed enough wealth to pay for the festivities. If either the bride or the groom grew dissatisfied with the relationship during the trial period, either one could end the liaison before its final consummation (Harris 1978; Albó and Mamani 1976). In addition, parallel inheritance was an important means of transmitting property, particularly land rights, in some parts of the altiplano. Wealth was handed down from mother to daughter and from father to son. Consequently, individuals depended upon their position in a generational sequence for property rights rather than membership in a particular household where spouses had "joint" property rights (Collins 1984).

It should come as no surprise that domestic service constituted a cultural and emotional shock for Aymara women. Moreover, sexual abuse by men was an ever-present threat in the households of all employers, regardless of class or ethnic background. Although cases of sexual abuse rarely reached the courts, the 1936 testimony of Francisca Huanca demonstrates the plight of many other young women like her. Huanca was ten years old in 1936 and had migrated to La Paz from a community near Lake Titicaca. She described how she was raped by her employer's lover, an army officer. "One day in November," she said, "[the employer's] lover

came [to the house], and when she left for the market, he called me into the bedroom, locked the door, and forced me into bed . . . paying no attention to my shouts. He abused me and caused me to hemorrhage. He wiped the blood off me and then gave me his handkerchief, telling me to clean myself so that I could go out to the street. When [my employer] came back from the market, I told her what had happened, but she . . . didn't pay any attention to me."[11]

Similarly, eighteen-year-old Virginia Capriles had been employed less than a month when she was raped by her employer's husband. According to Capriles, the señora left on a trip to Buenos Aires. Then, "[one day] when I was preparing to return to my home, the señor closed all the doors of the house and abused me. . . . For this indecorous act, he gave me a piece of cloth and two dresses. This morning he wanted to abuse me in the same way, but I escaped."[12]

Servants learned the meaning of gender, ethnic, and class subordination in particularly harsh ways, because they occupied the lowest rung in the social hierarchies of highly stratified households. Not surprisingly, considerable tension colored relations between servants and employers. These tensions shaped a mutual but unequal dependence that developed between mistresses and servants, and they were constantly negotiated in the language of paternalism, which both servants and employers used in their struggles to control the work and each other. Yet neither servants nor employers completely trusted the other, and the strains in their relationship could not always be contained within the bounds of the household and paternalistic appeals to duty.

⬚ DOMESTIC SERVICE: THE TIES THAT BIND

The social relationships of domestic service were a matter of private contacts and personal negotiations. Employers depended upon recommendations before bringing a servant into their homes, and those who owned haciendas sought out the female relatives of the most compliant workers for urban domestic service. They then used their personal acquaintance with a servant's family as a means of labor control. Other employers, who lacked ties to the countryside, relied upon *casera* relationships with chola market women and shop owners to obtain workers.[13] They also found servants in front of the Camacho market, where prospective household workers congregated in the morning.

In the ensuing encounters of daily life, servants and employers were obliged to find some way of accepting the other and overcoming their differences. This was extremely difficult because the routine of domestic life was so personal. The result was an ongoing struggle, which was never completely resolved, that turned around a tenuous set of expectations whereby servants traded service and obedience for the care and protection of employers.[14]

Servants, for their part, expected the provision of such necessities as room, food, minimal clothing, assistance in times of illness, and sometimes even help for family members who were ailing or experiencing hard times. They also counted on receiving small gifts at Christmas or during festive occasions. In exchange, employers demanded that servants be humble, loyal, and obedient, required them to be on call at all times, and assumed the right to punish those who breached the code of etiquette.

The expectations that bound servants and employers were rarely articulated, but they became explicit when a servant transgressed the rules that employers set for them. In 1932, for example, Neva Portocarrero railed against her servant. She stated that:

> I have raised her since she was little, teaching her the household chores in such a way that she has become an integral part of my home. Lately, however, she has changed her character from humble, servile, and good to perverse. She is now extremely disobedient, restless, and mutters, having reached the incredible extreme of raising her hands to me. Since my duties as protector and employer is to attend to the correction of her conduct and good manners and guide her along the path of goodness and virtue, I have had to inter her several times in the Colegio Buen Pastor to punish her and try to change her mood.[15]

Because the clashes of everyday life threatened to undermine the paternalistic authority of employers, benevolent acts were an important means of reaffirming employers' authority and underlining their power to bestow or withdraw favors. These acts were most successful when employers carried them outside the confines of the household to public settings, particularly the church. Employers commonly agreed to officiate at marriages, baptismals, and other religious and secular events by sponsoring important aspects of these ceremonies. By demonstrating concern for poor servants in the presence of kinfolk, acquaintances, priests, and God

27

himself, the wealthy reaffirmed their authority and charity. In this way, they strengthened the ties of obligation that molded the contours of daily life.

Yet the ability and willingness of employers to carry out their assumed duties varied: some took on very few responsibilities or carried them out imperfectly. Moreover, employers' capacity to offer care depended on the family being wealthy and, as we have seen, this was not always the case. In addition to the cholos, individuals who were either unmarried or widowed occasionally headed households and employed servants, and the strength of their authority was perhaps less convincing than when embodied in a married couple. The case of the merchants Benjamin Hinojosa and Carmen Castro illustrates the failure of employers to carry out their obligations and the manner in which servants and employers contested the relations of servitude within the ethos of paternalism.

In 1932 the couple had two servants, sixteen-year-old Hilarion Montecinos and seven-year-old Paulina Cusicanqui, who they were accused of mistreating. The couple had raised Cusicanqui as a servant from birth. In contrast, Montecinos had only recently joined the household. He was from the Cochabamba Valley and had been consigned to servitude by his parents for three years. The parents, who were peasants and in need of a cash income, knew Castro and Hinojosa as prominent merchants who operated in the region surrounding their home. They signed a contract with the couple that stipulated the conditions of Hilarion's service: Castro and Hinojosa would provide room, board, and a monthly salary of ten pesos. The parents, in turn, guaranteed their son's good character and were to receive half of his salary every month. They also expected the child to obtain an education during his sojourn in the capital.

None of this worked out, however. Although Castro and Hinojosa claimed to have fulfilled their part of the contract, the servants told a different story. According to Paulina, "Ever since they brought me to the city, they have treated me badly. They feed me dog food. If I ask for [anything] they beat me and always lock me in a dark room." Hilarion was even more explicit:

> They make me work inhumanly—washing, sweeping, and making little boxes from morning until night. . . . They hit me almost daily, leave me hungry, and give me only raw flour and corn to eat—a little in the morning and a little at night—and I am always enclosed in the room where I work. They brought me from Cochabamba with the offer that I could

28

learn how to be a telegraph operator, and that I could study. But they have not completed any of their promises.[16]

Castro countered that Hilarion was a thief, who had been handed over to her by his parents so that she could correct his antisocial behavior. She also asserted that the children were well fed and that any merchant from her neighborhood in La Paz could attest to this fact.

From the testimony, we can appreciate how paternalistic notions of duty and obligation infused the manner in which servants and employers understood their relations to each other. The case also demonstrates how the ties of obligation could extend beyond servants and employers to encompass a domestic worker's family members in ambiguous ways. Parents benefited from a child's wages, but they were nevertheless conflicted about sending them into servitude, and in the face of persistent abuse, they often went to great lengths to have the children returned.[17]

The ties that bound servants and employers took on different meanings, depending upon whether servants lived in (cama adentro) or lived out (cama afuera) and whether they worked as free laborers, criadas, or mitanis.[18] The presence of a variety of different servants among the upper class generated a labor hierarchy in which women worked as general housekeepers (amas de llave), cooks, childminders, doorwomen, washerwomen, clothing pressers, personal maids, and wet nurses. Furthermore, the spouses of married women often labored as gardeners and general handymen, while children ran errands. These differences conditioned the kinds of relationships that servants established with employers and each other.

The cooks enjoyed a greater degree of independence than other household workers because they were more commonly married and worked on a live-out basis. They did not experience employers' demands for additional work as much as their live-in counterparts, and they could more easily develop a social life beyond the workplace. Of the fifty-five cooks involved in litigation between 1930 and 1950, fifty women were twenty-one years of age or older, and 34 percent (19) were either married or had been at one time. In contrast, 82 percent (61) of the general servants named in court cases were single, and 45 percent (33) were under twenty-one years of age. More cooks (42 percent) than general servants (19 percent) were also urban born, and they spoke Spanish with greater fluency than their rural-born counterparts. For these reasons, the cooks generally tended to exercise more control in the households where they

worked than young peasant girls and to contest employer abuses more forcefully.

The cook Eulogia Vasquez was one example. Vasquez did not conform to the image of the humble, faithful servant so idealized by wealthy families. She found domestic service intolerable, because her employer failed to pay her wages. The employer argued that the room and board provided to Vasquez were sufficient compensation for the young woman's labor. Vasquez, however, was not convinced.

After being jailed by her master for alleged robbery, Vasquez denounced the employer, accusing him of slander and held him responsible for the death of her son. She stated: "The señor has two other girls for maids and with me, we are three servants in his house. Because of my detention I have lost my two-year-old son who was buried yesterday. The señor slanders me miserably by saying that I robbed him, but he says this so that he doesn't have to pay me. He is accustomed to not paying his maid's salaries." Two co-workers vouched for Vasquez's character and verified her version of events.[19]

Antonia Quino, who worked as a live-in, general servant found the isolation of her work and the constant demands of her employer the most difficult aspect of the job. Although she never directly challenged her employer, she left one day without notice after the señora's demands became intolerable. Quino then found a better job in a mining center, where the work was more to her liking and she could enjoy a community of co-workers. "I worked [as a servant] for two years," she recalled, "and the señora was very demanding. She really made us work a lot. I got up at six o'clock in the morning and worked until eight o'clock at night, and except for her twelve-year-old criado, I was all alone. I worked every day of the week, never went out, and only saw my family once a year."

Sometime in the 1940s, Quino left her job and went to work in Llallagua, the site of the tin empire of Simón Patiño. The higher pay and especially the companionship of a number of other young women seemed an improvement over her previous situation. "The work was alright," she told me.

I worked there for six years and got paid every week. We started work in the morning at seven o'clock and by three o'clock in the afternoon, we were leaving. I worked in the lower plant, where the metals came in. We separated rocks on one side, metal on the other. I had friends, other girls like myself. We used to go out on Saturdays and Sundays. Saturdays were

only half-days [of work]. We all lived together in the encampment in Lagunillos and shared rooms.

From the experiences of Quino and other servants, we can appreciate how the social relations of domestic service were most painful when endured from below, but employers, too, rendered themselves vulnerable, albeit to a lesser extent, by relying on mistrusted outsiders for the services that maintained their households and affirmed their social prestige. The presence of servants in the most private setting of upper-class life proved profoundly unsettling to the families who employed them. Employers constantly suspected servants of both real and imagined thefts. They also perceived household workers to be immoral and the carriers of disease. Because of the scope of the "servant problem," many employers realized that their paternalistic guidance was not enough to reform Aymara women and create model household workers, so they turned elsewhere for assistance.

In the aftermath of the Chaco War, for example, an outcry over health conditions swept the city and fueled persistent demands for tighter public control of servants. The clamor resulted from fears of contagion that grew out of the war, when many Bolivian troops died from treatable diseases. It was aggravated by newspaper reports that focused on domestic servants. One story cited "various cases of contagion [among children] caused by unhealthy nannies."[20] The account urged the creation of a public registry for domestic servants whereby women would receive a physical examination and an identification card that would attest to their good health.[21]

Nevertheless, the state, which found itself increasingly under attack after the Chaco War, was never able to enforce the medical examination, and the entire notion was hotly contested by servants themselves (TAHIPAMU 1986). Moreover, the intervention of the state in the control of domestic service might also have been viewed as a mixed blessing by employers. Too much state regulation could, after all, undermine employers' control of the workplace and their right to dictate wages. Given the heightened labor militancy in the postwar period and a brief experiment in "military socialism" (1936–1939),[22] such thoughts could not have been far from their minds.[23]

Employers also used more benign methods to control the moral character of servants and guarantee the quality of their work. In 1950 the National Council of the Women's Association of Catholic Action inaugurated a school for domestic servants that offered courses in hygiene, 31

literacy, and religious instruction. It also taught women how to cook, sew, wash, and iron; moreover, a special placement agency found graduates jobs and "guaranteed their efficiency." Leticia Antezana de Alberdi, a prominent socialite, raised the funds to construct the school from the municipal government and private citizens. In this way, she and other employers like her hoped to create a pool of honest, highly trained, and acculturated servants.[24]

Yet employers never acquired the pliant, dutiful servants they so desired. While some initiated private ventures or turned to the state to control servants, rising labor militancy and a widening public debate of radical social ideas in the 1920s and 1930s enabled some servants to mount an organized campaign for better working conditions. These household workers were not swayed by the paternalistic pretensions of employers. They were more attuned to the discourse of anarcho-syndicalism that was influencing sectors of an increasingly combative labor movement. These women understood that domestic service was a labor relationship just like any other, and they demanded the same rights that other sectors of the labor force had already won.

COOKS OF LA PAZ UNITE: THE RISE OF THE SINDICATO DE CULINARIAS

The guns of the Chaco War had barely quieted in 1935 when a group of La Paz cooks sparked a spontaneous demonstration against a municipal ordinance that prohibited them from riding the streetcars with baskets. Several women, who depended upon the streetcars to travel between the markets and their jobs, marched into the offices of city officials and demanded that the ruling be revoked. One of the leaders described the women's anger and the ensuing events:

> All of a sudden we couldn't ride the street cars. The señoras said to us, "These cholas, these women with their baskets. They tear our stockings." . . . The word went around the market that we would meet at the door of the municipality. . . . The municipality was filled with cooks and cholas. When I arrived we went into Señor Burgaleta's office and asked, "Why can't we get on the streetcars? The streetcars are for the cholas, the maids, not for the señoras. The señoras use automobiles. The streetcars are for people who work. (quoted in TAHIPAMU 1986:4–5)

Shortly thereafter, they organized a union, the Unión Sindical de Culinarias.

The cooks' militancy gained momentum after Bolivia's crushing defeat in the Chaco War. European Marxist thought had begun to filter into Bolivia via Argentina, Chile, and Peru. Local socialist parties were forming, and newspapers such as *Inti*, *El Universal*, and *La Calle* broke with the established tradition of elitist journalism by discussing the recognition of Indian communities, rights for labor and women, and the abolition of unpaid labor (*pongueaje*) (Knudson 1986). The Great Depression aggravated labor problems, but the Chaco War, more than anything else, pushed radical social ideas to the fore and marked the beginning of the end of the old order.

Losses in the Chaco conflict were astounding. Paraguay captured a huge section of Bolivian territory, and 65,000 Bolivian combatants, or 25 percent of the soldiers, died or deserted. Moreover, the racial divisions of Bolivian society were maintained on the front, and Indian troops suffered disproportionately in comparison to white officers. Yet after serving their country, Quechua and Aymara soldiers returned home to the same racial and economic discrimination that they had left. In addition, whites and mestizos of the "Chaco generation" were shocked at the corruption of the military high command and felt alienated from Bolivian society. The entire imbroglio generated widespread frustration with the political system and the social inequities of Bolivian society. In its aftermath, peasant agitation for land increased and unrest among urban workers escalated (Arze 1987; Klein 1982:193–194).

The cooks of La Paz waged their struggles amidst this deepening social crisis. They did so precisely at a time when more urban women were entering the labor force. Many working-class women had lost husbands in the war and were thrust into the position of sole family providers. A postwar price surge and the scarcity of basic foodstuffs aggravated their problems.

The cooks' struggles received support from various groups of urban artisans who were waging similar battles. The Unión Sindical de Culinarias, for example, was the founding member of the anarchist Feminine Worker's Federation (FOF), which subsequently included unions representing flower sellers, market women, and others. This umbrella federation was closely linked to the Local Worker's Federation (FOL), an anarcho-syndicalist group that represented tailors, masons, carpenters, cobblers, and other male artisans. The women of the FOF were fre-

quently the wives and companions of FOL men, who provided them with initial organizational support, but they were not subordinated to the dictates of male unionists. Indeed, exactly the opposite occurred. As the FOL became increasingly fractured by partisan political disputes in the postwar period, the female unions were less susceptible to this kind of factionalism, and from 1935 to 1946 the FOF emerged as the leader of the anarchist movement (Lehm and Rivera 1988).

The women who joined the Sindicato de Culinarias came from the privileged sector of the domestic labor force. Several could prepare elegant European dishes, which enabled them to acquire relatively well-paid jobs in the homes of wealthy *paceños* and foreigners. Because they worked on a live-out basis, these women enjoyed greater latitude in their union activities.

The women financed union activities through membership dues and by sponsoring fund-raising events. In 1936, for example, they organized a picnic to raise money for the construction of a union hall. All members and supporters were invited to the Sunday afternoon event in the region of Sopocachi.[25] Such activities were consistent with the union's anarchist leanings, contrasting with the practices of organizations in later years to depend upon assistance from political parties, churches, and foreign development organizations.

During its lifetime, the union engaged in a series of popular protests. In 1935 members protested the city government's attempt to impose a health examination on domestic workers. The exam offended the cooks' sensibilities because it took place in the same location where prostitutes were examined for venereal disease, and in a 1935 statement the union stressed that its members were "healthy, clean people who lead an honorable life." They took on the municipal authorities on subsequent occasions over increases in the cost of public transportation (TAHIPAMU 1986).

The relationship between the union leaders and the majority of domestic workers who were not cooks is not entirely clear. On one hand, leaders fought for better pay and working conditions for all domestic workers by advocating an eight-hour workday and a minimum wage. Workers in other sectors of the economy had already won these rights as early as 1929, but the advances remained elusive for domestic workers. On the other hand, the cooks wanted to maintain and consolidate their privileged position as cooks. At a workers congress in 1936, they advanced a series of demands that included the recognition of the culinary

34

arts as a profession and the clarification of the terms of their employment to specify cooking only. Washing, ironing, and childminding, they maintained, were tasks for other domestic workers (Lehm and Rivera 1988; TAHIPAMU 1989).

These concerns for workers' rights *and* professionalization reflect a certain ambiguity in the thinking of union leaders. Such ambiguity is not surprising given the position of La Paz cooks. Many of these women were the so-called *cholas paceñas*—urban-Aymara women who had experienced a certain social and economic mobility. They viewed themselves, and were often viewed by members of the dominant society, as socially superior to rural-born peasants and immigrants.

The cooks shared certain commonalities with the artisans of Chinandega, Nicaragua, most of whom were merchants, tanners, shoemakers, and butchers. The Chinandegan artisans, despite growing economic differentiation among them, stimulated a trade unionism that advocated the rights of both owners and nonowners of craft shops. Like the La Paz cooks, the fundamental antagonism that they recognized was between workers—any artisan or person of humble origin with or without control over means of production—and the "elite." As socialists became involved with union organizing, they fostered a competing definition of worker; one which emphasized the distinctive economic interests of workers and employers, and linked artisanal notions of popular democracy to a new working-class militancy (Gould 1990:65–74).

The comments of union leader Petronila Infantes provide some insight into the La Paz cooks' feelings about other servants: "The servants [worked] live-in and the cooks live out. . . . Some of the servants were with us, but others were not because the patrons did not allow them to go out. . . . I never washed [clothes], ironed, or cleaned the plates. I only cooked because there were servants to wash the toilets. . . . I made delicious dishes. I wasn't just anybody. I was a society cook" (quoted in TAHIPAMU 1986:8). Yet despite Infantes' condescension, the cooks managed to organize a union that challenged the social relationships of domestic service, which were so shrouded in paternalism. They demanded rights for women who were workers or professionals, not childish servants who owed obedience to parent-like patrons. They also insisted that the state play a greater role in defending their liberties, and they linked their struggles to those of others.

Unfortunately, this experiment in unionization did not survive the upheavals of the 1940s and 1950s. But why it failed is not clear. A series 35

of events and transformations undoubtedly influenced its downfall. The creation of new political parties and unions that contested oligarchic rule certainly competed with the anarchists for adherents, and the anti-party stance of the anarchists and their refusal to accept financial support form party organizations put them at a disadvantage vis-à-vis other competitors. In addition, the co-optation of the workers' movement by the Movimiento Nacionalista Revolucionario (MNR) after the 1952 national revolution and the institutionalization of clientelist politics made upward mobility as a *movimentista* possible, thus encouraging people to abandon anarchism (see THOA 1986a and TAHIPAMU 1986). Finally, new patterns of class formation after the revolution made the multi-servant households of the upper class increasingly rare. Specialization among domestic workers declined, and the single servant, who could preform a variety of chores, became the norm. Many cooks from the union became marketwomen (TAHIPAMU 1989:185, 187). Domestic service became a temporary occupation and the servant-employer relationship grew more "contractual." It is to the changes and continuities that characterized domestic service in the post-revolutionary period that we turn to in the next chapter.

MAINTAINING APPEARANCES:

DOMESTIC SERVICE AND

CHANGING CLASS RELATIONS,

1952–1980

The 1952 Bolivian national revolution effectively destroyed the economic base of the La Paz oligarchy and presented it with a series of new problems, which included the acquisition of loyal, competent domestic servants. In the aftermath of the revolution, the old guard could no longer command the labor of servants to the same extent that it had done so in the past. The new government, led by the Movimiento Nacionalista Revolucionario (MNR)—a broad-based coalition of peasants, miners, and sectors of the urban petty bourgeoisie—laid down a series of new regulations in 1954 that governed servant-employer relations. The regulations established a minimum wage and yearly bonuses for domestic workers. They also mandated a ten-day paid vacation for household workers after one year of service, and required employers to pay servants' medical expenses and allow them to attend school without wage deductions. Finally, the new laws stated that if servants were fired, employers had to pay them a monetary compensation for each year of service. The legislation sent a clear message to employers that house-

hold workers were entitled to many of the same rights already won by working people in other sectors of the economy.

Yet in subsequent years these laws were not enforced by the state and employers easily ignored them, but the revolutionary upheavals did change female domestic service by setting in motion a series of social changes that affected the relationship between mistresses and servants. Ruined oligarchs discovered that their reduced economic circumstances made appeals to paternalistic duty an increasingly futile means of labor control, and women of the newly empowered peasantry were less inclined to view domestic service as a long-term occupation. The deposed ruling class also found itself pitted against rising urban "middling" groups[1] and a reconstituted upper class, both of whom demanded domestic services and vied with the old guard for power and prestige. Newly empowered peasants and miners also demanded a greater voice in national affairs.

In the ensuing struggle to create a new social order, no group was sufficiently powerful to play a leadership role or to command the "consent" of other classes and class fractions. For a brief period following the revolution, the state became less the instrument of domination by a ruling class than the arena in which diverse groups contended for power. The MNR, for example, conceded a share of power to the labor movement. The Bolivian Workers Central (COB)—an umbrella organization set up immediately after the revolution to represent organized labor—supplied three ministers to the new cabinet, and the outspoken head of the mine workers' union, Juan Lechín, headed the Ministry of Mines and Petroleum.

Revolutionary nationalism—the modernizing ideology of the MNR that crystallized in 1952—was anti-oligarchic, anti-imperialist, and intensely nationalistic. It minimized the social cleavages of post-revolutionary Bolivian society and sought to unite the "people" into a harmonious nation, one which was ostensibly liberated from class domination and free to act independently on the world stage (Antezana 1983). Revolutionary nationalism negated all forms of ethnicity through which competing groups might assert a distinctive identity and lay claim to resources. Official pronouncements substituted the more neutral *campesino*, or countryperson, for Indian, and so-called whites no longer were referred to as such, although in practice the old distinctions did not disappear. To varying degrees and for diverse purposes, left- and right-wing governments in subsequent decades manipulated the rhetoric of revolutionary nationalism to their own ends.

Yet the political bombast could not conceal emerging patterns of class differentiation. The reassertion of local identities thwarted the construction of a new, hegemonic cultural order, and Bolivia's subordination to the world's industrial powers, especially the United States, deepened. There was little agreement about what kinds of men and women represented "real" Bolivians, and the social order that emerged was much less coherent than the one that had preceded it.

Female domestic service figured prominently in the daily battles waged by contending social groups to redefine class boundaries and ethnic distinctions. Servants were also indispensable to the creation of a comfortable, convenient lifestyle in an impoverished city that for employers grew ever more congested, unmanageable, and disordered. Employers and servants drew upon prior understandings to elaborate new social boundaries,[2] but they did so at a time when local, national, and international events were altering the experience of life in La Paz in novel ways. Consequently, old meanings were modified or discarded and new sensibilities emerged.

SOCIAL REVOLUTION AND DOMESTIC SERVICE

The Bolivian national revolution grew out of the social discontent of the Chaco War and, along with the Mexican, Cuban, and Nicaraguan revolutions, represents one of the most important social transformations in twentieth-century Latin America. The revolution began in April 1952 as a coup d'état led by the urban petty bourgeoisie and the MNR, but over the next year and a half, militant peasants and miners quickly changed it into a far-reaching reorganization of Bolivian society. In the aftermath of the brief fighting that marked the coup, rising worker demands and de facto peasant land occupations in the Cochabamba Valley and the region surrounding La Paz pressured the moderate MNR leadership to act.

The situation in the countryside was rapidly getting out of its control, and the government needed broad-based popular support to consolidate an independent power base. Thus, the MNR nationalized the major tin mines and instituted a sweeping agrarian reform, which legitimized the process already underway in the countryside and outlawed unpaid labor service (*pongueaje*). The revolution also enfranchised women and Indi- 39

ans, expanded the educational system, reduced the power of the army and organized the population into armed civilian militias to defend the new social order.[3]

Although legal loopholes and the absence of strong peasant mobilization in some regions of the country, such as the tropical lowlands and southern Chuquisaca, stalled the agrarian reform in these areas (see Gill 1987 and Healy 1982), hacienda owners around La Paz lost their land and control over the labor of Indian colonos. They could no longer count on a ready supply of foodstuffs from the countryside. Food shortages developed in La Paz because of changes in agricultural production and marketing, while prices and the overall cost of living rose precipitously. A rationing system instituted by the government was controlled by armed civilian militias of MNR sympathizers, and the families of dispossessed landlords were forced to stand on long lines to obtain basic food items at vastly inflated prices.

Faced with food shortages and a bankrupt treasury, the MNR sacrificed its initial independence from foreign domination and abandoned its policies of redistribution by turning to the United States for financial assistance. U.S. policymakers harbored early doubts about the composition of the new regime, but they proceeded to support those forces within the MNR coalition whose interests lay in accommodating to the capitalist world economy. Huge shipments of surplus farm produce were allocated to Bolivia under Public Law 480, and other monies were provided for education, road construction, and health care.

Although the food supplies allowed the MNR's urban supporters to weather the dislocations of the agrarian reform and additional financing reactivated the economy, the "aid" came at an exorbitant price. Bolivia's political and economic dependence on the United States deepened precisely at the time when the U.S. was consolidating its dominance in the post-World War II world economy and establishing the financial, political, and military mechanisms to incorporate Third World countries into its sphere of influence. By the late 1950s, the U.S. was paying one-third of the state's budget (Klein 1982:238) and rebuilding the Bolivian army in the intensifying cold war against the threat of communist subversion.

During the unsettled decade following the revolution, many formerly well-to-do families watched as their standard of living steadily declined. Some had to rent or sell their homes and move into smaller dwellings, which, combined with the abolition of unpaid Indian labor, made large staffs of live-in servants an impossibility. Employers lacked the space to

accommodate numerous workers, especially when servants were accompanied by relatives, and they were in no position to provide meals to household workers or to respond to their demands for higher wages.

Household workers also wanted more for themselves. They hoped to build a better life; one that did not include laboring as a servant. Poor Aymara women no longer perceived domestic service as a lifelong occupation, if indeed they ever had. Expanding educational and commercial opportunities moved young women to view paid household labor as a temporary occupation. La Paz matron Lola Zelaya described the effects of these changes: "The revolution changed everything. Maids were no longer *pongas* [unpaid laborers] and they didn't want to be servants any more. Mothers wanted their children to go to school, and there was a servant shortage."

The new social and financial constraints imposed upon formerly well-to-do families forced a restructuring of work relations with servants. Employers no longer invested their time and energy into the training of houseworkers because they feared that these women would leave as soon as they could command a higher salary elsewhere. Consequently, employers were less concerned with servants' welfare and with upholding an image of themselves as benevolent patrons. Servants thus paid for their independence. They lost many of the benefits of paternalism but did not receive greater protection and job security from the state. Despite the MNR's attempts to regulate domestic service, a minimum wage, an eight-hour work day, and social security benefits remained beyond the reach of most household workers. Increasingly, too, young Aymara women were frustrated in their attempts to get an education and advance in other economic pursuits.

Because of these changes, the institution of female domestic service was gradually transformed, even as many of its typical features persisted. Multi-servant households declined, live-out domestic service gradually increased, and specialization within domestic service steadily diminished. The *ama de llaves* and the wet nurse, for example, virtually ceased to exist, and the practice of raising child servants (*criadas*) ended among affluent whites. The lone, unmarried servant, who did a variety of chores, gradually replaced staffs of diversified domestic workers.

Changing servant-employer relations and the revolutionary transformations undermined upper-class beliefs about proper female behavior. Patriarchal controls over white women from the deposed oligarchy eased as these women entered the labor force for at least a portion of their adult 41

lives. Like other La Paz matrons, Pilar Argueta could not retain all of her servants and was faced with the loss of her place in the social landscape of La Paz society. Her husband had died in 1945, and then the family lost properties in the land reform. Desperate for income, Pilar rented three houses in Cochabamba and let rooms in her La Paz mansion, while she, a widowed daughter, three granddaughters—Maria, Tania, and Julia Argueta Espinoza—and a single servant settled into a wing of the La Paz house. Similarly, a friend of the Argueta Espinoza sisters, Leticia Camacho, moved from a spacious home on the Plaza España to a more humble apartment, after her father was forced into exile. Leticia's mother used rental income from the house to support the family and to pay for the services of a part-time cook. Leticia vividly described the disruptions that her family experienced:

> When they took my father away, we had no one to support us, and we had to rent the house. [We moved into a small apartment,] but there was nothing in it at first, and my sister and I had to struggle to furnish it. When you fall from such a social position, you really find out who your friends are, and I remember the satisfaction I got when friends came around to visit, even though they often had to sit on the floor.

The upper class's fall from grace also obliged Leticia Camacho and other proper young ladies like her to earn a living for the first time in their lives. While entry into the labor force as secretaries, accountants, and receptionists offered these women a limited independence from the patriarchal control of their fathers, brothers, and husbands, it also presented them with disturbing new insecurities. How, for example, could they maintain the appearance of distinguished ladies of leisure if they became involved with the monotony and degradation of waged labor or assumed the burdens of operating a small business? How would these activities reflect on their husbands' abilities to support them and the already circumscribed position of their families in the eyes of a rapidly changing society? Leticia Camacho described the prevailing attitudes:

> [Before 1952], women had to be in the household and know all the work of the home, such as sewing, embroidery, cooking, and supervising the servants more than anything else. When I started to work, many of my friends said to me, "How is it that you are working? How shameful! How can your father allow you to work?" But everything was changing, to the

point that many of my friends later came to my office to see if there was any work. All these people who lived from rents and no longer had the income from their *fincas* had to find something to do. But many did not know how to do anything. People who had studied were the ones who moved forward, and to be a secretary became very important [for women] at that time.

Indeed, the expansion of the urban economy, female enfranchisement, and rising educational standards opened up new possibilities for some women. They increasingly finished high school and undertook one or two years of secretarial training, which enabled them to assume new clerical positions, establish a measure of economic independence, and contribute to the households that they formed after marriage.

The economic and social changes that affected women and men of the oligarchy led to the splintering of this class. While many families found themselves on a downward economic slide, others were more fortunate. Middle-ranking mine owners arose from the ashes of the deposed ruling class and were the most prominent group to emerge in La Paz after the revolution. The new entrepreneurs often came from old, oligarchic families, but unlike other kinfolk, they successfully made the transition to post-1952 Bolivia. By 1967, these mining entrepreneurs controlled 24 percent of the country's mineral production and operated independently of the nationalized mining sector. During a short-lived commodity boom in the 1970s, their foreign sales skyrocketed, while the state-owned mining corporation became ever more taxed, indebted, and unprofitable, and they became a powerful political force on the national scene (Dunkerley 1984:226).

As the new group of mine owners rose to prominence in the highlands, another group of agroindustrialists and cash-crop producers consolidated power in the lowland department of Santa Cruz, where the impact of the agrarian reform was negligible and peasant organizations were weak. These entrepreneurs consisted of individuals from established Santa Cruz families and dispossessed miners and landlords who moved to the lowlands after the revolution (Gill 1987). They benefited from the assistance of the MNR and a number of military regimes after 1964, while favorable terms of trade in the 1960s and 1970s and generous foreign lending boosted their profits.

Along with the appearance of new groups of capitalists and industrialists, a number of urban "middling groups" expanded to fill administrative

43

positions in a vastly enlarged state bureaucracy, particularly in La Paz, where they gained important political power. Professionals, technical experts, and clerical workers toiled at a variety of economic levels. They came from the old white oligarchy and from less prominent families of modest economic means. New channels of upward mobility for men of humble origins also opened in the armed forces because of the generous U.S. military assistance during the long decades of cold-war hysteria.

Government bureaucrats laid an ever larger claim on the country's gross domestic product. Their share increased from $62 million in 1956 to $88 million in 1964, a raise that elevated the incomes of state officials fifty times above the national average. Although high-level bureaucrats benefited more than other employees, the military as a group advanced the most (Calderón 1983:93–96).

The expansion of new urban middling groups enlarged the domestic market for consumer commodities—both waged goods, such as food, beverages, and clothing, as well as a variety of luxury items, including automobiles, stereos, and televisions, but the size of the internal market was still severely restricted. The state's support for export-oriented production did not provide employment for most poor Bolivians, and it did nothing to spur an extremely weak domestic manufacturing sector, which could not expand without a dynamic local market for its products.

The 1956 economic stabilization plan that was implemented under pressure from the International Monetary Fund (IMF) led to a decline in national consumption and a drop in industrial production. The Investment Code (1960) and the Triangular Plan (1961), which reorganized the state mining industry, were welcomed by export producers but did not stimulate the stagnating manufacturing sector. The number of manufacturing enterprises that could offer jobs to poor Bolivians declined from 1,682 in 1955 to 1,000 in 1959, and by 1964 there were only 1,500 establishments (Zondag 1966).

The 1964 coup d'état of General Rene Barrientos deepened the pro-foreign capitalist policy adopted by the MNR and began eighteen years of turbulent military rule, characterized by heightened peasant and labor repression. Although the military rulers who succeeded Barrientos did not share a unified economic philosophy, the importance of the mineral and agroexport industries continued to grow throughout the 1960s and 1970s, and in 1971, the coup d'état of General Hugo Banzer left no doubt about state priorities. The Banzer regime (1971–1978) strengthened export industries, ruthlessly repressed labor and peasant organizations, and

satisfied urban, middle- and upper-class supporters by heavy recourse to foreign borrowing.

Consequently, the luxury goods demanded by enlarged, but severely restricted, urban middling groups were supplied in the 1970s with loans from major North American banks, which financed the importation of these products and spurred limited economic growth (Dunkerley 1984). This growth was not synonymous with an actual improvement in living conditions for the vast majority of Bolivians but it provided a facade of modernization by promoting speculative activity, a jump in the average income of the professional middling households and military officers, and a rise in urban construction to accommodate the rising expectations of these groups.

New consumer demands presented possibilities for the projection of U.S. power in Bolivia at a time when U.S.-based multinationals were enjoying an unprecedented expansion abroad. Although the multinationals showed greater interest in Bolivia's more prosperous neighbors— Brazil, Chile, and Argentina—their products increasingly appeared in the homes of upwardly mobile residents of La Paz. These men and women wanted to enhance their social status through the display of consumer goods, and they also hoped to create an untroubled lifestyle that depended upon the availability of automobiles, televisions, refrigerators, and a range of other commodities, most of which were made in the United States. They scoffed at locally manufactured products, rejected anything from the countryside, which they considered backward, and celebrated everything perceived as "modern."[4]

During the 1970s, La Paz grew in all directions. Ugly—but prestigious —hotels and high-rise apartment buildings sprouted up along the major thoroughfares, radically transforming the city's skyline. The exclusive Illimani building boasted the first luxury apartments with central heating, and other buildings included an array of small specialty shops on the mezzanines that catered to the upscale culinary and domestic needs of prosperous residents. Perhaps more than any other building, however, the monolithic, glass-plated Sheraton Hotel symbolized the excesses of the period. Erected with foreign capital, the hotel was continually indebted to foreign banks, and even relatively prosperous paceños could not afford a night in one of its high-priced rooms.

As modern buildings punctuated the skyline of central La Paz, the newly affluent built suburbs in the city's lower elevations. Calacoto and Cota Cota were the exclusive sanctuaries of the rich and powerful, and 45

High-rise apartment buildings in central La Paz.

Irpavi emerged as a residential enclave for high-ranking members of the armed forces. It was filled with outlandish examples of nouveau-riche architecture, situated along streets that bore the names of prominent military commanders. Formerly autonomous Obrajes became bloated with expensive new homes, and Los Pinos developed as a refuge for upwardly mobile, young professional couples.

The glitzy downward sprawl of the city into the lower valleys often eclipsed an equally dynamic process of upward expansion onto the steep hillsides overlooking central La Paz. A rising stream of rural immigrants erected squatter communities on the expanding urban periphery. An average of ten thousand men and women migrated to La Paz every year between 1965 and 1975 (Aranfbar et al 1984), because of increasing

land fragmentation and growing rural poverty (see chapter 3). The urban population increased from 178,000 inhabitants in 1950 to 700,000 in 1976.

Not all the migrants were poor, however. A group of entrepreneurial-minded Aymaras and cholos arose in the neighborhoods of Gran Poder and Alto Chijini, located on the city's western acclivity. Some of these individuals were paceño merchants who had long catered to an urban clientele. Many more migrated from the rural towns on the altiplano, where they had been petty traders and hacienda administrators prior to the revolution. Heightened peasant militancy intimidated them, and the agrarian reform undercut their locally based power. Several small altiplano towns virtually emptied out as these individuals left for the city. The reform also initiated the reorganization of the marketing system. New commercial opportunities opened up for merchants and intermediaries of various sorts who were eager to fill the void left by the *hacendados*.

Urban migrants opened a range of small businesses along the Avenida Buenos Aires, Max Paredes, and other bustling commercial thoroughfares that catered to a diverse clientele of Aymaras and cholos. Their businesses included restaurants, tailor shops, trucking enterprises, and wholesale and retail outlets for a number of basic commodities, such as sugar, flour, pasta and rice. They also ran stores that sold everything from household appliances, popular music, and electronic equipment to clothing and costume jewelry. Some of these small-scale entrepreneurs prospered because of their willingness to exploit family labor and develop ties with peasant producers (Buechler and Buechler 1992), and the contraband trade with neighboring countries figured prominently in their economic success,[5] given the absence of bank loans and government support. Yet despite their newfound prosperity, they were unable to enter the social circles of white middling- and upper-class paceños, who continued to view them as outcasts.

During the three decades following the revolution, then, La Paz was characterized by new patterns of both upward and downward mobility, and the city grew in all directions. The MNR pursued the continued and expanded integration of a class-divided, ethnically diverse population into a society based on capitalist relations of production. Men and women with differential access to power jockeyed with each other for social prestige and economic control. This process was most evident in the consumerist aspirations of the new urban groups, and it should come as no surprise that the crystallization of new consumption patterns, tastes, 47

and styles was embedded in a domestic market with strong ties to foreign corporations, which produced the commodities that Bolivian manufacturers could only dream of making.

Because of the political preeminence of the United States and the growing power of U.S. businesses, the concept of modernity became tied to the "American way of life."[6] This process was encouraged by a number of factors. Radio stations broadcast popular American music, and the creation of a television system in the mid-1960s corresponded with the great expansion of American TV exports abroad. Reruns of programs such as "I Love Lucy" and "Leave It To Beaver" were regularly broadcast in La Paz, providing city dwellers with a prototype of modern living. Similarly, the number of movie theaters in La Paz nearly doubled between 1960 and 1970 and the motion pictures offered to the public were heavily dominated by Hollywood productions. Cinema-goers in early 1970, for example, could choose between a variety of films that ranged from a Kirk Douglas hit to an X-rated movie featuring "innocent girls in the quicksand of sin."[7]

Local newspapers also printed international wire-service reports that focused on the United States. A paceño could read about the trials and tribulations of New Yorkers suffering through a July heat wave or contemplate a picture of Miss America, while more thorough local reporting was precluded by financial constraints or government censorship. Furthermore, the United States promoted numerous cultural activities, such as the Fulbright Scholars program and the creation of the Bolivian-American Center, which presented a particular view of U.S. citizens as white, educated, and prosperous.

U.S. businesses also became active in packaging and promoting a particular image of Bolivian "folklore" to an international audience. In 1970, for example, the La Paz branch of Citibank sponsored a beauty contest in which an attractive white woman from a socially prominent family was crowned "Miss Citibank." Citibank officials then sponsored her trip to Japan, where she competed in a similar event with international contestants. According to bank officials, the purpose of the trip was not only to "exhibit the beauty [of the new queen] but also to display [Bolivian] folklore, for which [the young woman] is being prepared by specialized teachers."[8]

The dominance of the United States in the capitalist world economy made English an important language for aspiring secretaries, entrepreneurs, and government functionaries. U.S.-funded scholarship programs

gave the children of well-connected families the opportunity to pursue higher education in the United States, where they learned English and studied agronomy, engineering, public administration, and a range of other subjects. Back in Bolivia, the graduates then parlayed a knowledge of English and their foreign academic degrees, which were more highly valued than local ones, into high-paying jobs in private enterprise and the state bureaucracy.

At the same time, U.S. aid agencies and multilateral organizations under strong U.S. influence poured millions of dollars into Bolivia during the 1960s, especially during the period of the Alliance for Progress (1961–1965). Much of this money came in the form of technical assistance and was directed toward developing the agroindustries in the eastern lowlands. In addition, the PL 480 program sponsored the dumping of U.S. wheat and cereal surpluses in Bolivia at cheap prices. These funds and programs were managed by North American experts steeped in the teachings of modernization theory and U.S.-trained Bolivian technocrats. They helped to create a benevolent image of the United States, even though they simultaneously undercut local producers.

The economic and cultural practices of the United States became a prototype to which social change and "progress" in Bolivia were constantly compared by nouveau-riche parvenus. For example, the views of Lidia Blanco, a forty-seven-year-old white woman, echoed the opinions of others like her. In the late 1960s, Blanco visited relatives in suburban California. She contrasted what she saw there with La Paz:

> Seeing other countries like the United States, one can see how they progress so much more because there is greater racial homogeneity. Here, the Aymaras have absolutely nothing in their heads. Peasants who come to the city become a problem and consume in a very minimal way. They're happy with anything, so there is no incentive for industry. No industry is going to produce for the few people who actually consume [in La Paz], and that makes things more difficult.

Despite Blanco's acceptance of a "melting pot" theory of social change, we should not view the opinions and cultural practices of middling- and upper-class Bolivians as evidence of a process of "Americanization." To do so would gloss over a far more complex reality. Despite the dominance of the United States, a number of European and Latin American countries also influenced social life in La Paz. They sponsored cul- 49

tural events, funneled scholarship money to Bolivian students, and promoted "development." A budding "culture industry" also began to emerge in Latin America, centered primarily in Mexico, Brazil, and Colombia. Brazilian and Mexican entrepreneurs created and diffused *telenovelas*, or soap operas, with the help of transnational finance and technology. In Bolivia, these programs successfully competed with U.S. serials because of the cultural advantages that they enjoyed. In addition, locally pioneered Bolivian "folk" music promoted by guitarist Alfredo Dominguez and charangist Ernesto Cavour was immensely popular with young paceños.

Furthermore, despite a superficial mimicking of metropolitan trends, most well-heeled Bolivians felt a profound ambivalence toward the United States and its citizens in Bolivia. Many had always viewed western Europe as the center of "culture" and "civilization," but they admired the prosperous, commodity-filled lifestyle so identified with the United States. Yet at the same time, their attempts to produce and purchase the same commodities that would make urban living more comfortable for them were constantly undermined by Bolivia's subordination to the United States. Their personal encounters with U.S. citizens in Bolivia were also often entirely unsatisfactory.

For example, many young U.S. tourists, who subsisted on a shoestring budget, traveled around Bolivia during the late 1960s and 1970s with their possessions crammed into backpacks. The young people's sloppy dress, penchant for fleabag hotels, and fascination with indigenous culture mystified their Bolivian class peers, who viewed them as wayward hippies lacking a sense of purpose in life.[9] More settled, "establishment" Americans affiliated with various U.S. agencies in La Paz also exasperated their paceño counterparts. Paceños, especially those from the old guard, complained that these individuals were crass money-grubbers who lacked breeding and a sense of the finer aspects of cultural life. Some likened them to the La Paz cholos, who they so despised, and took great delight in imitating the Americans' poor command of Spanish and boorish behavior.

Lawyer Hernán Montes frequently recounted the story of a sale put on by an American family. The family had settled in La Paz for a two-year stint with a development organization, and prior to its departure, the household head advertised a sale of various domestic possessions that would not accompany the family back to the United States. Montes attended the sale with his wife on the appointed day, and much to their

disgust and amazement, they found a half-used bottle of deodorant offered for sale amidst the pots, furniture, linens, and other household wares. How, they wondered, could anyone be so coarse? What must these "gringos" think of Bolivians if they really believed that anyone would buy their used deodorant?

We see then that upwardly mobile Bolivians who aspired to the "good life" did not unambiguously embrace Americans nor were they simply crude imitators of metropolitan styles and practices. They adopted cultural practices and consumed foreign-manufactured goods within a particular class and ethnic context that had its own historical dynamic. New patterns of consumption threatened older notions of good taste, and the exclusion of large sectors of the population from the nascent consumer society prevented consumerism from playing a more democratizing role in the heterogeneous context of urban La Paz. Cultural practices, symbols, and meanings were constantly reworked in accord with the shifting balance of power.[10] In the course of these struggles, prosperous paceños reshaped the meanings of breeding, nouveau-riche pretentiousness, and modernity. Female domestic service was an aspect of this process. It became an arena in which competing groups struggled to redraw class and ethnic boundaries, as well as create a modern lifestyle.

▣ DOMESTIC SERVICE AND THE CULTIVATION OF CLASS IN LA PAZ

Domestic service was about status and pretense. For ambitious paceño social climbers and those who had already arrived, the presence of a servant remained a crucial index of social standing. Although employing a servant could strain a household's budget, employers were usually willing to sustain the financial burden, if at all possible, in order to maintain the appearance of gentility. Those families who absolutely could not afford a live-in maid almost always hired a part-time laundress.

Yet the labor of domestic servants also served another important purpose. It was crucial to elaborating a convenient, urban lifestyle in an impoverished city, where domestic tasks remained extremely labor-intensive. Affluent employers used servants to both cultivate status and carry out the domestic labor that they so abhorred. Those women who were less involved in the chores associated with housework could then focus on the creation of comfort and image, particularly through con- 51

sumption. Their homes became a means of elaborating a superior class, ethnic, and gender status, and servants were adjuncts in this process of feminine self-realization because they helped white women embellish gracious and orderly homes.

By the 1960s and early 1970s, many white women had resumed their former household responsibilities, which they had never completely abandoned. Those from the professional middle class and the newly constituted upper class withdrew from the labor force to marry and raise children. If they remained married, the presence of a male breadwinner who could command a high income in a profession, business, or governmental occupation permitted these women the luxury of becoming full-time wives, mothers, and household managers.

Household workers played a key part in the elaboration of white, female domesticity because housekeeping was so time-consuming. Unlike their counterparts in North America and Europe, Bolivian housewives could not rely on supermarkets for quick and easy shopping. Frozen, prepared foods were unavailable. The cheapest, freshest produce was only obtainable in congested marketplaces, where considerable time and energy were required to negotiate the crowded spaces, select produce, haggle over prices, and return home, sometimes to the distant suburbs. The time needed to cook a meal in the rarefied air of La Paz was considerably longer than at sea level, and because inexpensive, fast-food restaurants did not exist, the traditional large, mid-day meal remained a fixture of white middling- and upper-class family life. Working husbands and students took two hours to eat a home-cooked meal with their entire families. Preparations typically began in the mid-morning, shortly after breakfast dishes were cleared from the table, and the final clean-up was not accomplished until mid-afternoon.

To complicate matters, only the wealthiest La Paz households possessed the full range of domestic appliances found among the North American middle class. This was because the foreign-manufactured devices were costly and difficult to service when they broke down. Employers soon realized that servants were more versatile and frequently more economical than any machine. Although the availability of domestic appliances occasionally made the job easier for servants, these devices also allowed employers to raise standards and thus did nothing to shorten the workday. Sometimes, too, employers feared that electrodomestic utilities would break down in the hands of servants and denied household workers the use of labor-saving technology.

Yet the importance of domestic service for employers transcended its utilitarian features. The continued presence of immigrant Aymara women in the homes of white urban families was enduring proof that old privileges had not been completely transformed by the revolutionary upheavals of 1952. The availability of servants—alien and distinct—to receive orders strengthened employers' egos by assuring them that there were always others more vulnerable and powerless than themselves.

Servants also allowed rising middling- and upper-class white women to distinguish their homes from the makeshift dwellings of the poor by enforcing rigid standards of cleanliness, which were closely connected to notions of moral superiority that whites associated exclusively with themselves. Whites believed that the immigrant neighborhoods teemed with filth and sought to separate their families from this growing threat by requiring servants to follow elaborate housekeeping routines.[11] Mopping floors on a daily basis, ironing laundered underwear to kill lingering germs, and scouring bathrooms from floor to ceiling were part of the assigned tasks.

The battle against filth was accompanied by a related struggle against noxious odors, which also signified health and moral hazards. Smells delineated social hierarchies because of their association with people and places. Affluent employers typically associated bad ones with the streets and the people who populated them. As Hernán Montes remarked, "Of the one hundred odors that one encounters in the street, ninety-nine of them are bad." It should come as no surprise that female employers, who were the gatekeepers of domestic virtue, frequently complained about their susceptibility to strong odors and had an obsession for fresh air.

To the extent that female domestic service freed affluent women from the constraints of housework, it also gave them more opportunities to elaborate the differences among themselves, as the old guard and the nouveau riche contended for the symbols of class privilege. Unlike men, women generally did not derive power from the ownership of a business, the control of a large income, or prominence in the state bureaucracy. Yet they shared social and political power with men through marriage ties. They projected this power, and elaborated upon it, through the minutiae of everyday life, which was an important means for them to judge and be judged. Clothing, home furnishings, leisure pursuits, personal demeanor, and family background became weapons in this struggle and differed dramatically from the less privileged.

Afternoon tea parties, which were a fixture of social life among mid-

dle- and upper-class women, provided a key setting for defining social distinctions. The gatherings typically included between four and fifteen people recruited from interlocking networks of friends and kinfolk. Sometimes the groups met on a weekly or monthly basis, but at other times the meetings were spontaneous affairs organized on the spur of the moment. When gathered together, the women discussed trips abroad, impending marriages and probable divorces, the activities of children, and current events. They also talked about fashion, played cards, complained about servants, and so forth.

The symbols of class emerged in a variety of ways. In the realm of fashion, a woman was trained from childhood to discern the fine points of dress. What constituted lady-like appearance for a white woman varied somewhat with age, but a mature lady had to demonstrate a refined elegance, which indicated self-control. Extravagant display exposed her to suggestions of looseness and irresponsibility. A woman had to know the difference between fashion and extravagance because the former promoted class position, but the latter undermined it.[12]

Women kept abreast of the latest European and North American fashion trends through magazines such as *Vogue*, *Bazaar*, and *Vanity Fair*. The wealthiest women traveled to Miami, New York, Paris, and other metropolitan centers to purchase clothing from expensive boutiques and department stores. Others had to content themselves with imports sold in a variety of upscale stores in the city center. All, however, hoped to distinguish themselves in the afternoon gatherings by the fashionable display of foreign styles. They were also extremely attentive to changing hair fashions and make-up, and hostesses worried about the appearance of their homes, the quality of the refreshments, and the manner in which Aymara domestics served guests. Given the limited areas in which women could demonstrate personal creativity, these concerns were not unusual and they formed an integral part of the broader process of class formation and struggle in which women, their husbands, and families found themselves immersed every day.

For example, early one evening Tamara Arguëllo returned to her family's high-rise apartment on the fashionable Plaza Isabel la Catolica after a tea with the female volunteers from the Children's Hospital. As her husband feigned disinterest, she breathlessly described the house in which the women had gathered. Located in Calacoto, it contained so many rooms that one could get lost inside, and its marble floors, brass fixtures, works of art, and stunning flower displays were the most elegant

that she had ever seen. How, Tamara wondered aloud, could she ever invite the tea group to her home after such an experience. Tamara's husband was a middle-level government bureaucrat. He, like his wife, came from the pre-1952 upper class, and his surname still carried a certain weight in elite social circles. He knew the hostess and her family but was unimpressed by the wealth and glamour. He scoffed that her husband was "a nouveau riche who had not had his money even ten years."

Other members of the old white oligarchy might easily have responded in the same way. Their disdain for garish consumerism came mixed with an element of envy, but they tried hard to elaborate a sense of breeding and good taste that distinguished themselves from the white and cholo parvenus. To buttress claims to status and prestige, they found subtle ways to inform strangers of their illustrious family histories, and children were steeped in an idealized family tradition from a young age. Some, such as the Arguëllos, patronized the La Paz Philharmonic Society, joined clubs to which the nouveau riche did not belong, and sent their children to elite private schools, such as the Colegio Alemán. And they, too, indulged in forms of conspicuous consumption, albeit with a slightly different "accent" than their competitors.

White nouveau riche and old guard alike ridiculed the practices and pretensions of rising Aymara and cholo entrepreneurs. They scoffed at the expensive trucks and lavish fiestas that most powerfully symbolized the newly accumulated wealth of this group, describing the entrepreneurs as aggressive Indians who no longer knew their place. The women, in particular, were perceived as completely unrefined, aggressive, and obnoxious, and their attention to a uniquely urban-Aymara version of feminine fashion was mocked. Yet at the same time, those chola women who wore more typical "western"-style clothing (*de vestido*) were ridiculed for being "de-cultured" (see chapter 5).

Despite the constant discrimination that these immigrant entrepreneurs and urban-born cholos endured, their political and economic power grew throughout the 1970s with the assistance of the Banzer regime. Perhaps more than anywhere else, the mounting strength of this group was evident in the annual celebration of the patron saint of Gran Poder, the neighborhood where many lived. The Fiesta del Señor del Gran Poder had long been a neighborhood event, typical of similar celebrations in other parts of the city, but by 1975 it had undergone a major transformation. In that year the parade, which represented an important part of the festivities, penetrated the heart of white-ruled La Paz, where it

flowed along the Prado Boulevard for several blocks through the central business district, until finally dispersing at the Plaza del Estudiante. The number of dance groups had also burgeoned, and because of the new economic prominence of neighborhood entrepreneurs, municipal authorities, politicians, and the heads of important businesses actively exploited the event for personal and political gain (Albó and Preiswerk 1986).

Although a variety of people from the country and the city took part in the parade, the dance groups that dominated the event were organized by occupation and represented the most powerful economic interests in the vicinity of Gran Poder: meat sellers, coca buyers, transporters, coffee merchants, and electrodomestic wholesalers. Only these individuals could assume the financial burden of renting or purchasing the lavish costumes. In addition, one of the prime movers behind the Fiesta del Señor del Gran Poder, Lucio Chuquimia, was a successful urban-Aymara entrepreneur who manufactured school uniforms. Son of a professional embroiderer, Chuquimia headed the Association of Folkloric Groups of Gran Poder and assumed the enormous, but extremely prestigious, financial burden of *preste*, or sponsor, on more than one occasion (Albó and Preiswerk 1986).

The parade and associated events gave newly rich cholos, who were excluded from the inner sanctums of white society, an opportunity to exhibit their economic prosperity and cultivate status. They did so in a way that combined an ambiguous reassertion of their ethnic heritage through the medium of "folklore" with the ostentatious display of wealth.[13] The result exhibited their incorporation into the dominant, white society, while simultaneously contesting its cultural symbols and staking out a positive definition of Aymara identity. Not surprisingly, whites who were not seeking political support or markets for their products often tried to ignore the entire event because of its association with an inferior social group. They did, however, regularly travel to the altiplano town of Oruro to dance in a carnival parade that was more socially and economically heterogeneous.

Unlike the white ladies of La Paz, chola women had never been assigned the exclusive tasks of elaborating an orderly and virtuous "home," because they had always been involved in the daily business of making a living. In addition, the "public" sphere of work and the "private" sphere of home were not as clearly drawn for them, as homes and family businesses often occupied the same premises. For these reasons, the extent to

which chola women could use the home as a means of feminine class and ethnic expression was necessarily limited.

Yet like their white counterparts, they, too, hired servants, but their household workers were less auxiliaries in the process of feminine self-realization than apprentices or temporary hired hands. And sometimes they were rural kinfolk. These workers did some "domestic" chores, but they also assisted employers in small businesses and a variety of other income-generating activities.

The greater cultural affinity between chola mistresses and immigrant servants often dramatized the rural, Indian origins of employers in ways that they found particularly vexing. Status-conscious employers, for example, often felt that the distinctions between themselves and their workers became clouded when servants sought to equal them in dress and appearance (see chapter 6). These concerns generated complex tensions that were constantly being negotiated.

For their part, Aymara immigrants were not eager to be servants for anyone, and they reserved some of their harshest criticism for chola employers. They took servant jobs because these positions were among the very few opportunities available to uneducated, Indian women from the countryside. The women, however, were really searching for something very different. They desired a more prosperous life, which they hoped to acquire through commerce, and perceived domestic service as merely a chance to establish a foothold in the urban economy. In the next chapter, we examine how these rural-born Indian women incorporated themselves into the urban labor force as domestic workers.

FROM THE COUNTRYSIDE TO THE CITY: AYMARA WOMEN, MIGRATION, AND WORK IN LA PAZ

In 1977, thirteen-year-old Barbara Chuquimia ran away from her home in the Bolivian highlands. Chuquimia did not speak Spanish nor did she have a cent to her name, but she convinced a lorry driver to take her to La Paz, where she hoped to find work with the help of an aunt whom she had never met. "My mother always yelled at me," she explained, "and my father had died. There was no money to buy clothes for me, and I wanted to have new clothes. That's why I came to La Paz."

But when she arrived in the city, Barbara discovered that she did not know the exact location of her aunt's house, only the name of the neighborhood. So she began asking passersby on the street for help. Some people understood her questions but others did not. Nobody seemed to know the aunt, and as day turned into night, Barbara grew frightened and began to cry. Finally, a woman who understood Aymara took pity on her and helped locate the aunt, who was surprised and angered at the young woman's exploits.

After sending word to Barbara's mother, the aunt agreed to help Bar-

bara find a job, and within a short time the young woman found herself working as a domestic servant for a chola woman who operated a small restaurant. The experience was not what Barbara expected, however. She recalled that the "señora was really bad. She pulled my ears and my braids. She made me peel potatoes and told me that I was going to cook. But I didn't know how to cook, and she paid me very little. She told me that when I learned how to do everything she would increase my salary, but after a month nothing changed."

During the decades that followed the national revolution, Barbara Chuquimia and thousands of other young women like her migrated to La Paz with a variety of hopes, fears, and expectations. They moved from a deteriorating household economy, where social relationships and the sexual division of labor were changing, to an impoverished city, where the right connections and access to cash increasingly defined the kinds of people that immigrants could, and could not, be. Their experiences were not the same, but as Aymara women entered the urban labor force, they underwent the transition from the countryside to urban domestic service in complex ways. Participation in a commercialized, consumer-oriented society transformed concepts of work, space, and time for them. A rigid gender division of labor structured access to jobs and resources in ways that marginalized immigrant women to the lowest level of La Paz society. Waged employment and strict forms of labor discipline led to the separation of work from leisure, and a new realm of "leisure" activities beckoned young women. New time rhythms were experienced as a speed up in the pace of life and work, while the organization of urban space symbolized the gender-, ethnic-, and class-specific framework through which power was experienced in La Paz.

This chapter explores the process by which rural Aymaras become servants in La Paz. Rural women enter a city where the manufacturing sector is too restricted to provide employment for everyone, and those who do find factory jobs are usually not from the countryside. Immigrant women must either create work for themselves by selling on the streets or take a position as a domestic servant, which forces them into subordinate relations with employers. Yet, despite this depressing scenario, they keep arriving in La Paz. Why, one might ask, is this the case?

A job—any job—is often more than cash-strapped peasants have in the countryside. The city also offers more than just the possibility of finding work. Young peasant women want to buy consumer goods, meet new people, and escape from what many perceive as the monotony of rural

59

life. When they find themselves working in a low-paying job, they must then negotiate the demands of employers and their own desires for personal autonomy. This is a process fraught with deep contradictions.

⬜ GENDER, MIGRATION, AND THE CHANGING GENDER DIVISION OF LABOR

Aymara women flocked to the city in the aftermath of the 1953 agrarian reform. Although the land reform made most peasant families property owners, the subsequent fragmentation of landholdings through inheritance and population growth led to a steady erosion of peasant agriculture. Small, unproductive plots in the highlands could not satisfy the subsistence requirements of families, nor did they require the daily labor of numerous people, and family labor became redundant at certain times of the agricultural cycle. This situation deepened the need for cash, which was an old problem for many peasant families,[1] and Aymaras were forced to combine subsistence agriculture with a multiplicity of other income-generating activities. Some peasants migrated to La Paz in search of waged employment. Others staked out claims to frontier land in the Alto Beni, a lowland settlement zone that opened up in the 1960s.

A steady stream of migrants poured into La Paz during the decades that followed the agrarian reform. Nearly a third of those who settled in the city between 1953 and 1980 did so in the late 1960s and 1970s, when the limited expansion of the urban economy created a handful of new opportunities for immigrants (Albó, Greaves, and Sandóval 1981). But by the late 1970s the boom had turned into a bust, and Bolivians braced themselves for what became a prolonged economic crisis. The so-called informal sector of itinerant street vendors, shoeshine boys, brickmakers, part-time construction workers, and domestic servants burgeoned. It continued to grow throughout the 1980s, as economic chaos and a series of natural disasters in the countryside further eroded living conditions and stimulated additional migration.

Declining terms of trade for Bolivian exports and an economy bankrupt after years of profligate foreign borrowing undermined the legitimacy of the Banzer regime. Mounting demands for a return to democratic rule finally forced the military's hand. Banzer agreed to general elections in 1979 but widespread fraud denied the presidency to Hernán Siles Suazo, candidate of the Democratic Popular Unity party (UDP). A

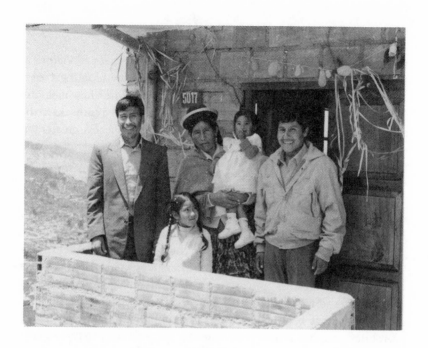

An immigrant family from the Bolivian countryside.

second election in 1980 established Siles as the popular favorite, but before he could assume power a military coup d'état led by General Luis Garcia Mesa suspended Bolivia's precarious democratic opening.

Garcia Mesa, and a series of short-lived juntas that succeeded him, soon discovered that right-wing regimes could not remain in power without the support of the United States. For nearly two years the generals used the apparatus of the Bolivian state to run an international cocaine-smuggling operation, which brought down the wrath of the U.S. State Department. The United States refused to recognize the military regime and cut off economic aid to Bolivia. At the same time, mismanagement of the economy, declining exports, rising interest rates on the nation's outstanding foreign debt, and massive popular mobilization against the military proved too much for the generals. In late 1982 they stepped down. Siles Suazo was then sworn into office, and for the first time in eighteen years, the country embarked upon a sustained period of civilian government.

Siles, however, was unable to control the spiraling economic chaos. World-record rates of inflation battered urban wage earners. In 1985, Si-

les was replaced by the nominally democratic government of Victor Paz Estensorro. Paz brought inflation under control only by adopting a series of draconian fiscal austerity measures pushed by the IMF. These measures froze wages, cut government subsidies, mandated massive cutbacks in the state sector, and encouraged, albeit with very limited success, greater foreign involvement in the national economy. In the same year, the world tin market collapsed, throwing the Bolivian tin industry into a depression from which it still has not recovered.

The crisis initiated the deindustrialization of La Paz's nascent industrial sector and marginalized large sectors of the working class. Some 20,000 state-employed tin miners were thrown out of work. Along with hundreds of peasants, they gravitated to the intermontane valleys of the Chapare and Santa Cruz, where work in clandestine cocaine factories offered a hedge against starvation.[2] Other miners erected tent settlements on the periphery of La Paz, where they survived for a time on meager severance pay before joining the army of urban unemployed. Some even briefly pitched tents in the central plaza of the city to protest government policy. Clearly, unemployed miners and peasant immigrants did not join a "proletariat," understood as a wage-earning population incorporated into an industrial economy, but the migrants resembled a more classic proletariat in an important way. Both groups lacked control over productive resources and they did not command the labor power of others.[3]

The crisis led to a decrease in demand for the goods and services that immigrants provided, and as more and more people flocked to the city, competition among them increased, while earnings declined.[4] This situation was devastating for people who needed cash to purchase the basic necessities of life. Alicia Colque and Maria Mamani summarized what the transition from a rural community to cosmopolitan La Paz meant to them. According to Colque, "In the countryside . . . there is a lot of work, but we [women] do everything—spin wool, make sweaters, and even weave shawls. But in the city we can't do this. We have to work for the señoras. Also, in the city we have to buy everything. This is the difference between the city and the countryside." Maria Mamani concurred, "We spend a lot more money in the city. You have to wake up with money and go to sleep with it at night in order to survive." Yet because of the growing commoditization of social life in their home communities, the intensive, unwaged labor of Colque, Mamani, and others like them was not sufficient to maintain a household in the countryside.

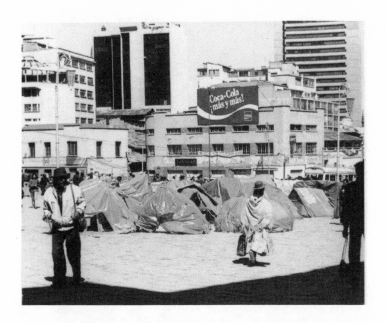

Unemployed tin miners encamped in La Paz's Plaza San Francisco protesting IMF-backed structural adjustment policies and the privatization of the economy.

In one way or another, they had to scrape together a cash income because they could not ride out the crisis by depending on unwaged labor or reverting to agricultural production for subsistence. This meant migrating to La Paz.

The manner in which poor peasants incorporated themselves into the urban labor force varied by gender and age. Although both men and women left the countryside for La Paz, young women migrated in greater numbers.[5] Fewer waged employment opportunities existed in the countryside for women than for men, but in La Paz women could capture a wage at a younger age by working as live-in domestic servants. They also received room and board, which allowed them to remit a portion of their earnings to rural kinfolk at the same time that they freed families from the burden of supporting them. In addition, the shortage of land in highland communities put more pressure on daughters to migrate because land rights most frequently passed to sons.[6] Older daughters were responsible for many tasks in the household, such as cooking and caring for younger children, but once younger sisters could take over these activities, parents encouraged older daughters to marry or migrate to the city. 63

Peasant woman drying potatoes.

Over 80 percent (50) of the women interviewed for this study migrated to La Paz from the rural communities of the high plateau and valleys that surround the city. The largest number of the migrants (41 percent) obtained their first jobs as live-in servants between the ages of eleven and fifteen years. Nearly a third (18) of the young women, however, started careers as household workers between the ages of six and ten because of domestic conflicts or misfortunes that disrupted family relationships.

Although the stability of peasant families has long been taken for granted, family life was often far from harmonious for peasant women. Interdependence and obligatory sharing in the increasingly cash-dependent peasant household bred conflict that weighed heavily on the young. Immigrant accounts of domestic violence, conflicts with step-parents, the abandonment of children, family members losing track of

Peasant women and children in rural village.

each other, and the untimely death of parents attested to the estrangement and tensions of social life.

Six-year-old Zenobia Flores fled to La Paz with her mother in 1972 to escape the drunken rages of her father, who regularly beat up his wife and children. "I came [to La Paz] when I was very young," explained Zenobia, "because my father was really bad. He didn't treat us well. When he was drunk he always hit my mother, and I think that he hated me the most [of all the six children]." She stayed with an aunt, but then one day she decided to take a bus by herself. Zenobia got lost and did not see her family again for three years.

She was taken home by a chola woman, who saw her crying and walking aimlessly down a street, and for a year Zenobia worked for this woman, grinding chilies into powder and selling in a small dry-goods store. She was never paid and frequently went hungry, and the woman eventually abandoned her on a street corner. Another chola woman rescued Zenobia and put her to work, but two more years passed until the young woman was finally reunited with her mother.

Five-year-old Francisca Quispe and nine-year-old Primitiva Mamani began to work as domestic servants after the deaths of their mothers.

Quispe was abandoned by her father, who established a relationship with another woman, and she was placed in domestic service by an elder sister. Mamani, in contrast, was incorporated into a new family when her father remarried, but tensions with the stepmother eventually pushed her out of the household. The stepmother, who faced dismal prospects for herself and her own offspring, was unwilling to accommodate additional children for very long. So when Primitiva's father made arrangements for his daughter to work as a maid, she was happy to go.

The tensions and conflicts that shape household relationships were only aggravated by the crisis of the 1980s. Growing impoverishment put more pressure on individuals to find multiple sources of income to meet domestic needs, and the manner in which scarce resources were allocated within the household became ever more problematic. Separate income streams may also have strained the commitment of individuals to shared consumption and the domestic unit.[7]

As men and young, single women became laborers in the city, their personal claims on wages frequently conflicted with the needs of rural households for an income (see chapter 5). Wives and mothers who remained in the countryside grew marginalized on unproductive subsistence plots, where they rendered reproductive support to men and children. Their work not only included a number of extremely labor-intensive chores, such as drawing water, weaving, spinning, and preparing meals, but also involved long hours of toil in the fields, which extended the length of their working day well beyond that of men.[8] Some maintained marketing activities, but others grew more dependent on migrants for a monetary income, which they had difficulty generating themselves. The economic opportunities for migrant mothers in La Paz were also constrained by domestic responsibilities, especially childrearing. Women with children were ineligible for jobs as live-in servants. The only options available to them were street vending and part-time, live-out service for more affluent women.

Peasant women, then, become differentiated by their work trajectories and domestic responsibilities. The manner in which they supply labor to urban households and peasant small holdings varies according to age, marital status, and number of children, a conditioning factor that does not pertain to men. For young women, moving from a rural peasant community to an urban household entails more than just an uncomfortable bus or truck ride over the rough roads of the altiplano. It involves crossing class and ethnic boundaries and participating in an increasingly

commoditized economy. In the confines of an employer's home, they experience feelings of loneliness, the loss of control over their work, and new concepts of time and efficiency.

 BECOMING A SERVANT

For Antonieta Huanca, her first experience in the home of an urban employer was extremely intimidating. "Aye," she recalled, "I was so afraid of the señora that I couldn't even wipe my nose in her presence. She'd tell me to go clean something, but I didn't know what she was talking about. And the food was so strange. Of course I had eaten rice and noodles, but the señora with her vegetable salads—I didn't know how to eat them. Salads with lettuce reminded me of the kind of food that rabbits eat."

The food is only one aspect of life as a domestic worker that unnerves Aymara peasant women. The tall buildings of La Paz make them feel claustrophobic. The crush of traffic and people in the city center overpower them, and they are terrified by the elevators in the high-rise apartment buildings that house employers. Yet life as a servant also holds certain fascinations. Domestic workers are intrigued by employers' televisions. One woman recounted how she puzzled for days over a TV, wondering how people could become small enough to fit into such a tiny black box. Telephones and the disembodied voices that emanate from their receivers also seem mysterious. Learning to talk on a telephone is fun, but some new recruits find the experience distressing, especially when employers expect them to take messages and the individuals at the other end of the line are rude and impatient.

Young, single women migrate to La Paz and find work in a number of ways. Approximately 60 percent of my interviewees have traveled to the city with a relative. They then temporarily reside with urban kinfolk, who provide them with the necessary contacts to land a job in domestic service. Sometimes a female relative already employed as a servant knows of openings, and men who work as gardeners or caretakers in wealthy neighborhoods also link immigrants with urban employers.

Julia Yapita came to La Paz with her female cousins when she was twelve years old. For over a year, she lived with an older sister, who resided in one of the sprawling immigrant neighborhoods in the Alto. The sister sold food on the street and knit sweaters for tourists. Julia assisted her in these tasks but resented always being ordered about. "My sister

67

bossed me around a lot," Julia explained, "and my aunts, who lived next door, told me to find a job, because my sister was never going to buy me clothes. They knew of a chola lower down [in the city] who wanted a maid and took me to meet her. She wore a pollera [a large gathered skirt] and sold *salteñas*.[9] I started working for her that day."

Not all the women benefit from the hospitality and orientation of urban-based relatives. Almost a third of the interviewees (18) move directly from rural communities to urban homes. They are recruited by other migrants, who periodically return to the countryside with instructions from employers to bring back a worker. School teachers and merchants also induct peasant girls into domestic service. These individuals, who are usually urban-based chola women, establish godparent relations with peasant families in the course of their activities in the countryside. They then offer to clothe, educate, and raise the young women in their urban homes in exchange for personal services.

Barbara Faniquina came to La Paz with her godmother. The young woman's mother had passed away and her father had taken up with another woman who had several children from a previous relationship. Faniquina did not like the new domestic arrangements. "My stepmother was very abusive," she recalled. "She was always humiliating me. My godmother saw how I was suffering and that's why she brought me to La Paz." The godmother was a merchant who regularly visited Faniquina's community after the harvest to buy potatoes and sell goods such as sugar, rice, soap, and cooking oil to the peasants. In the city, she operated a dry goods store, where she put Faniquina to work running errands and minding a three-year-old child.

When personal connections are unhelpful, immigrant women try their luck outside the Mercado Camacho, as they have in the past. Prospective servants line up every morning to offer their services to the housewives who come to shop. Their numbers range from ten or fifteen to sixty on any given day. The job hunters seek positions as general live-in servants, as well as live-out laundresses and day workers. Competition among these women has increased, as the Bolivian economic crisis deepens and the so-called informal sector becomes ever more saturated. For example, rivalries between older mothers who depend upon day work, and young, single women have intensified.

Margarita Choque, a fifty-four-year-old widow, relies upon a variety of part-time jobs to support herself and her daughter. Because of her domestic responsibilities, Choque cannot work on a live-in basis, but she in-

creasingly finds herself competing with young women for the live-out jobs that are crucial to her survival. She explains that "there is a group of women who come to the market [to look for work], and we all know each other. But now there are lots of others—all kinds of people—who come, too. Young women are asking for work, but there is no washing. I tell them: 'You are young. Why don't you work live-in? I'm old and I can't work that way.' Because of this, we fight."

When all else fails, women walk from door to door in residential neighborhoods asking for work. Sometimes, too, they seek the assistance of employment agencies that specialize in matching domestic workers with the needs of employers. The agencies require that prospective workers give proof of residence in the city and possess a national identity card, which many immigrant women do not own. This documentation is used to assure employers that in the event of theft or property damage, workers can be located and held accountable for their actions. The agencies then compel the job seekers to commit themselves to work for one month in the home of an unknown employer, who has to pay a finder's fee equivalent to a servant's monthly salary. If the young women find the working conditions unsatisfactory, they have to pay a fine in order to recuperate their identification cards and receive no remuneration for the work. Not surprisingly, servants and employers tend to treat the agencies as a last resort.

Employers may require a prospective servant to present a work certificate from a previous employer as evidence of a young woman's honesty and trustworthiness. They also demand other qualifications that have less to do with an immigrant woman's ability to carry out domestic work than with an employer's ethnic identification and social aspirations. The classified section of La Paz's daily newspapers are replete with advertisements for domestic servants "con buena presencia [with a good appearance]." Some advertisements also specify how a servant should dress. On any given day, announcements for "sirvientas de vestido [servants who wear western-style dress]" are located next to others requesting "sirvientas de pollera [servants who use polleras]."

Once a young woman lands a job as a live-in servant, she has to overcome intense feelings of loneliness. Work consumes most of her waking hours, from early in the morning until well into the evening. Particularly on holidays and other festive occasions when parties and family gatherings occur, it is not unusual for servants to work until two or three o'clock in the morning.[10] Even after completing all of the assigned tasks, ser-

vants are still on call at all hours. They may be summoned to open the door for teenage children late at night or required to make meals at odd times.

Domestic workers also labor in isolation. Particularly in the exclusive suburban redoubts of the upper class, they toil behind high walls and iron fences, which effectively segregate them from the outside world. Many employers also habitually lock up servants when they go out, because they fear that servants will abscond with their possessions and let strangers into their homes. Sundays are generally the only days that servants do not have to work, but one day does not always provide the relief that young workers need. Recent immigrants cannot negotiate the city by themselves, and for many young women a day is not enough to return to distant rural communities. Consequently, they remain in employers' homes or seek out relatives in the immigrant neighborhoods.

Maria Laymi vividly recalled the profound loneliness that she felt. In 1971, Laymi, who was twelve years old, migrated to La Paz with her family. Her mother, father, brother, and three sisters rented a small room where they lived together, but Maria was sent to work for a middle-class family almost immediately. "I cried for a month," she said, "asking myself why I had to work there. I remembered how my mother used to get angry when I misbehaved. I wondered why I had done those things and why my mother didn't come to get me. In fact, my family lived a long way away. My mother also worked and didn't know her way around the city very well. Once she did come to visit me, and I told her that I wanted to leave. But she said that we didn't have any money and that I had to stay."

Because of their young age, the isolation of domestic work, and the lack of emotional support from family members, servants are almost forced to establish a personal relation with their employers. Many household workers initially look to female employers for the nurturing that they so desperately need from their own families. Not surprisingly, they feel that one of the most important aspects of any domestic service position is that the señora "treat them like another member of the family."[11]

Lidia Ticona is a case in point. She is one of six children—four boys and two girls—from a poor peasant family in the rural highlands. "I wanted to study," Ticona told me, "but the boys had to study first." She migrated to the city with an elder sister, who had worked as a domestic servant and knew La Paz well. The sister found her a position as a live-in servant with a former employer, whom she described as a "good patrona." Ticona soon concurred with this opinion. "I really liked to cook," she

explained, "and I felt very happy there. I lived with the señora, her husband, and their daughter, and they were very good to me. I loved them a lot, as if they were my own family."

Some employers are indeed more caring and considerate than others and may adopt a motherly attitude toward domestic workers, treating them almost as adopted children. They promise worried relatives that no harm will befall the young women in the city, give servants special gifts at Christmas, and distribute secondhand clothing to them. Occasionally, an employer might even encourage a young servant to attend night school. Like the more elaborate paternalistic rituals of the past, these acts create close but unequal bonds between employers and household workers. But servants are not part of employers' families, even though they are not complete outsiders, either. The ensuing contradictions prove extremely vexing. Unlike an employer's children, servants do not live with their parents, enjoy an extended childhood of adolescent friendships, hobbies, and leisurely pursuits, and they usually do not attend school. Yet during the course of a working day, they come into close contact with the private aspects of their employers' lives without participating directly in them.

Family fights and conversations in the presence of household workers often take place as normally as if they are being conducted in private. In addition, the supposed inferiority and distinctiveness of household workers makes it possible for some employers to confide their most private concerns to them. These employers unburden themselves to servants because they feel that their secrets can not possibly be exposed by someone from such a vastly different social world. Yet at the same time they completely deny the needs and feelings of domestic workers, who are not encouraged to discuss themselves and their problems in a similar way. The denial of servants' humanity reflects deeply entrenched racist sentiments about Aymaras and is a profoundly unsettling experience for young women.[12] Servants must not only bear mute witness to the trials and tribulations of employers, they must also constantly attend to the changing interpersonal alliances of family members, which may affect their position within the household.

As they struggle to overcome feelings of loneliness, household workers also experience the loss of control over most aspects of their job. They are subjected to a new work discipline in which employers dictate not only the work tempo, but also the chores, pay, and vacation schedule. The routine, however, does not require them to carry out the same dull

chore in a steady, systematic manner, nor does it demand an organized plan for undertaking the tasks at hand. Although such regimentation is generally associated with the control of working classes (see Thompson 1967), it is not a feature of domestic service in La Paz. Female employers themselves have not learned these habits, and they do not approach household management with the systematic method of businesspeople or factory managers.

The management styles of mistresses are quite personal and often capricious. They require maids to be at their constant beck and call. The job involves more than the obvious tasks associated with household maintenance, such as cooking, dusting, mopping, and washing clothes. It also goes beyond answering the telephone, buying bread, opening the door for visitors, serving refreshments, and numerous other details. Employers demand that servants attend to their slightest requests at all hours of the day and night. Indeed, this is the essence of servitude, and the absence of a written contract makes young women even more vulnerable to the incessant demands of employers.

Mistresses and servants also have very different concepts of time. Aymara peasant women come from a world where the rhythms of life are determined by personal promptings and seasonal variations in the agricultural cycle. In contrast, time is measured by the clock in La Paz and controlled by mistresses. Justina Andrade is a case in point. She experienced time in her employer's home as a form of work speed up. For several months, Andrade was the sole servant for a family with nine children. Her employer expected her to cook, clean, and service the individual needs of all household members. Justina was overwhelmed by the chores. After starting the workday at six o'clock in the morning, she often did not finish until eleven o'clock at night. "I could never keep up with all the work," Justina explained, "and the señora always rushed me and said that I was slow." She described one incident that cost her the job:

> One day I was in a rush and didn't make all the beds right. When the señora discovered that the sheets were not all shaken out well, she started to complain. Then her daughter came and grabbed my braids, yelling that she had taught me how [to make beds]. I told her that I was tired and had a lot of washing to do, so I wasn't going to make the beds again. She called me a disrespectful *imilla* and then grabbed my hair again and told me to leave.[13]

Middling whites and the upper class equate immigrant notions of time with backwardness and ignorance. One employer, for example, assured me that "Indians and cholas are different [from whites] because time means absolutely nothing to them. They will sit on the street for a week or twenty days selling four oranges and two bananas because that is what they are made for. It [the passage of time] doesn't affect them at all."

As new concepts of time guide the working days of immigrant women, the structuring of space reinforces the subordination of domestic workers, particularly among the upper class and aspiring wannabes. The spatial proximity of household workers and employers in urban households belies the enormous class and ethnic chasm between them. Employers must therefore reorganize domestic space to reproduce these social distinctions within the private boundaries of their homes.

Servants' quarters separate household workers from those they serve. They delineate a separate space for servants that is removed from the private realm of employers but that provides workers with little privacy, because mistresses and their family members may always enter. Typically located next to the kitchen, servants' quarters usually consist of a small room with little or no furniture and a separate bathroom. In some high-rise apartment buildings, they are even designed without windows to reduce construction costs.[14] Not surprisingly, the rooms often double as storage space for employers, who reserve the right to store brooms, spare propane gas tanks for the stove, ironing boards, and so forth in them. Employers justify these spartan rooms by pointing to the peasant huts in the countryside and maintaining that their accommodations represent a marked improvement. They might arguably be correct, if these rooms were not situated amidst the affluence of their own homes. In such a context, servants' quarters serve only to define the distinctiveness and inferiority of household workers.

Employers also constrain the movements of servants within households. Domestic workers are confined to their rooms and the kitchen when they are not working in other areas of the house. Employers also lock certain closets and cupboards to keep servants out. Occasionally, servants watch the evening soap operas with an employer's family, but they eat alone in the kitchen, while their mistresses preside over the family meal in the dining room. In the most genteel households, mistresses keep a small bell in the dining room so that they can summon maids to serve the next course or bring more of a particular dish without raising their voices. Sometimes, too, a buzzer connects the servant's room with

the mistress's bedroom, where some employers take breakfast. All of these practices underscore servants' inferiority, reinforce servile behavior, and reproduce class and ethnic differences.

Employers also create social distance by the imposition of certain linguistic practices. They refer to the household workers as "chica," "hija," or "muchacha" regardless of the woman's age, thus suggesting that she is childlike and irresponsible. Also, they almost always call maids by their first names and address them with the familiar Spanish *tu* but expect the women to call them "señora" and use the formal *usted*. In addition, employers may require workers to add such titles as "joven," "señorita," and even "niño" to the names of their children. Because household workers speak Spanish as a second language, their accent and grammatical mistakes are also constantly ridiculed by employers.

Although chola employers may also uphold some of these conventions, such practices are less common in poor households, where servants and employers may all sleep in the same room and eat together. Similarly, the inequalities so inherent to domestic service are often glossed over by the use of more egalitarian terms. Employers, for example, often refer to employees as *ayudantes*, or helpers, and sometimes, too, young female workers refer to mistresses as *tia*, or aunt, instead of the more formal señora.

It is no surprise that rural immigrants who enter domestic service for the first time feel lonely and intimidated. As they struggle to accommodate mistresses, they must also contend with the possibility of sexual abuse by men. The sexual harassment of household workers generates tensions between them and men and gives rise to anxieties among mistresses, who, despite claims to superior class and ethnic status, share one thing in common with servants: their subordination to the male household head.

SEXUAL DANGERS AND AMBIGUITIES IN THE WORKPLACE

The sexual harassment and abuse of household workers is one of the enduring features of female domestic service in La Paz. Practically every servant knows of other women who have been mistreated by male employers, and because of bad personal experiences or the perceived threat

of sexual abuse, they often try to ignore men on the job and limit their interactions to the mistresses. Claudia Morales is one example.

When Morales was fifteen years old, she worked for a school teacher and her husband in the middle-class neighborhood of Miraflores. The couple lived in a modest home that did not have a separate room for the servant, and Claudia was thus forced to sleep on the kitchen floor. She recalled that early one morning around five A.M., the husband returned home in a drunken stupor. He rang the doorbell incessantly, but neither she nor the mistress got up to open the door. He finally let himself in, and then, according to Claudia,

> He came straight to the kitchen and grabbed me. He said, "Oh, Claudina, you're so hot." I was really scared and started screaming for the señora. Then I grabbed a broom and told him that I was going to split his head open if he didn't leave me alone. The señora finally came and started yelling at him. I collected my things and left for my brother's house immediately.

Despite the mistress's pleading, Claudia refused to return to work on a live-in basis. She chose live-out service instead because she could avoid contact with the husband who worked during the day.

Although household workers suffer the physical and emotional impact of sexual abuse most directly, the sexual harassment of servants also creates antagonisms and confusing paradoxes for female employers. As we have seen in chapter 2, white ladies are assigned the responsibility of maintaining a proper moral atmosphere in the household. They must uphold high standards of cleanliness, personal behavior, and servant-employer interactions, all of which reinforce their class and ethnic superiority vis-à-vis servants and the lower class. Yet class-based notions of feminine morality become threatened when husbands and sons sexually molest domestic workers. Adulterous sexual liaisons, especially in an employer's own home, are a moral and personal affront to white women. They may also be perceived as dangerous when carried on with servants, because household workers are considered unclean and the carriers of venereal diseases. Mistresses may therefore sense a health threat to themselves.

Some mistresses hope to curtail encounters between servants and male family members by constant surveillance, a practice that simul-

taneously underlines their own subordination within the household. The wife of a high-ranking military official, for example, locks her maid up every night. As she explains:

> Every night before I go to sleep, I lock the maid in her room because I have sons. In La Paz it is very common that the patrons, especially the sons, go into the maid's room. When my maid learned how to speak Spanish, I told her that she had to take care of herself because of the men—you know how men are.

Yet sometimes these women may tacitly condone male behavior. Teenage sons regularly gain experience in sexual intercourse through encounters with household workers, and they often do so with the unspoken consent of their mothers.[15]

Despite the transgressions of men, neither overt sexual rivalries nor feelings of gender solidarity develop between white female employers and servants. This is because of the class and ethnic inequalities that structure their relationship to each other and shape their common subordination to the male household head. White women do not perceive servants as individuals with the same needs and problems as other women, including themselves. Women and men may consider servants to be awkward and physically misshapen—the antithesis of feminine beauty and grace as defined by the dominant society. For example, one employer expressed a typical attitude in joking about her maid's appearance in a bathing suit and laughingly described the young woman's attempts to swim as similar to those of a beached whale.

Sexual liaisons with servants pose virtually no threat to the economic well-being of female employers, because white men never leave their wives and children to establish new households with servants, despite soap opera portrayals to the contrary. In addition, the marriage contract enables wives to claim the class status of men and provides them with an exclusive license to produce children who can make similar claims. Neither servants nor their illegitimate children, who are the products of unions with male employers, have this right.[16]

In the households of chola employers the situation is not so clear-cut. Greater cultural affinity exists between servants and employers, who may be immigrants themselves or only a generation removed from the countryside. As a result, blatant rivalries develop between servants and employers over the attentions of men, fashion, and so forth (see chapter

6). As one disgruntled worker stated, "To work for a *pollera* is a disgrace. They say, 'I lost my earring.' They say, 'You slept with my husband.' That's how they talk. They are very jealous." In addition, chola women who live in consensual unions may feel more vulnerable because their relationships lack an official stamp of legitimacy.

We can thus appreciate how immigrant peasant women who enter domestic service become immersed in the social and economic life of La Paz in contradictory ways. They are neither part of employer families nor are they complete outsiders, but the nature of the work and their own isolation obliges them to establish a personal relationship with female employers. In the process, they suffer from racial discrimination and male sexual abuse, while at the same time they are exploited as wage laborers.

EMPLOYERS AND

THE WAGE NEXUS

I won't tell you that my maid has learned everything 100 percent correctly. Maybe she's only learned 20 percent, but I hope that with a little more patience she might reach 50 percent.

—Employer, La Paz, Bolivia

Although servants cannot direct the work routine and are vulnerable to abuses, they are not mere pawns in the hands of mistresses. Veteran servants grow increasingly sophisticated on the job and learn how to extract the most for themselves from situations that they do not completely control. This, of course, is a constant irritant to employers. White women incessantly complain about servants, but the economic turmoil that plagues the well-being of their families frequently stymies attempts to exercise more effective control over household workers.

The crushing weight of foreign debt, rampant inflation, declining productivity, and cutbacks in public-sector employment have closed the window of economic opportunity that facilitated the emergence of new urban middling groups. The crisis has moved many white women to re-enter the labor force or participate in it for the first time, provoking extensive changes in household organization that vary with the education, number of children, and marital status of women and their access to eco-

nomic resources. It has also changed the way that middling white women see themselves and understand their relations with others. Rising divorce rates have awakened parents to the fact that daughters have to be prepared to compete in a shrinking job market, and many young women hope to realize their potential by actively pursuing professional careers.

The activities of white women now extend well beyond the home and beneficent work to include wage labor and professional careers. The "new woman," who is usually young, questions the presumed natural association of women with a "private" sphere of social activity and seeks professional work outside the home. Other women, who are usually older and less educated, feel threatened by the steady erosion of class-based, feminine privilege and resent growing pressures on them to earn a living. Yet despite the growing differences among them, most white women continue to express dominant beliefs about domesticity in the rituals of daily life. They affirm the primacy of motherhood and the creation of a home for themselves, and they try to adhere to prevailing notions of feminine decorum in their speech, dress, and social behavior. Nevertheless, traditional beliefs and practices are increasingly contested, as white women must simultaneously confront the demands of work, families, and independent-minded servants. Renegotiating relationships with servants is one aspect of their efforts to meet the changing exigencies of social life.

In this chapter I examine the struggles that shape servant-employer relations. I do so by situating the personal interactions of mistresses and household workers within the broader context of rising economic insecurity and shifting white beliefs about a woman's proper place. First, the analysis explores how the economic crisis impinges upon servant-employer relations and shapes prevailing definitions of "the servant problem." The growing participation of middling white women in waged employment is then addressed. The pinch of hard times obliges these women to immerse themselves in the drudgery of housework, while ever more savvy servants compel employers to accommodate them in new ways.

EMPLOYERS AND THE "SERVANT PROBLEM"

Well-heeled employers assert that contemporary household workers are not as good as those in the past. They claim that servants are more ag- 79

gressive, demanding, unreliable, and even subversive than ever before. My La Paz landlady, for example, insists that servants today are "very irresponsible." She cites the pleasure that maids in her building derive from dropping water balloons onto pedestrians at carnival time as evidence to substantiate this claim. Many paceños, however, engage in these antics during the festivities that surround carnival. Unfortunately, the meaning of a good time is defined differently for servants and other members of the lower class. Indeed, the stereotype of the devoted servant who dedicates her life to the service of one family is the image against which any deviation is negatively evaluated. Housewife Teresa Menacho speaks for many other employers when she describes the debasement of servants:

> Formerly servants were a lot better than today. They stayed for much longer. A young girl remained until she married and formed her own home, and if she left, another person came immediately. They were trustworthy. They would watch the house if we had to leave and take care of the children as if they were their own. Today servants are not as good. If you have jewelry or money, they will steal it the minute that you turn your back.

These grievances express the aggravations felt by mistresses who have lost control over the lives of servants. As we saw in chapter 1, servant-employer relations have always been characterized by tension and conflict. Contemporary beliefs about loyal, life-term servants represent less the historical memory of employers than nostalgia. They are a selective appropriation of the past experiences of some employers, which are then generalized to stand for everyone. By conjuring up an idealized past, employers can more powerfully justify their views of dishonest, irresponsible servants. These convictions then enable them to stake out a moral high ground in current struggles over domestic service.[1] They prove extremely useful for women whose economic problems are threatening the moorings of their comfort and privilege.

The rampant inflation of the early and mid-1980s, which peaked in 1985 at an annual rate of 25,000 percent, consumed the incomes of middling families and eroded employers' ability to pay servants. For some families, live-in servants temporarily became an unaffordable luxury and former mistresses took on domestic tasks themselves; other women grew so exasperated with recalcitrant maids that they shifted to part-time, live-out workers, who also enabled them to save money. Servants'

monthly wages plummeted, sometimes by as much as 10 percent a day, and immigrant women increasingly opted out of household labor. In the early 1980s, more and more of them invested meager savings into street vending, where they hoped to cash in on the speculative opportunities offered by hyperinflation, but this behavior outraged employers who denounced servants for laziness and irresponsible behavior.

Like many other young Aymara women, Justina Osuna left domestic service to buy and sell wage goods. Osuna traveled to weekly markets in small altiplano towns to sell kerosene, rice, canned sardines, and other items that she acquired in La Paz. With the earnings from these sales, she then visited a large, bi-weekly market in Desaguadero—a Peruvian border town—to purchase cloth and blankets, which she smuggled back to La Paz and resold at higher prices. She did very well for several months until a policeman finally caught her on a return trip to La Paz. He confiscated her entire stash, which she had hidden under a bus in a secret compartment, and demanded an exorbitant bribe that she was unable to pay. Osuna thus lost her investment and went out of business.

Although everyone did not suffer Justina Osuna's fate, the economic opportunities offered by hyperinflation were abruptly curtailed in 1985 when Paz Estensorro launched Decree 21060 and the fiscal austerity measures contained in it. The black market for contraband goods disappeared, as consumer prices adjusted to their "real levels." Inflation then quickly became negative, because demand virtually disappeared and the collapse of popular resistance ensured that the government would not raise wages. Working-class Bolivians sank even further into poverty, and immigrant women had to reconsider domestic service, which they had never completely abandoned.

The greater availability of immigrant women willing to work as servants has done nothing to diminish employer discontentment. As Aymara women acquire more "street smarts" in the city, they become sophisticated in their dealings with employers. Servants know that once they learn the intricacies of bourgeois housekeeping, they can parlay the skills into higher-paying positions, and they are constantly on the lookout for new opportunities. In the high-rise apartment complexes of the city center, they use chance encounters with other servants in the hallways and elevators to compare wages, discuss working conditions, and seek out better jobs.

Servants' wheeling and dealing outrages employers, who find themselves in the uncomfortable position of competing with neighbors for the

services of household workers. Apartment resident Teresa Menacho speaks for other employers like her:

> I've had girls to whom I've taught everything right from the beginning, shaping them to my lifestyle and what I want. Then along comes another person and offers to pay them more and they are gone, leaving me without any help. You can hardly go to the window to shake out a rug without the maid downstairs asking you for work. I don't like this because it creates rivalries between neighbors. But you can't help it. The first thing that the maids do after they get to know each other is compare salaries.

Similarly, Teresa Menéndez complained about one maid who was brokering the movement of servants throughout her apartment building. The young woman, who worked on another floor, told Menéndez that she would find someone to replace a former servant, who had returned to the countryside. Securing a replacement, however, involved reshuffling three other domestic workers among different employers in the building. The complicated bargaining involved in this process exasperated Menéndez because she often felt uninformed about the ongoing negotiations.

Echoing these sentiments, a paceño gentleman fumed that "the main problem with servants is that they are very unstable [in their work patterns] and never tell you the truth." He was upset about his family's servant who had recently quit, ostensibly to care for a sick relative. Only two days after her departure, however, he encountered the young woman in the elevator, carrying the neighbor's baby, and she sheepishly admitted that she was working for another family.

Strapped for cash, middling households face keen competition for servants from more prosperous families, and considerable disparities exist in the wages that employers are willing and able to pay domestic workers. For this reason, a servant's workload does not always correspond to the wages that she receives. Rather, the amount of work attests to a young immigrant's ability to negotiate working conditions and the alternatives that are available to her at any particular time. In one high-rise apartment building, for example, a servant works for an elderly couple in a small, one-bedroom dwelling and earns seventy-five dollars a month. Yet on the floor below, another Aymara woman labors in a three-bedroom apartment for a family of four who constantly entertains. Her monthly wage is only forty-five dollars. Given these discrepancies, it is no surprise that household workers are always searching for greener pastures.

Foreigners, especially North Americans and Europeans, and the paceño upper class pose the stiffest competition for middling employers. Expatriates who work on embassy staffs or under contract with international development organizations typically have expense accounts and can pay servants higher wages, sometimes even in U.S. dollars. The frustration of paceña patrona Eugenia Morales with this situation is expressed in her hyperbolic explanation:

> There are ads in the newspaper—foreign family offers, for example, two hundred dollar monthly salary—or the maids hear about an opening on the television, especially on the Compadre's program.[2] Then they leave, swearing that everybody can pay the same amount. They usually go to Calacoto because most of the foreigners live there. When I hear about these salaries, I almost go myself.

To counter the untimely loss of household workers, mistresses manipulate wages in a number of ways. They may refuse to pay servants who quit on short notice, because, they argue, the time invested in training a domestic worker entitles them to a longer, albeit unstipulated, period of service. In addition, employers often refuse to set a wage until after servants work for a one-month trial period. At the end of the probation, however, they may dismiss workers with little or no pay and sometimes falsely accuse them of theft. Similarly, mistresses withhold wages, or pay them only in part, when the monthly payday falls on Friday or the day before servants go on vacation, because they fear—often correctly—that the young women will leave and not return.

The experiences of Ana Ticona poignantly illustrate the indignities that domestic workers endure. Ticona is a thirty-three-year-old laundress who worked as a live-in servant for most of her youth. One day when she was only thirteen years old, Ticona was looking for work outside the Mercado Camacho. A prospective employer approached her and offered a live-in position for approximately $125 a month. Ticona considered the offer a good one and immediately accepted. The work went well at first, but then her relation with the employer soured. "She bitched at me about everything," Ticona said. "'Why haven't you done this and why haven't you done that?' That's how she was." To make matters worse, Ticona was locked in the house every time the mistress and her family went out. At the end of the first month, she decided that she had had enough. Ticona announced her plans to quit, but the employer constant-

ly delayed paying the final wages. Another month passed and, despite repeated requests, Ticona still had not received any money. She described what happened next:

> One day the señor came home with a policeman. He pointed at me and said, "This girl stole four shirts, a graduation ring, and a tie clip. I'm not going to pay her salary until she returns these things." Then they took me to the police station on the Plaza Murillo with my *aguayo* on my back. I cried a lot because I didn't have it in my heart to steal. Then one of the agents asked me why I had stolen. I told him that I had taken nothing, but he said that he was going to put me in a chair with electric current.

Fortunately, Ticona was not tortured. After spending three days in jail she was released, but she never received the back wages.

Ana Ticona's case illustrates certain aspects of the servant-employer relationship that are very common. The case demonstrates the manner in which employers manipulate servants through the wage nexus; first, by offering high salaries and then, by not paying them, or not paying them in accord with an initial agreement. Ticona's experiences also highlight the vulnerability of household workers whose employers rightly or wrongly accuse them of a crime.

Despite constant efforts to regulate servants, employers often feel that they are waging a losing battle. Given their considerable power to dominate household workers through the control of wages, such sentiments seem unwarranted. We can, however, begin to understand their frustrations if we first explore how the increasing entry of white women into the labor market challenges dominant gender ideologies and alters the balance of power within the household.

MISTRESSES, ECONOMIC CRISIS, AND SHIFTING GENDER IDEOLOGY

The increasing diversity of the life experiences of white women has meant that the stresses and strains of the Bolivian crisis are not felt the same way by everyone. Mothers and daughters, married women and divorcees, housewives and wage earners grapple with economic decline in ways that are shaped by their evolving positions in the home and the wider society. Many young women, for example, now aspire to career

goals, as the involvement of all white women—young and old—in waged employment grows, and the crisis has highlighted the importance of professional training for them.

Women from white, professional households have been attending La Paz's two universities—the Universidad Mayor de San Andrés and the Catholic University—in growing numbers over the last three decades. Some have been lucky enough to study abroad. Parents initially viewed a university education for young women as simply another adornment that went along with class status. If resources were scarce, they favored sons for university training, and women often faced considerable opposition if they chose to pursue a professional career. Alcira Mendizábal, who entered the Universidad Mayor de San Andres in the 1960s to study medicine, was typical. She described her father's reaction to her plans:

> My father gave a speech at my high school graduation in which he said that "some would now go far away to study, others would stay close by, and still others would remain with their families and be the pearl of the home." Afterward, I realized that he wanted me to stay and be the pearl of the home, but I told him that I wanted to study medicine. He didn't like the idea, but he finally said I could go to university, if I agreed to study dentistry, because dentistry was more adaptable for a women.

Today, Mendizábal operates a successful dental practice, and professional women like her are not hard to find, even though they are still a minority in La Paz.[3] Parents no longer question the validity of a university education for female children, nor are young women pressured to be "pearls of the home." Parents cannot reasonably assume that daughters will marry and remain under the care of husbands for the duration of their adult lives, and male wage earners are hard-pressed to single-handedly support families. Yet most white women entering the labor force are not professionally trained. Many—especially those who are middle-aged—prefer to remain at home, managing the domestic sphere and enjoying the benefits of feminine class privilege, but they do not always have this choice. Fifty-year-old Tania Argueta is one of these women.

Argueta's family did not escape the crunch of economic hard times. Her husband accepted an important political appointment during the military regime of Garcia Mesa, but when the military fell in 1982, he found himself on the wrong side of the political fence and lost his job. For

several years he had difficulty landing a comparable position and held a series of short-term appointments, none of which paid enough to maintain the family's standard of living that included the private-school tuition for two teenage children.

The couple's only asset was a large house, which they constructed during the boom years of the 1970s. After long deliberations, husband and wife rented the house, moved into a smaller apartment, and subsidized their lifestyle with the rental income. Meanwhile, Argueta's children urged her to find ways of earning additional income. A son encouraged her to open a delicatessen; a daughter suggested gourmet cooking classes for monied friends. Both children argued that she would be happier controlling her own income.

Argueta considered these suggestions but worried about the implications of such a decision. She liked the idea of an independent income, and the family certainly needed the money. But if she worked people might think that her husband was unable to maintain the family. The husband harbored similar fears and did not provide the same support as the children. For these reasons Argueta never pursued the matter and continued to dedicate herself to the home, albeit a much smaller one.

Other married women and widows forestall waged employment by dabbling in knitting, sewing, housesitting, and baking to supplement husbands' salaries or inheritances. These activities are not considered "work" but they provide women with the appearance of domesticity and allow some of them to cling to a lifestyle centered around the home. Many of their daughters, however, do not desire such a life. Tania Argueta's twenty-year-old daughter, Carla, studies at the Catholic University. She holds the "long-suffering mothers" of her parents' generation in contempt and hopes to have a career in journalism.

Carla and other young women of her generation seethe at the patriarchal constraints to which they are subjected by families, although few would describe themselves as feminists. Most parents continue to oblige daughters to reside in the parental home until after marriage. They do so for economic reasons, but also because the virtue of a young woman living alone is still questioned, and this, in turn, reflects on the status of the entire family. Indeed, when Tania Argueta insisted one day that she accompany Carla on a routine visit to the gynecologist, her daughter was furious. Tania argued that a young woman's morality might be ques-

tioned by others—especially family acquaintances—if they saw Carla visiting a gynecologist alone. Carla countered that her mother's attitude demonstrated a lack of trust.

Parental control is particularly irritating for those young women who have studied abroad and lived independently with student friends. Some young paceña women have even followed the example of their North American and European counterparts and established co-residence with lovers and male friends during foreign sojourns. Upon returning to La Paz, however, these relationships either end or are formalized in marriage. Co-residence remains a practice that whites associate with cholos and the lower class. It is avoided by those concerned with upholding family honor and class-based notions of feminine propriety. Marriage and motherhood remain the most important way to establish adulthood and social respectability for young women. Servants, too, continue to be crucial to their "liberated" lifestyles. Because of the availability of immigrant Aymara women to relieve them of the double day, young, white ladies feel that it is at least theoretically possible to have everything: husband, job, and children. This, however, is not always the case.

White, female-headed households have become more numerous as the incidence of divorce increases. Although statistical data are unavailable to document this trend, men and women agree that the practice is more frequent today than at any time in the remembered past. Most people have friends or relatives who are, or have been, divorced, and some have gone through the ordeal themselves. Divorcees face a particularly difficult time defending their identification as *gente decente* and establishing economic independence. Only certain kinds of jobs are acceptable to status-conscious, middling women, but age discrimination jeopardizes the access of older women to them. Clara Landázuri, a forty-six-year-old divorced mother of two, describes the situation that she and other women like her must face:

> The situation here in Bolivia for the woman who has no money is terrible. You're not going to go out on the street to sell a few tomatoes and peppers like an Indian, because you're not made for this kind of work. But in the offices, we get to a certain age, and the bosses don't want older women. It's the same in every office: they prefer young women. I don't have the time to study, either, because I'd have to leave work. But I work because I need to eat and buy clothes [for my children].

87

In addition to the threat of downward social and economic mobility, single mothers face a paradoxical situation. On one hand, they are viewed as failures by their class peers, either for choosing the wrong partner or for an inability to maintain home and family intact. They are also suspected of sexually licentious behavior. It is reasoned that in the absence of a husband, father, or brother to protect their honor, they are more likely to succumb to uncontrollable sexual urgings or the duplicity of men seeking casual sexual affairs.

On the other hand, those women who work hard to support themselves and their children in the absence of a male household head are frequently admired by friends and family. Like the long-suffering mothers of an earlier generation, they are perceived as sacrificing everything for their children and referred to as "mujeres muy trabajadoras (hardworking women)." Ironically, to be so defined is the only way that an unmarried woman can independently head a household and still uphold her social standing in the eyes of white society. Furthermore, such a designation carries no hint of selfishness, a quality that is more likely to be associated with working mothers who are married.[4]

Clearly, economic and social changes are pulling middling white women in a number of different directions. As they grapple with economic decline, divorce, low-waged employment, changing views of themselves, and sometimes professional careers, they must reconcile the exigencies of economic necessity and traditional feminine propriety with the demands of household chores and servants, who do not passively accept conditions laid down by them. How they manage these competing agendas hinges upon their participation in the labor force.

⬚ NEGOTIATING SOLUTIONS

Those non-waged housewives who seek to uphold the dignity of the bourgeois home and their place within it face a frustrating dilemma. They cannot successfully compete for experienced servants with the paceño upper class and foreigners and are often left with immigrants who know none of the intricacies of housekeeping. Some mistresses prefer green recruits who are easily intimidated and less demanding than more experienced workers, yet they detest the constant demands that un-

trained servants place on their time and energy. Becoming too immersed in the drudgery of housework is, after all, tiresome and entirely unbecoming for a lady.

In order to maintain appearances, these mistresses construct an elaborate division of labor whereby they control the intellectual work and then assign the menial chores to servants. Mistresses, for example, will control child rearing, spending, and the managerial aspects of food preparation, while household workers scour the floors, launder clothing by hand, serve meals, and so forth. Yet maintaining a strict division of mental and manual labor is not always possible because there is never a guarantee that a servant will do a good job, and housewives often find themselves assuming the work of a maid. They complain, for example, that household workers ruin electrical appliances by plugging equipment that requires one hundred and ten volts of electrical current into outlets that emit two hundred and twenty volts.[5] Rather than risk the destruction of an expensive vacuum cleaner or floor polisher, they may simply do the task themselves.

Employers also must deal with servants who resent the orders, demands, and manipulations to which they are subjected. Sometimes, as we have seen, a servant will simply depart without notice, after finding better opportunities elsewhere, and leave employers and their female children to fend for themselves. Servants also respond to perceived injustices by engaging in petty theft and intentional carelessness. Worker Ascencia Chambi, for example, could not convince her employer to raise wages, so she began to sabotage meals. She explains, "There was a lot of work for me, and the money stayed the same. This really made me mad, because I couldn't afford to buy anything. So I started to cook poorly. One day I made the lunch real salty and the next day I didn't put any salt in it at all. Another day I didn't wash the lettuce." Some servants even openly challenge employers over working conditions. According to twenty-year-old Hilaria Condori,

> There are señoras who take advantage of maids, like you were their little slaves. There are also some girls who are very quiet and don't defend themselves. I've always had a strong character with the señoras. If they say things to me, I argue with them. For example, one señora got mad at me about a little rubber cover for the gas and started to shout. I told her that I wasn't deaf and that she couldn't treat me like her slave.

89

Housewives become locked in a constant battle with servants, who lack experience, have only a short-term commitment to the job, and resent the machinations of employers. They are thus grudgingly obliged to immerse themselves in domestic chores so that the tasks are done properly. Sopocachi housewife Lidia Ballesteros tidies up the bedrooms and periodically scours the bathrooms because "the maid doesn't know anything and cleans them [the bathrooms] very superficially."

Similarly, Tania Argueta has never been able to retain a servant for more than nine months. In 1987 she was constantly frustrated by a parade of servants who passed through her home. None of them knew how to cook, and she found herself spending an inordinate amount of time in the kitchen with them. If she left the young women alone, her husband and children complained about the food, which she, too, found inedible. On one occasion, after the arrival of yet another new servant, Tania commented, "If I have to go into the kitchen with this one, I'm going to be really irritated."

Yet even when servants learn the rudiments of housekeeping, housewives find that the appearance of involvement in domestic chores is necessary to preserve effective control over them. Only constant surveillance can insure that servants are not pilfering behind their backs or cutting corners to finish the work more quickly. Sustaining such a level of vigilance is not only tiresome, but also takes time away from more enjoyable activities, such as beneficent work, attending to kin networks, and so forth. It undermines the image of feminine refinement that employers try so hard to cultivate. As Sopocachi patróna Eugenia Moreno explains, "Housework is a very heavy daily routine . . . that conditions women to lower themselves."

Wage-earning employers, by contrast, cannot closely supervise servants, nor can they easily assume the burden of chores if a servant leaves without notice. These women have to reconsider the organization of domestic tasks in their home and find new ways to accommodate household workers. Yet how, they ask themselves, can they ensure that Aymara women will carry out household chores in their absence? How can they allow distrusted servants to have unsupervised access to their homes? Employers have no easy answers to these questions, but as more of them hold full- or part-time jobs, finding reliable servants and retaining their services becomes extremely important.

Mothering, in particular, is an arena in which the dominant definition and emergent practices conflict, as white, middling women have to

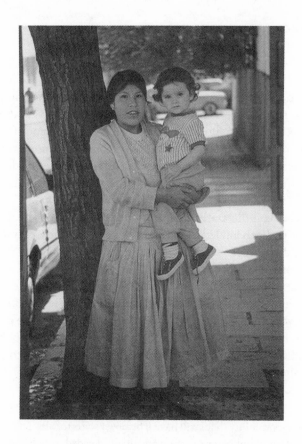

Young domestic servant and her charge.

simultaneously juggle the demands of work, child rearing, and servants. White women rarely question the desirability of motherhood, because of the availability of servants. Children also represent an important source of old-age security for middling families, because of their economic vulnerability and the inadequacy of Bolivia's social welfare system. Motherhood is therefore a logical and accepted outcome of holy matrimony. It is viewed as an expression of an innate "womanly" nature that is communicated through emotional nurturance in the serenity of a home. A childless woman is held in very low esteem, and if a woman has not had a child by her mid-thirties, she is pitied at best and viewed as emotionally unbalanced and even neurotic at worst.

Yet white women do not feel comfortable leaving their children under the unsupervised care of domestic workers. Paying an untrustworthy out-

sider to care for one's child strains the concept of motherhood, which is done for love, not money.[6] Women believe that servants cannot give children the love and nurturance that only a real mother can provide. Many also fear that servants will infect, neglect, and even abuse children. Working women, however, are forced to give up some of their prerogatives and surrender more of the responsibilities of mothering to domestic servants. This threatens their identities as women and gives rise to considerable ambivalence about their responsibilities to family and job.

Manuela Leon illustrates these contradictions. When she was in her mid-twenties, Leon landed a job as an economist for the Central Bank of Bolivia and had high hopes of pursuing a full-time career. She subsequently married and bore two children, but she continued to work full-time because of the assistance of a live-in childminder. As her children grew up, she worried about not spending enough time with them, and when her youngest son did not learn how to talk, she became consumed with guilt. Finally, convinced that the servant was to blame for her son's problem, Leon quit the job and devoted herself completely to the children. As she explains her decision:

> It seems that the servant abused my son. That's why he doesn't talk. Imagine the responsibility that I will have if he never starts to talk. That's why I had to take account of my situation and finally decided to dedicate myself to my child. Why should I work if I don't have to and my husband is willing to support me and the children?
>
> I either realize myself as a woman or realize myself as a mother. You really can't do both, because something always suffers. Being a mother is more than just vaccinating your children, and if I were to go back in time and pursue a career, I would not have children.

Of course, all working mothers do not and cannot opt for Leon's choice. Those who continue to work often characterize their relations with servants as "more flexible" than the servant-employer relations of their mothers' generation. Twenty-eight-year-old Selma Salinas recounts how her mother requires the servant to get up early in the morning to wash clothes before making and serving breakfast to the family. The maid then works until late at night, cooking, cleaning, and so forth, and she is chastised for the slightest mistake. "For my mother," says Salinas, "the servants are Indians; that's to say, something different [from

white people]. I don't have this conception of servants. I believe that everyone has certain rights and that the maid can sleep in the morning at least as long as I do." Salinas is also more dependent upon the labor of her servant, and a closer examination of her life helps to understand why.

When she was in her early twenties, Selma Salinas began a journalistic career and married shortly thereafter. Because her husband was a full-time university student, Salinas assumed the temporary burden of primary wage earner for the household. She decided not to hire a servant in order to save money, and even after the birth of her first child Salinas felt that the additional income was still more important than a servant. But Salinas soon discovered that she was wrong.

The daily routine was overwhelming because her husband claimed to be too occupied with his studies to assist with the household chores. A female relative came to the rescue and offered to babysit in the morning, but even with this assistance Salinas found herself totally exhausted at the end of every day. She would return home in the afternoon to a pile of dirty diapers and numerous other domestic chores that she could not ask the relative to do. "I didn't use disposable diapers," she said, "because they are all imported and very expensive. I needed to save money, so I washed the diapers myself."

Finally, she gave up and hired a servant. She also began to purchase disposable diapers because, as she explained, "I can't make the maid wash diapers. She would get tired. I used to wash them because it was in my interest to save money, but if I gave diapers to the maid to wash all day, I think that she would be irritated. That's why I've opted for disposable diapers."

Disposable diapers are not the only concession that wage-earning employers make to accommodate servants. Many women find that they must also place more trust in the abilities and integrity of household workers. Unlike unwaged housewives, who rarely entrust servants with enough money to purchase large quantities of goods in the market, working women often find that they have no other option. Marketing takes considerable time and energy, which these employers do not have, and they must delegate the job to servants.

Lupe Andrade is a case in point. Andrade lives in a spacious five-bedroom apartment in central La Paz. She is married, a full-time business administrator, and the mother of four children. Andrade attended college in the United States and returned to Bolivia in the mid-1960s, when she married and began to form a family. While her children were young,

she taught literature on a part-time basis at the state university, but since 1979 she has pursued a full-time business career. Andrade jokingly says that "I became a man and I no longer do anything at home. It's beautiful."

She and her husband, who "does absolutely no housework," are away from home all day, so she employs two live-out maids—a cook and a general servant—to carry out the domestic chores. The cook, who does all the marketing, works from 9:00 A.M. to 3:00 P.M., and the general servant arrives at 7:30 A.M. and leaves in the mid-afternoon. In addition, a washerwoman comes once a week to launder the clothes. According to Andrade, "The cook is very efficient. She has her *caseras*[7] and knows how to bargain. I haven't done marketing for years because it's really an inconvenience and takes the entire morning. I'm more like the gentlemen of La Paz: I go to the market on Sunday mornings and buy my little fruit. That's all."

Andrade is fortunate. The cook has remained in her service for nineteen years and the general servant has worked for six years. This loyalty is not lost on Andrade, who pays high wages by local standards and is well aware of the trials and tribulations of her servant-employing friends. Andrade has also tried to establish a good relationship with the workers. Nevertheless, she is never completely sure that they are not stealing behind her back, but she values her time more highly than the goods that the servants might pilfer. As she explains, "They're not supposed to take food home with them, but they probably do. I'm not home when they leave, so I don't see anything. I also can't swear that the cook doesn't keep some of the money that I give her for the marketing. But I spend more money when I go to the market, and my time is more important than if she steals 10 pesos ($5) every week."

Most employers are not as lucky as Andrade. They experience weeks or months without the benefit of a servant, and these periods rankle them more than their non-waged counterparts. Sometimes they must lower standards and leave the housework undone, while at other times they extend the length of their working days to include domestic chores. In the absence of a servant, the burden of domestic tasks may also fall on female children and relatives not employed outside the home. And when working women hire a maid, they cannot take time to teach new recruits the intricacies of the job and how to operate household appliances.

Clara Landázuri, for example, lives with two teenage children—a boy

and a girl—in an apartment in Obrajes. She is employed as a secretary in the city center, where she works a full eight-hour day. She has had a number of different household workers over the years. The present servant is a young immigrant who has been in Landázuri's service for six months and received most of her training from Landázuri's fourteen-year-old daughter. Landázuri recalls, "It wasn't so bad because she [the servant] started in December and my daughter was on vacation from school. Even though I tried to teach her, it was really my daughter who taught her everything—how to dust, make the beds, cook, and clean. The girl doesn't know anything because she came from the countryside."

The woman now cleans the house and prepares the midday meal, even though she still lacks experience as a cook. Landázuri, however, is resigned to simple meals. "During the week," she says, "I can't explain what she doesn't already know. I can't tell her to do this, that, and the other thing, so we eat simple food. Because of the distance between my home and my office, I arrive from work and eat at full speed. Then I have to go back out to the street and wait for a bus. Sometimes they are so full that I have to wait for the next one and the traffic is usually so bad that it takes a long time to go up to the city. I am often late."

Forty-seven-year-old divorcee Marta Delgadillo shares many of Land-ázuri's problems, yet she has decided to forsake domestic servants and assume the entire burden of household work herself. Delgadillo must raise three children with no financial assistance from her former spouse and is unable to hire a full-time servant. Although her eldest son works and contributes to the household, the heaviest financial burden falls on Marta. She scrapes together a modest living as a factory supervisor and occasionally knits sweaters on a piece-rate basis for a store in the city center.

After working a full day in the factory, Delgadillo returns home, eats a quick dinner, and prepares meals for the following day. She arises at six o'clock in the morning to clean the house and make final preparations for the midday meal so that she can arrive in the factory by nine o'clock. She does the marketing on weekends, when an elder son accompanies her with his car. Delgadillo admits that it is an exhausting routine but rationalizes her system. She explains that

I don't have servants because . . . first of all I can't afford them. Also to have a bad servant who you can't pay well is no good, either. I prefer to do

the housework myself. I'm not going to have a maid just for appearance sake like so many people in La Paz. So I've grown accustomed to doing things myself.

Marta Delgadillo, Clara Landázuri, and other mistresses—waged and unwaged—must constantly balance the competing demands of housework and economic necessity. Those who employ servants have to continually renegotiate relations with domestic workers in order to manage new tensions created by employment outside the home, divorce, declining standards of living, and shifting beliefs about feminine propriety. This is an ongoing, uneven struggle that is not waged the same way in every household. Yet despite the variations in the balance of power in the household and the concessions made by mistresses, employers continue to dominate domestic workers through the control of wages. By so doing, they sustain their lifestyles by controlling the labor power of other women. And even as dominant gender beliefs grow increasingly contested with the entry of more white women into the labor market, the real challenge to the status quo does not come from middling and upper-class employers. Rather, it emerges from the ranks of young servants, who want to experience the pleasures of an urban consumer society and enjoy a brief moment in their lives when they are not encumbered by husbands and children. It is to their leisure-time pursuits that we turn next.

CITY PLEASURES

Household workers have no intention of dedicating their lives to the service of others. They want to move out of domestic service and move up the social and economic ladder. The experience of being wage laborers gives young migrants greater economic independence and control over when, where, and how to dispose of their earnings. Because live-in workers are single and do not pay for food and accommodations, they can afford to spend a portion of their earnings on themselves. Despite the isolation of their work, the women quickly develop lives beyond the workplace. They meet other young women like themselves, court men, and partake of the pleasures offered by the urban consumer society. In the process, they create an alternative understanding of feminine beauty and propriety, which poses an implicit challenge to the ability of dominant groups to act as the final arbiters of womanly gratification. Yet their desires to fully indulge in the joys of consumerism clash with the daily reality of demeaning, poorly remunerated household labor, the needs of kinfolk, and their own vulnerability as young women

living away from home. The ensuing tensions between family obligations and self-indulgence reshape ties to rural kinfolk, as the experience of urban waged labor simultaneously changes the manner in which immigrant women perceive themselves.

For young immigrant women, paid household labor is merely a foothold in the urban labor market. They eventually want to leave domestic service to "progress" (*progresarse*) and "civilize" themselves (*civilizarse*). These terms are used by domestic workers to describe their desire to marry better than one can in the countryside, "dress well," and pursue an education, and they are inextricably linked to dominant class and ethnic notions of feminine propriety.

In the parlance of white society, "civilization" refers to an achieved condition of social order and refinement that whites alone have attained. It is further associated with a continuous process of development that is linked to modernization and capitalist development. The concept is typically contrasted with savagery, understood by many whites as the state in which rural Aymaras live.[1] Immigrant Aymara women, however, do not simply internalize these dominant views, but as they struggle against their own subordination, they must engage the symbols, practices, and language of domination to free themselves from it. By so doing, they immerse themselves in the fictions and, perhaps more important, the silences perpetuated by white society about them.[2]

Ambiguous understandings and creative tensions emerge from this domain of emergent social knowledge and transformative experience. As Aymara women adopt dominant symbols and practices within a lower-class, immigrant context, their acquisitions simultaneously represent a form of accommodation to ruling beliefs *and* opposition to them, and they constitute the terrain on which symbolic struggle takes place. This chapter explores these emerging contestations.

WAGE LABOR, SOCIAL MOBILITY, AND KINFOLK

Few domestic workers actually realize their dreams of upward mobility.[3] The plight of laundress Gumercinda Flores and her children illustrates the degradation suffered by immigrant women who are unable to fulfill their hopes of a better life. Flores launders clothing on a piece rate basis to support herself and seven children. The four eldest children assist

their mother to meet the family's financial needs, and seventeen-year-old Isabel boasts that she can iron forty shirts in a day. Gumercinda, however, is not in good health, and after enduring a severe beating at the hands of her ex-husband one day, she suffered a partial loss of vision and entered the hospital for a prolonged stay.

The family was thrown into disarray and the children were forced to fend for themselves. Isabel found a position as a live-in servant and brought her one-year-old sister along with her. To avoid detection by the employer, Isabel shut the little girl in the basement of the house and smuggled food out of the kitchen for her as often as she could. It was not long, however, before the subterfuge was discovered. As Isabel explains,

> One day the señor caught me taking food down to the basement. He asked me what I was doing and I didn't know what to say. He went into the basement and saw my sister and said, "How is it possible that this crazy woman is locking a child up in the basement?" He ordered me to take her out and got very angry. The señora was more sympathetic and gave me fifteen days to work out the problem with my sister. I couldn't tell her about my mother.

The suffering, humiliation, and sheer brutality experienced by this woman and her children are a frequently unexpected consequence of the so-called civilizing process that immigrant women endure. The misfortunes of the Flores family are suffered by other Aymara women, whose social relationships are torn apart by the simultaneous processes of incorporation into a system of capitalist domination and marginalization from its rewards. Yet their understanding of such experiences often exists in confusing tension with notions of progress and civilization, comprising the ground upon which an alternative conception of themselves and the world might emerge, but remaining, nonetheless, more "structures of feeling" (Williams 1977) than crystallized explanations (see chapter 6).

Although the discourse of revolutionary nationalism, which achieved an enduring power in the aftermath of the 1952 revolution (see chapter 2), continues to provide them with some ideological tools, it does not speak to the condition of poor women and celebrates an entrepreneurial capitalism from which these women are largely excluded. Moreover, as political leaders increasingly embrace IMF-backed structural adjustment and neoliberal philosophies, the rhetoric of revolutionary nationalism increasingly disappears from political discourse.

Domestic service and small-scale street vending are the primary opportunities that La Paz offers poor, immigrant women. Prior to the age of twenty-five, single, childless women move in and out of live-in service, remaining an average of only two years in any single position. By their mid-twenties, most women have married, formed consensual unions with men, or borne a child, all of which disqualify them for jobs as live-in servants. Employers do not want to deal with servants' children, nor do most mistresses have the means to accommodate the relatives of domestic workers.

Consequently, servants with children and husbands take up small-scale commerce or work part-time on a live-out basis, becoming laundresses, part-time cooks, and so forth, because this work provides them with the necessary flexibility to cope with domestic responsibilities. Others return to their home communities or migrate to a frontier colonization zone with their families. The occupational and residential shifts usually represent a lateral move from one kind of low-paid, female occupation to another and do not represent an improvement in the standard of living. Only one of thirty-three interviewees over the age of twenty-five has withdrawn from the labor force and become a housewife, and one quarter (11) of forty-five interviewees for whom information is available report that their mothers were also domestic servants. Clearly, domestic service offers young women very few opportunities for economic advancement and social distinction.

It does, however, create novel possibilities for young immigrant women who do *not* have to bear the burden of children and family responsibilities. Migration dilutes the authority that families exercise over migrant daughters and allows women to diversify their relationships in the city, while access to a wage enables them to gratify some of their personal desires for consumer commodities. At the same time, however, immigrants are aware of their tenuous economic position in the city and do not quickly forsake ties to rural kin.

Young women feel strong emotional attachments to rural kinfolk and want to support them as best they can. Single, domestic servants, perhaps more than any other group of migrants, diligently remit cash and waged goods to rural relatives. Even though servants can not always return to the countryside on a regular basis, especially if their communities are located far from La Paz, nearly all of them schedule at least one return visit every year. These trips usually last from two weeks to a month and

typically coincide with the harvest or a community fiesta. When they can not personally make the trip, immigrant women find ways to send packages with urban friends and relatives.

The women remit gifts of goods and cash not only to support rural households but also to reaffirm their claims to local resources. Access to land, animals, and other property through inheritance or membership in a corporate community remains extremely important to them because of the vagaries of the cash economy. Maintaining amicable ties to rural kinfolk is therefore crucial to their survival in La Paz because it enables them to retain access to important resources, especially land.

Yet only a small percentage of domestic workers actually enjoy direct access to land, although most hope to acquire land in the future through marriage, inheritance, or use rights.[4] Over time this situation may weaken the commitment of female migrants to rural kin. Family ties do not always prevail over the temptations of La Paz, especially in those areas of the countryside where young women stand to inherit little or nothing, and conflicts erupt with family members who can not completely command the labor or the deference of young migrant women.

Parents who worry about their daughters alone in the city often go to considerable lengths to limit young women's exposure to the people and consumer pleasures of La Paz. Some parents seek to restrict the free time available to daughters by urging employers to confine them in the evenings and to limit the number of free days available to them. One mother, for example, told her daughter's employer to only allow the young woman every other Sunday off, instead of the traditional weekly Sunday holiday. "I don't want her to leave [the employer's home]," she said, "because I don't want her to go off and talk to other maids. They get together and start behaving badly."

Aymara women chafe at these restrictions. As their lives unfold in the city, the beliefs that immigrants hold about themselves and country kin grow more ambivalent, especially as rural life becomes less and less a part of their lived experiences. After sixteen years in La Paz, laundress Maria Mamani has developed keen insights into the immigrant experience.

Generally young women come directly from the countryside to work for the señoras. I see them with their country clothes and their sandals. They find work, but the señoras exploit them because they don't know how to do anything. They go from one señora to another and gradually become more

101

refined and act like real cholas. They start to discriminate against their families and even change their names because country names aren't as dignified in the city. The city really changes people from the countryside.

Indeed, if we consider the experiences of Ema Lopez, we find the truth in Mamani's words. Lopez works for a wealthy white family. She is very impressed by her employer's affluence and unfavorably compares her family's dwelling in the countryside with the mistress's urban home. Lopez dislikes the fact that her family sleeps in one room, which also serves as a kitchen. "At the señora's," she explains, "there is a kitchen and the bedrooms are separated. The house smells like perfumes, but when I return to my house I notice a different odor." She also resents her family's lack of concern for order and cleanliness. "I like everything clean, but my family's house is so disorderly. I pick things up and organize them when I go to visit. I always ask [my family], 'Why is this so ugly? Why do you do things this way?' I organize things at home because the señora has taught me to keep house this way." Cleanliness is also a theme that comes out in the accounts of other immigrants. Echoing Lopez, Antonieta Choquehuanca comments that "in the countryside nobody pays attention to the filth. That's just how it is. People change their clothes only if they are really dirty."

Immigrant women, then, become immersed in the social and economic life of La Paz in contradictory ways. They are unable to move up and enjoy the social and economic benefits of a white middle- or upper-class lifestyle, but at the same time they are increasingly removed from rural life. As they participate in a consumer-oriented world, the availability of cash, the display of wealth, and "right living" become closely tied to notions of personal success. Urban wage labor seems to offer new possibilities for economic advancement and personal autonomy, but low pay, the needs of family members, and persistent gender and ethnic discrimination constantly thwart their desire for social mobility and restrict the range of leisure activities available to women.

A young domestic servant's week is fractured into periods of work and leisure. They can enjoy a brief respite from their grinding work routines on Sundays and an occasional Saturday afternoon, when they are free to stroll in the city parks and plazas, visit friends and relatives, attend worship services in a variety of different churches, freely court young men, or take in a movie. These activities give them an opportunity to keep

abreast of the latest fads and styles, and "dressing well" is extremely important, because it is a way to express their newly acquired urban sophistication.

Poor married women who work as live-out servants and those with small children rarely experience a separate "leisure time," because they alternate between waged labor and domestic responsibilities. In contrast, men, whose workdays more closely approximate an eight-to-ten-hour schedule, face a very different situation. They experience a more clearly defined period of leisure because they are not burdened with domestic responsibilities. They can therefore participate in sports, go to bars, belong to immigrant associations, and attend the meetings of unions and political parties during their non-working hours. This homosocial world of male activities is not readily available to women.[5]

For young domestic workers, fashion is one arena in which their marginal independence as wage laborers, the pull of family loyalties, and aspirations for greater social and economic mobility are contested. It is also where immigrant women and their urban-born counterparts elaborate an alternative version of femininity that implicitly challenges dominant concepts of ideal womanhood. This alternative concept of femininity is itself dynamic and riven with internal contradictions. It is not the result of a consciously articulated rejection of whites. The cultural practices elaborated by immigrant women emerge out of years of confrontations and dealings with each other, as well as from conflicts and encounters with more powerful social groups.

⬚ AYMARA WOMEN ON THE TOWN

The manner in which styles, cultural practices, and forms are generated and manipulated by women of different class and ethnic backgrounds is captured by Sider's notion of cultural production. Sider defines culture as "the form and manner in which people perceive, define, articulate and express their mutual relations" (1980:24). Culture expresses "the actual ties people develop with one another in the course of organizing both the labor of production and daily life, and the social appropriation of the product" (22), but it does not strictly coincide with class, as different social classes may share aspects of the same culture. Nevertheless, the tensions and conflicts that arise within a societal field of force[6] separate,

rearrange, and transform the domain of cultural practices and beliefs into what constitute, at any particular time, dominant and subordinate forms (Hall 1980; Lagos 1993; Gould 1990).

Young migrants abandon their country clothing and don fancy new garb as soon as they save enough money. The new clothing is the visual symbol of their wages freed from the control of family members, and the bright colors and distinctive forms implicitly challenge the señoras' view of themselves as the ultimate authorities on feminine self-realization. Yet at the same time, their choice of styles expresses the ambivalent feelings that these women harbor about themselves and their relationships to others in the city and demonstrate how the imitation, imposition, and appropriation of styles expresses emerging class conflicts and shape new social and cultural forms.

The latest Aymara fashions are the contemporary manifestation of an ongoing historical process in which contending groups not only create new cultural forms, but also detach older styles from their original context, transplant them to new settings, and give them new or slightly different meanings. Many of the elements of a contemporary urban Aymara woman's wardrobe—a gathered skirt (*pollera*), shawl, derby hat, embroidered blouse, special jewelry, and shoes—are viewed by paceños of all social classes as being uniquely Aymara. Yet sixteenth-century provincial Spanish women were the first to wear the forerunners of these styles in the Americas.

By the late eighteenth century, urban Aymara women, who had become involved with commerce, began to adopt these styles to distinguish themselves from their rural counterparts. Indeed, Indian women and men had been manipulating clothing styles since the conquest to both cultivate status and avoid the payment of tribute (Barragán 1991). Sometimes, however, they did not have a choice. In the aftermath of a 1781 pan-Andean rebellion against Spanish rule, colonial officials forbade the use of indigenous dress in order to suppress any identification with an autonomous Indian culture. The Indians, according to the *visitador* José Arreche, started to dress in these clothes with "manifest disgust and repugnance" (Paredes Candia 1982).

Although historical information on subsequent changes and modifications in dress throughout the eighteenth and nineteenth centuries is not available, we do know that by the early twentieth century urban Aymara women wore the so-called Panama hats, which were actually produced in Ecuador. These hats were subsequently replaced in La Paz by

the contemporary derbies sometime after World War II. The most fashionable brand—Borsalino—was produced in Italy, and even after the firm closed its Italian factory, it opened another one in La Paz exclusively for the Bolivian market (Canavesi de Sahonero 1987).

Nowadays, the derbies and the polleras are proudly worn by many Aymara women as symbols of ethnic and gender pride, but we can nevertheless appreciate that the notion of a traditional Aymara pattern of dress is a retrospective invention (see Hobsbawn 1983 and Trevor-Roper 1983). Young domestic workers, who make fifty to seventy dollars a month, save their salaries and even go into debt to buy or rent elegant shawls, hats, and polleras for Sunday outings, fiestas, and visits to their home communities. In this way, they hope to appeal to young men and distinguish themselves from their country relatives.[7]

Alicia Huanca is a case in point. In 1987 Alicia purchased a beautiful pollera on credit that was similar to the most stylish skirts being worn by other young Aymara women like her. The pollera cost seventy dollars, but Alicia purchased the skirt on credit with a forty-five-dollar deposit, promising the vendor that she would provide the balance in a couple of weeks. In the meantime, she switched jobs, and her new employer agreed to pay her only after a one-month probation period. But the employer would not specify a wage, insisting that she would discuss pay only after evaluating the quality of Huanca's work. Consequently, Alicia could not pay the debt on time. Her creditor constantly showed up to ask for the money, irritating Alicia's employer. Although Alicia repeatedly promised to repay the loan, she worried that she would not have enough money at the end of the month to send home to her mother. The mother was a widow, who lived with a young son, and she depended upon the remittances that Alicia sent from the city.

Alicia and other women like her purchase clothing in the commercial neighborhoods of Ch'jini and Gran Poder, where cholo entrepreneurs cater to the tastes of an Aymara clientele, and the clothing is more expensive than the imported, Western-style fashions commonly sold in street markets. For example, polleras range from $80 to $100; shawls vary between $50 and $80; shoes sell for $9 to $13; and a regular bowler hat goes for $18, although the most elegant Italian-style Borsalinos are more expensive. As a result, a well-dressed Aymara woman can easily spend $160–$220 on a single outfit and, to make matters worse, styles constantly change.[8] In the early 1980s, for example, young women wore velveteen polleras, but the most stylish polleras are currently made out of

brightly colored, brocaded synthetic silk cloth—preferably light pink, blue, or green—which is manufactured in South Korea and stands out in stark contrast to the browns, grays, and muted colors chosen by the white middling and upper-class women.

As they cultivate cosmopolitan, urban personae, young immigrant women confront the older, more prosperous migrants and the *cholas paceñas*. These relatively better-off women may not be entirely comfortable with their class identity (see Seligman 1989) and often resent the influx of impoverished rural women, who undermine their commercial ventures by selling on the street and pose a threat to their social position vis-à-vis the dominant white groups. Yet because they cannot enter the exclusive circles of the white ladies, better-off Aymaras strive to cultivate a superior class position by elaborating new variations on a basically similar style of dress, in order to distance themselves from the poor masses with whom they share a common cultural background, ties of kinship, and commercial relationships. The result is a more exaggerated, expensive, and ostentatious version of urban Aymara femininity.

The *cholas paceñas* use higher-quality cloth in their polleras and can afford more costly vicuña shawls and the Borsalino derbies of which they maintain a collection in various colors. They also wear nylon stockings with back seams and keep money in bulging purses around the waist, which imply both prosperity and a certain degree of economic independence. Perhaps more than anything else, however, they announce their wealth and urban refinement through the ostentatious display of expensive jewelry. Large, dangling earrings made with pearls and rubies differentiate the well-to-do Aymara women from immigrants and members of the lower class, and the women are astute judges of quality, quickly distinguishing cheap imitations from the real thing.

Yet even as Aymara women contend with each other and constantly modify the elements of an alternative feminine fashion, many choose to forsake this clothing, cut their characteristic long braids and adopt skirts, blouses, and ready-made Western clothing. Indeed, a single woman may alternate between these two modes of sartorial expression over the course of her lifetime, and women in the same family may adopt different forms at the same time. Those women who abandon the pollera for a dress, skirt, etc. are referred to as "*de vestido*," and there are two important reasons why they opt for this path. The first is economic. The dresses, skirts, and blouses that are sold in a variety of popular street markets scattered throughout the immigrant neighborhoods of the city are considera-

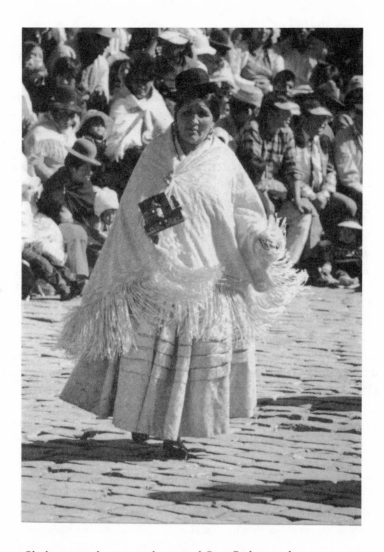

Chola paceña dancing in the annual Gran Poder parade.

bly cheaper than the attire of an Aymara woman. Given the severity of the economic crisis, many women simply cannot afford to indulge themselves with expensive clothing.

Second, many seek to avoid the stigma attached to being Aymara, which is strongly felt in all public places and grows more intense as Aymara women develop new relationships with whites and mestizos through work, the schools, and so forth. On city buses, women who wear

the pollera are insulted and in offices they are not attended or forced to wait and generally treated as second-class citizens. Even some of the *cholas paceñas*, who are recognized by all sectors of society as having achieved a social and economic position superior to many women "de vestido," feel that the whites no longer appreciate the differences between a peasant woman, a former peasant who lives in the city, and themselves. They complain that they are "treated like Indians," and consequently becoming "de vestido" is a strategy that some adopt to avoid the confusion (see Albó, Greaves, and Sandoval 1983:29).

The ambiguities of feminine fashion and the social tensions that give rise to them are evident in the personal experiences of Hilaria Calderón, the daughter of a prosperous La Paz meat seller who left home to work as a maid so that she could buy clothing and escape the domestic violence that plagued her household. When her father discovered where she was working, he came to beg her to return home. As Calderón explained, "My father didn't want any of the neighbors to know that his daughter— the daughter of a meat seller—was working as a maid. So he convinced me to go home." But she eventually persuaded her parents to let her work and took a position as a live-in servant for five months. At the end of this period, she could not stand the routine any longer and returned to her family's home in La Paz. She then used her earnings to buy skirts and tight sweaters, which shocked her parents and her friends. Calderón described their reactions:

> [After I quit work], I went directly to buy clothes. I bought a couple of skirts and sweaters, things like that. When my father saw me with these clothes on he immediately told me to change, and when my friends saw me walking around the neighborhood in these clothes and with one pony tail, they wouldn't even look at me. "Ah, Hilaria is *de vestido*," they said. "She thinks that she is better than we are." They told me that I looked like a white person. My face had turned white on the job, too, and after they criticized me, I had to rub dirt on my face so that I would become browner again.

The peer pressure eventually became too great for Calderón to bear and she switched back to polleras. Then when she met her future husband and made plans to marry, her father ordered her to sell the skirts once and for all.

As Aymara women seek to distinguish themselves in the realm of con-

sumption, they alternately ally and distance themselves from each other and the whites through their "fashion statements." At the same time, their relationships with men further sets them apart from white women, as well as older Aymara mothers and the young women in their home communities. Young immigrant women who are single and childless can meet and interact with men in a much less restricted manner. The men that they court are usually immigrants like themselves, who work as bricklayers, cargo carriers, or soldiers completing an obligatory year of military service in the capital. The couples arrange trysts in the city parks, plazas, and working-class movie houses. In these places the women are able to seduce, and be seduced, beyond the scrutiny and control of prying employers and family members.

Despite the new freedoms enjoyed by immigrant women, the *absence* of parental control and authority creates new problems for them because the same freedom that allows women more latitude in their interactions with men also renders them vulnerable to male entrapment and abandonment. Courting may be a time of romantic strolls and seductions, but it is also part of a practical bargain between the sexes in which women trade sexual favors for men's promises to settle down with them and provide wages to the domestic unit. Torribia Mendoza, for example, met her companion at an uncle's *presterio*[9] and was "married" by the end of the evening. "I married my husband without knowing him," she explains. "My uncle had a presterio, and I went to drink with everyone else. My husband was drinking and stole me [my virtue] there. Now I have four children."

Premarital intercourse frequently becomes a token of betrothal, but this exchange is problematic for women, who risk pregnancy by carrying through on their half of the bargain before men complete their obligations.[10] The young men, like themselves, are also freer from familial pressures and constraints than those in rural communities, and it is therefore relatively easy for them to disappear and leave the women stranded. Those women who become pregnant and bear children are no longer eligible for most live-in positions as domestic servants, and without the economic support of men it is impossible for these mothers to earn a wage that is sufficient to completely support themselves and their children.

Yet even when men fulfill their responsibilities to women and children, the economic crisis has undermined their role as family providers and eroded their control over women and children. As they are either

laid off from or unable to acquire relatively well-paid jobs in mining, con-
struction, or commerce, women can still find work, however miserable,
as part-time, live-out servants and street vendors, which provides them
with some means of support apart form men. The comments of one live-
out domestic worker express the feelings of many other immigrant wom-
en I interviewed and illustrate once again the relationship between style
and identity. She stated: "It's not worth having a husband anymore be-
cause their earnings are not enough. At times they don't even work. We,
the polleras, have to sacrifice ourselves a lot. We leave home to work and
we even work like maids in our own homes."

Since women continue to do housework even when they are the main
supporters of the family, it is no surprise that they question the reason for
remaining married. The case of Juan Delgado and his family demon-
strates how men experience this transition. After working for thirteen
years as a tin miner, Delgado was fired in the mid-1980s, following the
world tin market crash and the forced closing of the mines. His salary had
ranged between $300 and $400 a month, which made him the principal
wage earner for a family of eight, but after the paychecks ceased and the
severance pay ran out, he moved his family into a sprawling squatter
community in the Alto of La Paz. A year later he still had not found
permanent employment. Delgado earned a sporadic income making ado-
be bricks but this was not enough to support an entire family. His wife
and one daughter took up street vending while another daughter worked
as a domestic servant. Juan's position and prestige as primary wage earner
had been eroded.

> The reason that my daughter works as a domestic servant is the following:
> I used to work in the Milluni tin mine. I wanted to keep working. I wasn't
> lazy, but they decided to close the mine and now we are suffering the con-
> sequences. Since we came down from the mine, my family has not eaten
> meat. I continue unemployed. My wife goes out to sell *fresco* on the street.
> She is able to bring some food home, but we have no money for clothing or
> anything else.
>
> That's why my daughter has to work as a maid. If I worked, she
> wouldn't have to got out and do these things. I never thought that I would
> find myself in this situation, and I'm very upset about it.

June Nash[11] found several cases of miners' wives going to the city to work
as maids, which was unheard of prior to the closing of the mines.

As the earnings of women and children play a more important role in family maintenance, the construction of gender becomes more controversial for men. The erosion of men's positions as primary bread winners leads to self-doubt and opens them up to accusations of laziness. Exercising greater control over women is one way that some men struggle to recapture and enforce masculine authority. Husbands, lovers, and fathers frequently attempt to dictate to young women what they can and cannot wear, as in the case of Hilaria Calderón. Many insist that women use the pollera, because they believe that women in polleras are more humble and less available sexually to other men.[12]

For example, Justina Colque's former employer had urged her to dress in skirts and blouses because, she argued, polleras were "too bulky" and cumbersome to do domestic work. Colque herself grew to prefer Western-style dress, but when she left domestic service after nearly fifteen years Colque discovered that her new husband held a different opinion. He found the skirts totally unbecoming and told her to switch back to polleras. Colque explained that "my husband said that skirts don't suit me. He said that he loved me, but he didn't want me to be de vestido, because skirts are ugly. Even though I prefer to be de vestido, I decided to do what he wanted, because I still had polleras."

What it means to be a woman in La Paz, then, is constantly contested, as dominant notions of the ideal woman are not inclusive of everyone. The differential incorporation of immigrant and urban-born Aymara women into a highly commercialized, consumer-oriented urban economy, and their simultaneous exclusion from full participation in it, generates new challenges to dominant beliefs about feminine propriety. The oppositional and continually renewed forms of feminine self-realization elaborated by Aymara women have the potential to subvert the efforts of white women to act as the ultimate judges of womanly gratification and social morality. Consequently, dominant groups must constantly seek new ways to control the social practices and cultural forms of Aymara women in order to maintain the symbols of their privileged position in society. How they attempt to do so is explored in chapter 6.

BEYOND THE SERVANT PROBLEM: EMPLOYERS AND THE CREATION OF PLEBEIAN WOMANHOOD

You have to understand . . . that there are many things that my
maid doesn't know. She's never eaten cake or ice cream. It's really
strange.

—Employer, La Paz, Bolivia

As they contemplate the perceived immorality and chaos of
the lower orders, white people feel profoundly disturbed. They
see the denigration of "true" womanhood in the fancy dress and promis-
cuously sociable lives of young Aymaras, and beyond that the threat of
gradual social decline as more immigrants crowd onto the hillsides above
them. Beleaguered by financial worries and uneasy about changing gen-
der relations in their own households, whites believe that they have a
stake in maintaining the inequalities of the status quo, and they wage a
battle against anarchy and immorality on several fronts. They have sup-
ported right-wing political parties and even military intervention when
social "order" appeared threatened by strikes, demonstrations, and pro-
test marches. And, as we have seen, they shield themselves from the an-
ger of the masses by creating exclusive suburban enclaves and erecting
high walls studded with jagged glass around their homes.

In the prosaic struggles of daily life, white women play a crucial part in
preserving the character of elite privilege. They target Aymara servants

for reform with a zeal that at times resembles the militant fervor usually associated with the activities of Protestant fundamentalists in La Paz. White employers strive to improve Aymaras as servants *and* remake them as women. They may impose notions of plebeian femininity on those immigrants deemed most worthy of white patronage and thus temporarily create assimilated, hard-working servants who are acceptable to genteel society. Yet the simple imposition of dominant social and cultural forms does not always work. Dominant groups can often more effectively weaken challenges to the symbols of their privilege by redefining the meanings of social relationships and cultural images. This involves the selective reworking of "tradition," manipulating cultural beliefs, and selectively encouraging certain kinds of behavior, all of which are an important part of the construction of a hegemonic cultural order.

IMMIGRANT IMAGES AND THE CREATION OF PLEBEIAN WOMANHOOD

The very existence of female servants working away from the patriarchal control of their families violates white precepts of a young woman's proper place, and the dress and behavior of these women send shock waves through the genteel circles of La Paz society. Large numbers of poor, seemingly rootless women who move in and out of domestic service and street vending, become pregnant out of wedlock, and support the men with whom they establish consensual unions, are profoundly unsettling to middling and upper-class whites. Employers view such women as loud, abrasive, and untrustworthy, and dismiss their boyfriends, lovers, and husbands as lazy and parasitic.

Indeed, single mothers symbolize everything that is wrong with the masses of poor immigrants who have flooded into the city. The most visible cases are peasant women from the drought-stricken region of northern Potosí department. Clad in distinctly indigenous dress and tiretread sandals, these women and their small children panhandle during the day along the major streets of the central business district and huddle together at night in doorways and alleys, where they fall easy prey to thieves. Although virtually unknown a decade ago, these indigent women have become one of the most glaring reminders for affluent city dwellers of the contemporary crisis in La Paz.

Fearful whites, who anxiously perceive the signs of social decay all 113

around them, counterpose their perceptions of debased immigrant women to more soothing visions of humble, innocent Indian girls, living in closely knit rural communities and tending herds of llamas on the barren, wind-swept expanses of the altiplano. Such images of rural women and the Bolivian countryside have, of course, very little to do with reality or actual experiences in the countryside. They emerge from the whites' experiences in the city with immigrants and members of the lower class. The representations act as powerful countersymbols to the social disorganization of La Paz by depicting the countryside as timeless and serene. They are the contemporary creation of a particular notion of "tradition," one that portrays peasant women as passive and isolated in an unchanging present. Country women are then seen as purer than their urban counterparts because they know their place in the social order and have no interest in participating in the affairs of the "modern" world (Roseberry 1989b and Williams 1973a).

Yet these idealized notions of Indian girls in a pastoral countryside are contradicted by actual experiences in rural areas, particularly those of the old white oligarchy. Many of these individuals witnessed at firsthand the invasion of their haciendas by land-hungry peasants prior to the 1953 agrarian reform, and all Bolivians are aware of the turbulence that has characterized the country's more recent agrarian history. The 1979 and 1983 peasant blockades of La Paz, the 1984 murder of a white estate owner—the scion of a wealthy bourgeois family—by one of his peasant workers, and the 1986 "March for Life," in which thousands of miners, peasants, and students protested government austerity measures, are only the most prominent examples of this continuous strife.[1] Consequently, romantic images of country folk coexist in an uneasy tension with representations that portray rural people as savage, degraded barbarians. These negative conceptualizations heighten anxieties about the presence of rural Aymaras in the city and in white homes, and to neutralize a variety of challenges to the symbols of their power, dominant groups invoke both positive and negative images at different times.

The images are disseminated in a variety of ways that include television, newspapers, popular music, and "folkloric" events. Sometimes, too, they become transformed in novel ways, such as tourist posters that depict "Aymara" women as white women in "traditional" Aymara clothing who are usually performing a folk dance, holding flowers, or simply smiling demurely. The posters are used by tourist agencies and hotels, which may receive state subsidies, to attract the business of foreigners and other

non-Indians. They present a white version of the "typical Bolivian woman," one that has no basis in the lived experiences of actual women.[2]

Alternately, popular television and radio soap operas present "success" stories of lower-class women who manage to leave their impoverished, rural origins behind. In these stories, young women, who are often servants, suffer incredible hardships, including unwanted pregnancies, unemployment, and physical abuse, but ultimately find happiness and meaning in their lives when a handsome, honest, and hard-working man, who comes from a superior social class, asks them to marry. The message, of course, is that young women can overcome their humble Indian pasts and participate in a consumer society by working hard and waiting for the right man.[3] Not surprisingly, watching the evening soap opera is one of the few activities that female domestic servants and their employers do together.

Even as images of Aymara and lower-class women are manipulated in a number of ways, employers adopt tactics in their dealings with immigrant women to maintain the inequality so characteristic of their relationship to women in their domestic service. We have seen how matrons dominate servants by integrating them into their homes as "adopted daughters." They also control telephone conversations, decide who can visit the home, and dictate when a servant may or may not leave. This, of course, is a form of labor control, but employers are doing more than just inculcating strict labor discipline. They are also upholding a particular notion of feminine propriety and asserting their perceived right to define and impose standards of social morality.

Similarly, employers believe that only constant vigilance will contain the health threat posed by servants who must enter what they consider to be the aseptic confines of their homes. They lecture young Aymara women about personal hygiene and require household workers to shower on a regular basis. One matron explains, "Personal hygiene is part of the education that one gives to a maid. You always have to teach them how to use the shower because these people don't have running water in the countryside, and they are not accustomed to bathing."

Identifying Aymaras with unhygienic behavior and blaming them for the proliferation of disease is one strategy of social control during an unsettled period in which the access to Western medical practices may be limited. Placing blame delineates the limits of healthy behavior, reinforces personal and social boundaries seemingly threatened by the immigrant masses, and distinguishes whites from the cause of their fear.[4] 115

Miriam Leal, who prides herself for a nearly canine sense of smell, exemplifies these tendencies in her description of an experience with a new servant:

> I have an extremely well-developed sense of smell and was absolutely disgusted by the mortal odor of this maid. I made her take a shower immediately, and then the next day I took her for a medical examination. I always take new servants for a check-up. Well, it turned out that she had venereal disease.
>
> I came home, disinfected everything, and threw out a lot of things that she had touched. Unfortunately, a high percentage of this kind of people have venereal diseases. They are ignorant and don't take care of themselves, and that's why they spread diseases.

Leal's account is significant because it so clearly illustrates the ideology of "right living" that comes packaged with employers' fear of contagion. Unwittingly articulating the ignorance that she attributes to her servant, Leal is clearly uninformed about the manifestations and transmission of venereal disease. None of the various forms of the illness is associated with strong body odors. Furthermore, the disease can only be transmitted through sexual contact and cannot be contracted from contaminated surfaces or clothing.

Leal's reactions demonstrate that white notions of cleanliness encompass much more than basic concepts of health and sanitation. They are related to questions of lifestyle and morality. Cleanliness means not being poor. It entails living in a home separated from productive labor and equipped with indoor plumbing. It also requires sexual restraint and morally upright behavior, which are qualities that, according to whites, the poor, by definition, do not possess.

Assigning blame to poor Aymaras for the spread of venereal diseases limits the responsibility of the larger society and places the onus of culpability on the victims. Employers may then adopt a superior attitude as they "educate" servants about proper personal hygiene and impart key aspects of a "civilized" lifestyle to them. By so doing, they also allay personal fears about the presence of dangerous strangers in their homes.

Along with efforts to control the personal hygiene of servants and educate young women in particular ways, employers manipulate the distinctive dress of urban Aymara women to dilute its significance as an al-

ternative symbol of womanly gratification and to suit their own needs. For example, some white women who employ Aymaras as domestic servants may look favorably upon those women who use the pollera and related accessories because this clothing clearly differentiates the servants from those they serve. This differentiation is especially pronounced in the exclusive neighborhoods of the upper class, where immigrant women are cut off from the social ties that sustain them in the Aymara neighborhoods of the city and their home communities. The pollera, which in other contexts symbolizes ethnic pride, takes on a new meaning. It denotes servitude and "otherness"—a different lifestyle, a distinctive set of values—all of which make it easier for employers to differentiate themselves from servants and reaffirm their own class and ethnic superiority.

Alternately, affluent white employers may encourage household workers to wear uniforms. Such uniforms are locally manufactured from cheap cotton cloth with a standardized checkered design. They are modeled after the pollera with large gathers around the waist but embody none of the finery and elegance that Aymara women display in their dress. Employers, however, often oblige servants to use uniforms because, they argue, polleras are too cumbersome and unhygienic for domestic work.

At times, however, white mistresses' contempt for Aymara dress appears ironic. Many affluent women have a sincere appreciation of "folk customs" from other countries, especially Europe, but patterns of dress that comprise these traditions are often strikingly similar to those found among the Aymara of La Paz. During one week in June 1987, for example, a Polish ballet troupe performed a variety of peasant folk dances in La Paz's main theater. The female dancers wore full, brightly colored skirts that closely resembled Aymara polleras and combed their hair into two long braids.

The week-long presentations were sold out on several occasions, and the audiences were uniformly comprised of affluent, white paceños, who claim the theater for themselves. The intensive socializing before the performance and during intermission suggested a high level of familiarity among them. After one evening show, selected patrons attended a reception for the performers, and many repeatedly commented on the beauty of the costumes. Yet the similarities between the Polish peasant outfits and the dress of urban Aymara women seemed to escape everyone. In-

deed, the performance removed the costumes from a rural, peasant context and placed them within the exclusive confines of the La Paz theater, where they could be understood and appreciated by paceño theater patrons as a manifestation of European cultural heritage.

Well-heeled employers are not the only women to express hostile or ambivalent attitudes toward Aymara dress. Less affluent employers, who themselves often come from rural origins, may also emphasize Western-style clothing for their servants as a way to display greater "modernity" in the home and distance themselves from their rural and/or Aymara backgrounds.

Nora Vasquez is a case in point. Vasquez is a forty-two-year-old *chola paceña* who is one of six children born to her parents in La Paz. Her father was a laborer and her mother, who used polleras, sold vegetables in the Mercado Camacho but died when Vasquez was only five years of age. Vasquez and her four sisters were all raised "de vestido," because, according to Nora, schools did not permit them to wear polleras and her parents found skirts and blouses to be a more economical way of clothing them.

Vasquez did not attend high school and married at age seventeen. Because she lacked the education and social connections necessary to land a more prestigious secretarial position, Vasquez followed the path of other urban Aymara women into a career as a market woman. At the same time, she started to wear her late mother's polleras, which the family still possessed, even though her older and better-educated sister, who worked in a record store, remained "de vestido."

Today Nora is a prosperous merchant and the only female member of her family to be "de pollera." She sells electronic goods to the public from a stall in the Huyustus market and also prepares a number of dishes in the Mercado Popular for a busy lunchtime clientele of office workers and public officials. In order to purchase, prepare, and sell the food, Nora relies on the assistance of a thirteen-year-old servant named Manuela, who recently migrated to the city.

In lieu of a salary, Vasquez buys Manuela clothing, but she purchases skirts and blouses rather than polleras for the young woman. Nora explains her choice:

> Of course I like the pollera, but it is more expensive because you also need a shawl, a hat, shoes, everything. To be "de vestido" you just combine a blouse and a skirt and it costs less. I also want Manuela to speak Spanish well and not be so Aymara and that is why I send her to night school.

Vasquez, however, feels no qualms about displaying her particular version of Aymara ethnic identity, and she would also feel diminished if her servant equaled the elegance and sophistication that she strives to radiate in her dress. These sentiments come out when Vasquez talks about women "de vestido".

> We [cholas paceñas] make fun of them. We say, what is a dress? A dress is nothing more than a skirt and a blouse. But when we get dressed up, it's a question of a lot of money. We're not just anyone. I cook for all of La Paz society.

Vasquez's seemingly contradictory statements are, in fact, understandable given her ambiguous position in La Paz. Because of the limits that class and gender barriers placed on her upward mobility, she was forced to seek a livelihood in commerce, which was, and is, one of the only avenues open to Aymara women in the city, and through her dress and social relationships, she developed the cultural practices and social ties that increasingly set market women apart from the dominant White society. She then sought to defend her limited prosperity and social status against immigrant challenges from below, and save money as well, by dressing her servant in cheap skirts and blouses, while at the same time providing the young woman with certain tools, i.e., education, to advance both socially and economically. Clearly, the ways in which employers seek to define and manipulate the symbols of femininity vary in accordance with evolving patterns of class and ethnicity.

As employers selectively manipulate the dress of young servant women and mold servants to fit a plebeian image of bourgeois womanhood, prosperous white women also distinguish between the worthy and the unworthy poor in the city. The worthy poor woman eschews relationships with shiftless, unreliable men; attends to her personal hygiene; sacrifices everything for her children; and manages to keep her spirits up in spite of overwhelming hardships. Her perceived isolation from the social milieu of the poor, and especially her devotion to children, makes the poor woman eligible for white charity, provided, of course, that she demonstrates the proper deference.[5] Indeed, long-term servants who remain in white households are usually women who have no affective ties with kinfolk, because of the early deaths of parents, spousal abandonment, and so forth.

White women are willing to extend junior memberships in the cult of

119

the "perfect" woman to some poor women whom they encounter in their homes as domestic servants and through volunteer work with a variety of beneficent organizations. Yet because of the very nonisolated nature of most immigrant women's lives, their participation in such an exclusive group is usually only temporary. To constrain the gregarious lifestyles of domestic workers, some white women have turned to an old ally—the Catholic Church—for assistance, and they have found support from Opus Dei, a right-wing movement within the Church. Opus Dei operates a training program for household workers in which religious militants teach the domestic arts of cooking, sewing, hygiene, and embroidery. Thus equipped with the proper skills, immigrant women, it is believed, will not regress into a wretched degeneracy, but will themselves be able to transcend their class milieu.

"The Work," as Opus Dei is popularly known, gained ascendancy in Franco's Spain and was elevated to a worldwide prelature in the late 1970s, following the accession of Pope John Paul II. By promoting the Vatican's conservative political agenda, it has since grown to include over 60,000 members in eighty countries. The order responds to the pope's ambition to dismantle liberation theology. Through the creation of legions of activist lay people who are influential at the grass-roots level, the movement seeks to counter progressive movements that challenge the status quo. Asceticism, rigid hierarchicalism, and religious militancy are its hallmarks, and Opus espouses a concern for justice, service, and self-sacrifice, which it promotes through a variety of educational institutions (Lernoux 1989).

In La Paz, "The Work" has operated a school since 1979 for the training and education of domestic workers.[6] The school emphasizes the importance of work and professionalism as a means of sanctification. According to Opus activists, housework, if conducted in a self-sacrificing manner by qualified professionals, is an ideal means for women to serve God, the community, and their families. Although instructors do not view the students as intellectually gifted, they believe that young women can develop manual skills. As one administrator pointed out, they "have not developed their intellectual capacities, [but] we help them develop manual skills so that they can earn a living."

This requires proper training and spiritual guidance. Every Thursday afternoon between ten and fifteen young immigrant women meet in the Opus offices with a volunteer teacher for training in the domestic arts. None of the household workers wear polleras to the classes. They dress in

typical servant uniforms, and many have also cut their hair or wear it unbraided in a ponytail. The classes are followed by twenty minutes of religious instruction with a priest, who emphasizes the sublime aspects of work and service. "We help them to improve through work," a priest told me, "because work is a means of sanctification. They try to be better in their work and closer to God by practicing the Catholic religion and taking the sacraments. We also encourage them to be loyal and responsible to the people for whom they work."

Most of the young women are sent to Opus Dei by mistresses, but a few are also recruited by other household workers who participate in the program. All of the women, however, have received permission, if not direct encouragement, from their employers to attend. Without the consent of an employer, a servant could never leave work for two hours in the middle of the afternoon to attend classes. As an administrator assured me, "We don't promulgate class hatred, but rather just the opposite. We try to get [the employers] to help by giving a little charity and love. We've also seen how domestic workers and cholitas will respond to affection."

Yet what this woman understands as charity and love, we can appreciate as a specific form of class domination, and the "response" of domestic workers is really much more complex than what the Opus administrator implies. An uneasy tension permeates the interstices between the personal experiences of household workers and the manner in which Opus Dei interprets these experiences for them. Yet it is a tension that is rarely made explicit. This is due, in part, to the inchoate, embryonic nature of most servants' own emergent social consciousness, which combines a mixture of contradictory conceptions. It is also the result of the lack of an alternative explanation of servant-employer relations that "makes sense" to household workers, one which unifies the progressive features already contained within the commonsense understandings of these young women and reshapes them into a new conception of social life. The experiences of young Aymara women at Opus Dei thus remain "in solution," or what Williams (1977) has described as structures of feeling that are not yet precipitated into distinctive concepts or forms. They are not easily appreciated as social and are usually understood by servants as private or idiosyncratic, even though they may be shared by many other young women.[7]

For example, insofar as domestic workers feel treated "like another member of the family," they may not perceive the mistress-servant relation as particularly exploitative. As one Opus Dei participant remarked,

"If the señora is good, if she cares for me, and if she treats me well, I don't really care how much money I make. I feel good—like I'm in my own home." Yet after women leave domestic service, end the close personal contact with mistresses, and consolidate different social relationships, few express such charitable feelings. The former servants I interviewed tended to be much more critical of domestic service in general and mistresses in particular than current domestic workers.

For former household workers, domestic service is no longer a social experience that is still in process. Selective and imposed interpretations and lived experiences in the present become more recognizable when they are effectively in the past. By that time, the "structures of feeling" are more easily fixed into categories, explanations, and linguistic forms, where they become something altogether different from the practical consciousness of the true social present (see Williams 1977:132).

We can begin to appreciate the ambiguities and cross-cutting currents of this practical consciousness in the case of twenty-three-year-old Daría Alejo. Alejo has been a servant to the same family for ten years, but now says that she is tired and would like to quit. Alejo believes that she has worked hard over the last decade and that God appreciates her devotion to Him and the employer's family. "The work is really a lot," she says. "The señora has a big, two-story house and seven children. Cooking, cleaning, and making the beds for so many people is time-consuming and sometimes hard to do all by myself. But God knows what I am doing, and the señora likes me very much. She treats me like a daughter." Alejo dreams of becoming a pastry chef and is grateful to her employer for the opportunity to participate in the Opus Dei program.

Yet Alejo is also angry about the mistress's apparent refusal to offer any compensation beyond monthly wages for the ten years of consistent service that she has provided. "She is paying me very little," Alejo explains.

> One hundred twenty pesos buys very little with everything so expensive, but she has fincas in Copacabana that she could give me. She says that she must decide whether to give me money or land, but meanwhile she does absolutely nothing. I don't really think that the señora will ever give me anything, because she thinks that she taught me everything. She believes that I owe her and that's why she will never give me compensation. She has never liked me to look good or live my own life, either.

Alejo, however, refuses to pressure the employer, even though she believes that she has a right to some recompense for all the years of hard work. "I don't want to demand anything," she says, "because I don't like to make trouble. I prefer to simply leave and dedicate myself to something different."

Daría Alejo illustrates the contradictory amalgam of beliefs imbibed from Opus Dei, the employer, and her own experiences. Alejo's long-standing commitment to the mistress and her feelings of devotion come wrapped in resentment. The mistress's hesitancy to offer compensation is perceived by Alejo as selfishness, an egotistical refusal to acknowledge the self-sacrificing labor of a committed worker. Alejo experiences the servant-employer relationship as a peculiar mixture of identification with the precepts and practices advanced by Opus Dei and encouraged by her employer, while simultaneously taking offense at the indignities to which she is subjected. Although Alejo believes that her request for compensation is legitimate, she is unwilling to demand her rights, preferring instead to quietly withdraw and not disrupt the servant-employer "consensus" advanced by Opus Dei.

Daría Alejo and domestic workers like her are susceptible to the reformist efforts of Opus Dei and employers because they lack strong organizations that provide practical support and crystallize their feelings of indignation and resentment into a coherent explanation of servant-employer relations, one which challenges the received dogma and the status quo. The Bolivian labor movement and traditional political parties have ignored domestic workers, largely because the male leaders do not grasp the distinctions of class and gender. They perceive paid household labor to be "women's work" par excellence, and because it is conducted in the privacy of a home, domestic service remains excluded from the class struggle, which, by definition, is masculine.[8] It seems appropriate, then, to turn to a discussion of the relationship between household workers and broader movements for social change in Bolivia.

UNION MAIDS AND

PROTESTANT SISTERS:

WOMEN AND MOVEMENTS

FOR SOCIAL CHANGE

Women have been present in all the major political move-
ments that have affected social life in Bolivia. Although their
involvement has often been ad hoc and spontaneous, there are several
examples of the organized political struggle of Bolivian women (e.g.,
Nash 1975, 1992). Urban cholas of the MNR's Female Commands vied
with the oligarchy in the late 1940s and defended the gains of the revolu-
tion in the post-1952 period (Ardaya 1985). Beginning in the early
1960s, the Housewives Committee of Siglo XX sought to improve the
living conditions of tin miners and their families (Barrios de Chungara
1978), and the Bartolina Sisa Federation of Peasant Women emerged
from the Katarista movement in 1980 to provide a limited voice for
Aymara peasant women of the altiplano (León 1990).

In all of these cases, however, the party, the union, and the movement
did not address the specific demands of women as an exploited group.
They chose instead to subordinate the women's struggles to specific class
or party interests, even though the demands of the women tended to

complement the announced objectives of the various groups. Men, and even some women, considered any proposal that smacked of "feminism" to be divisive of the popular movement.[1] The women were further excluded from participating with men as equals in the decision-making process and did not control a commensurate share of political power (Ardaya 1985; León 1990). In the first half of the twentieth century, only the Sindicato de Culinarias (1935–1958) has addressed the distinctive concerns of women, focusing on the demands of female cooks who were a relatively privileged group among domestic workers (see chapter 1).

Because male leaders have a restricted understanding of women's work and its importance to society, they have weakened the ability of political parties and the labor movement to assist domestic workers and advance the cause of working people in general. Current global economic restructuring and its Bolivian variant—IMF-backed "structural adjustment"—have devastated mining communities, long the center of the most militant trade unions in South America. They have further accelerated rural-urban migration and generated a huge increase in the so-called informal sector of low-wage, insecure, and nonunion employment. Within this context of rising insecurity and social dislocation, women's work, as we have seen in previous chapters, becomes more important for the survival of households. Yet the labor movement, which is already on the defensive, is not generating a more pluralistic account of the Bolivian crisis that recognizes the gender and ethnic diversity of the working class. Many labor leaders even employ domestic servants in their households.[2]

Because of this situation, it is difficult for women workers, and especially domestic servants, to find their voice in the labor movement and the larger political arena. As they search for answers to their problems, many women turn to a growing number of fundamental Protestant sects that have inundated the city. These relatively new organizations try to capture the imagination of the poor and unemployed by orienting the terms of debate around personal, religious, and lifestyle concerns. In the process, the language of class and class struggle disappears. The principle of solidarity, which encourages people to organize against oppression, domination, and exploitation regardless of whom they affect, is replaced by a plethora of sects that seek to erect particular versions of religious "Truth" to the exclusion of all others.

In its many guises, Protestant fundamentalism offers a specific and easily understood program for people who increasingly confront the

world as individuals. It draws its strength from a claim to universal truth that is at least theoretically accessible to everyone and spreads among women and men who feel helpless because their lives have been disrupted by hyperinflation, unemployment, and tantalizing new symbols of consumption that remain completely out of reach. Familiar institutions —the family, political parties, unions, communities, and the state—are unable to overcome a pervasive sense of despair. The alternative to the present hostile and exploitative social order is not an immediate concern for committed believers. Hard work, self-denial, and family loyalty become the glue that holds society together and prepares individuals for Judgement Day, when they will ascend to heaven. The Bible, which represents the literal word of God, provides a practical guide for daily living and a moral handbook on all matters.

How, one might ask, are domestic workers and other poor immigrant women shaping, and being shaped by, the shifting economic, political, and religious alignments of contemporary La Paz? In order to answer this question, we will examine the efforts of household workers to create a union and the obstacles that have impeded this endeavor. We then focus on the more dramatic success of Pentecostalism in attracting immigrant women and their shifting, often ambiguous, relationship to it.

⬚ THE UNION OF HOUSEHOLD WORKERS AND PENTECOSTAL CULTOS

In 1984 a small group of La Paz domestic workers embarked upon a tentative experiment in social change: they decided to create a union. They did so amidst the growing fragmentation of the Bolivian labor movement and with the assistance of a few Catholic nuns, who were influenced by liberation theology and attuned to the changes in Catholicism set in motion by the Second Vatican Council (1968). Known as the Union of Household Workers (Sindicato de Trabajadoras del Hogar), the group originally consisted of a handful of domestic workers who met every week in the neighborhood of Sopocachi.

The union members were primarily young, live-in household workers who had emigrated from the countryside. By 1987 some one hundred women belonged to the organization, and by the end of the decade the union had spawned another group in the San Pedro neighborhood. The

stated purpose of the original union was to further the cause of household

workers by struggling for fair wages, an eight-hour workday, social securi-ty, health benefits, and access to education. The women also hoped to revalidate the dignity of domestic labor by insisting that they were household workers (*trabajadoras del hogar*), rather than servants or maids (*empleadas*).

The union's work has not been easy. The lack of support from orga-nized labor is aggravated by Bolivia's financial crisis. The Federated Union of Bolivian Mine Workers (FSTMB)—the most radical, aggres-sive, and influential organization within the Bolivian Workers' Central (COB)—is in disarray. Formerly the leaders of the continent's most combative labor movement, the FSTMB and the COB could forcefully challenge state power and mobilize Bolivians far from the mining com-munities. Their power is now waning in the wake of low international prices for tin, the closure of unproductive mines and the privatization of the mining industry, government hostility, and the rising importance of the illegal, albeit extremely lucrative, cocaine industry in the eastern lowlands. Without the support of organized labor, which has tradi-tionally ignored them, domestic workers find little compassion from em-ployers and a government committed to servicing the foreign debt and implementing IMF directives. Similarly, the household workers inspire no interest on the part of progressive political parties. Although union members have been inundated with offers from party representatives to provide "orientation" lectures, the parties deal with domestic workers in a purely opportunistic fashion, and the women complain that party mili-tants are only interested in them for partisan support at election time.

Despite these obstacles, the union has persisted, establishing ties to the labor movement and other domestic workers' unions. In 1985 it affil-iated with the Departmental Workers Central of La Paz (COD), which is a member of the COB, and for several years members have marched in the annual May Day labor parade. Two representatives also attended the first and second International Congress of Latin American and Caribbe-an Household Workers in 1988 and 1991. The congress was sponsored by the Confederation of Latin American and Caribbean Household Work-ers, a fledgling organization that is struggling to unite household workers' organizations from various countries with the financial support of North American and European nongovernmental organizations. Still very much in its infancy, however, the confederation has not yet been able to support the La Paz union.

The difficulties that beset the labor movement are not the only prob-

127

lems that impede the growth and consolidation of the household work-ers' union. As we have seen, domestic workers are separated from one another in the homes of employers, which inhibits communication among them. Union member Delfina Menéndez tries to overcome this situation by organizing volleyball games in a park where household workers congregate on Sunday afternoons. She also uses these occasions to discuss working conditions and raise the issue of unionization. The women are not always interested, however. Household workers do not view domestic service as a life-long occupation, and some may even lie about their employment to avoid the stigma associated with domestic service.

In La Paz, a small research group of five European and Latin American women collaborated with the union in the mid-1980s by teaching classes on the recent history of Bolivian domestic service. Yet most "feminist" organizations in the city have only begun to consider the plight of do-mestic workers. The women who direct these organizations are white, from middle- or upper-class backgrounds, and frequently educated in Eu-rope and the United States, where many first encountered the broad cur-rents of middle-class, Western feminism. They depend upon household workers for domestic services, as well as the freedom to pursue careers outside the home, and they are generally reticent about conceptualizing relations with their servants as problems. Moreover, foreign agencies that support La Paz-based feminist organizations are usually unwilling to fund projects directly related to labor issues.

Finally, as in all union struggles, the hostility of employers poses a ma-jor barrier to the growth and consolidation of the movement, and be-cause of the fear of employer reprisals, the union has led a semi-clandestine official existence. Members constantly worry about employ-ers discovering their union involvement and have thus been slow to make official denouncements of working conditions, particular employ-ers, and so forth. To protect members' privacy, the union holds meetings on Sunday afternoons, beginning at around 3 P.M., when most domestic workers are free and do not have to request permission from mistresses to leave. By so doing, it hopes to accommodate live-in servants, who are most closely controlled by employers. Nevertheless, safeguarding the pri-vacy of union members is not always possible.

Delfina Menéndez, a former union leader, worried for her physical safety after an employer, who was affiliated with the right-wing Acción

Democrática Nacional (ADN) party, saw her on television. Menéndez was one of two union delegates to attend a meeting of the COD, and as she was leaving, a television crew asked her about the household workers' union, which was virtually unknown to the public. Menéndez responded that the organization hoped to obtain social security benefits and better wages for its members. She also criticized the draconian, IMF-backed, economic measures that had recently been implemented by president Paz Estensorro.

When she returned to her employer's home, the mistress's son confronted Delfina about her televised statements and warned her against further involvement with a union. Over the next several days, he and other family members made threatening remarks about the subversive nature of unions and how activists often disappeared. "[When I heard these statements] my entire body began to tremble," Delfina said. "I thought that maybe they were thinking about making me disappear. Every night for a week I slept with the door to my room blocked with furniture so that nobody could enter while I was sleeping, and during the days, I gradually removed my belongings from the household. When everything was finally gone, I told the señora that I was going to my community for two days. I left and never returned."

Faced with employer resistance, a seriously weakened labor movement that has always subordinated the specific concerns of women workers, the isolation of domestic work, and the personal doubts of household workers themselves, it is easy to understand why efforts to unionize female domestic-service workers have met with only limited success, at least for the moment. Because of these difficulties and the desperate, frequently overwhelming situation confronted by young rural women who must forge new identities in the city and grapple with demeaning jobs, hundreds of domestic workers are experimenting with evangelical Protestantism. They hope to find comfort and the assistance of a new network of believers who can lend a sense of coherence to their lives and revalidate their personal experiences of reality. Helping them to deal with their feelings of insecurity and isolation are over one hundred and twenty-four religious groups who vie with one another and the Catholic Church for the souls of impoverished women and men.

Evangelical Protestants have been the most successful in recruiting converts,[3] even though compared to certain other Latin American countries, like Brazil and Guatemala, the impact of evangelical Protes-

tantism in Bolivia is less.[4] They claimed 244,000 converts, or 4 percent of a national population of six million in the early 1980s (Barrett 1982), but this figure is conservative and has grown in the last several years.[5]

Unlike the Mormons and Baha'is, who found most of their converts among the middle class, evangelicals enjoy the greatest success among peasants, lower-class urban dwellers, and rural migrants, and their growth curves began to swing upward in the 1960s. The Assemblies of God began a program of "total evangelization" in 1967 and a decade later boasted six hundred preaching centers with over twenty-seven thousand members. In 1965, five hundred local churches from thirty-six established denominations began an "Evangelism-in-Depth" crusade that ended with over nineteen thousand professed converts (Barrett 1982).

Under military rule from the mid-1960s to the early 1980s, the Bolivian state directly intervened in religious affairs. A series of pro-U.S. military regimes facilitated the entry of evangelical Christian organizations into Bolivian society in order to curb the influence of liberation theology, which the military labeled "communist" (Lernoux 1980). With the return of elected government in 1982, new regulations required religious groups to state their beliefs, have at least 1,500 members, and possess their own building in order to operate legally. But in practice, little changed; the rules were ignored and new groups simply affiliated temporarily with better-established ones.

The ecstatic forms of worship associated with Pentecostalism—the most popular variant of evangelical Protestantism—have taken hold in urban squatter settlements, where the presence of the Catholic Church is nominal at best and often completely absent. Catholic clergy find themselves poorly prepared to minister to impoverished urban dwellers for a number of reasons. Years of specialized religious training required for the priesthood, and a declining number of men interested in devoting their lives to the Catholic Church, have produced a chronic shortage of priests.[6] Whether priests are foreign-born or native Bolivian, they invariably come from a different social background than their parishioners and typically live in isolation from the latter's problems.

Pentecostals and other Protestant evangelicals rapidly fill that gap. They win more converts by expanding into neighborhoods where the institutional Catholic presence is weak than from wresting believers away from the Church in areas where it is dominant. Long periods of training are not necessary for aspiring leaders to propagate the evangelical message. Local men who receive "the calling" set up their own store-

front churches with the support of small groups of followers. Some of the most successful Pentecostal churches are established by local men who break away from missionary control. Such leaders develop their own particular interpretations of the scriptures and can conduct worship services in Aymara if they need to communicate with new migrants from the countryside. Splits and regroupings distinguish the spread of the new religious groups, a process often aggravated by divisions on the national and international scenes (Stoll 1990).

Immigrant Aymara women represent the majority of converts and affiliates to the new Protestant churches, although preachers are entirely male. The female churchgoers represent a more heterogeneous slice of La Paz's immigrant population than the members of the household workers' union. They include domestic workers, market women, and a few school teachers, as well as numerous widows, divorcees, and abandoned mothers of all ages (Gill 1990). What, we might ask, do these women find in evangelical Protestantism?

✳ Women and Pentecostalism

Organized religion represents perhaps the most common way that women in La Paz develop new relationships within socially prescribed boundaries. Among Pentecostals, the *culto*, or worship service, offers them an institutional base for developing important social relationships. It also provides the rituals to validate these emerging bonds, which help to create a shared sense of community. In one Pentecostal church that I regularly attended, the culto occurs five times a week and is an ongoing process of conversion whereby believers purge themselves of Satan's diabolical influence through collective song, prayer, and music.[7] The human body, according to Pentecostals, is occupied either by Satan or the Holy Spirit, and in order to evict Satan one must be cleansed of sin. This requires the observance of a number of puritanical practices, which include abstaining from alcohol, tobacco, sexual intercourse for non-reproductive purposes, dancing, and the cinema, and also entails attendance at as many cultos as possible.

Participation in the culto is crucial to an individual's salvation because the cleansing and healing powers of God can be mobilized most effectively by the active involvement of all believers. Indeed, attendance is so important that the pastor often asks church members to pray for

131

those who are absent. But more than simple attendance is required. Congregants must also take part in the singing, shouting, handclapping, praying, and testifying that characterize a typical culto.

A culto begins with praying and singing to the beat of musical instruments. The pastor, standing behind a pulpit with a lighted sign that reads "Jesus Heals and Saves," leads the congregation. Periodic shouts of "Hallelujah" and "Glory to God" punctuate the ceremony as congregants extend their hands toward heaven. The level of intensity gradually builds, culminating with the pastor's sermon, which, if successful, transforms the gathering. People start to writhe on the floor, speak in tongues, and even lose consciousness, all signs that the Holy Spirit is waging a successful battle against Satan for control of the individual. Individuals will then begin to testify about discovering God for the first time and the subsequent changes in their lives.

Women in this setting are not merely passive recipients of a religious message. They actively participate in the experience by singing and directing hymns, receiving the Holy Spirit, testifying, and even preaching on rare occasions. Such behavior contrasts with that characteristic of the traditional Catholic liturgy, which is much less participatory and in which the sermon may be given in a language that Aymara speakers do not fully understand. Women are also involved in an array of other church-related activities that include proselytizing on the streets, visiting needy church members in their homes, attending family services, and traveling to church meetings in other cities and foreign countries.

In the course of these activities, women meet other women like themselves with whom they share the intensity of the Pentecostal experience, and their dealings with men are governed by rigid puritanical rules that curtail abusive male behavior—such as drunkenness and the overt expression of sexuality—which is often tolerated in other contexts. This enables them to construct new social networks that are emotionally supportive and economically useful. These ties extend well beyond the church into the individuals' daily lives. Believers provide one another with information about living arrangements, jobs, medical assistance, and business opportunities in the city, and they are readily available for assistance and support in times of crisis. To varying degrees, these ties replace ties with kin left behind in the countryside, offset the rigid hierarchy that domestic servants encounter at work, and supplant social and marital relationships in the city that are no longer viable because of di-

vorce, abandonment, or the death of a spouse. They also enable women to develop greater self-confidence and personal integrity.

Forty-two-year-old Paulina Limachi, for example, is childless, unmarried, and speaks with a bad stutter, and she has periodically worked as a servant since the age of eight, when she was orphaned and placed in domestic service by a relative. Limachi became affiliated with a Pentecostal church because she felt isolated from her surviving relatives, who had little time for a barren woman without a husband. She found many friends in the church and was able to interact with them at every culto. Many eventually became "like a family." She also advised me—a then unmarried, childless, thirty-two-year-old woman—to marry an evangelical because, she explained, "they are the best kind of husbands. They don't get drunk and run around with other women like the Catholics."

The Pentecostal church, then, and particularly the collective setting of the culto, offers women the possibility of establishing new social relationships and reaffirming them on a regular basis. But the church also requires them to adopt a new set of beliefs about the world and their relation to it. These beliefs provide them with the means to validate their membership in a new community and to reinterpret past experiences in light of a changing social identity. This process begins in the culto, and it continues with individual possession by the Holy Spirit.

Although Pentecostal religious conversion demands continuous participation in the culto, it is also an individual experience that starts with the baptism of the Holy Spirit. This is an extremely emotional event in which a believer discovers "the Truth" and the road to eternal salvation by directly encountering the power of Christ and establishing a personal relationship with him. The experience infuses converts with a new and stronger sense of God, who, they believe, actually exists. If they submit to his will and acknowledge their sins, he will lift them up to heaven when he returns to earth on Judgment Day, and they will be saved.

Believers describe their conversion experiences in highly emotional accounts that sharply distinguish the pre- from the postconversion characteristics of the individual's life. They tell of the desperation and despair that once plagued their lives and the peace and happiness that they encountered after a surprise meeting with God changed them forever. These stories are based on actual experiences, but the meaning of the past is reinterpreted by individuals in light of the new ideology and their present social reality (Gill 1990).

Yet women must also simultaneously confront a religious ideology that upholds a belief in the natural inferiority of women and sanctions them for deviant behavior more harshly than men. Indeed, belief in the innate inferiority of women is so firmly entrenched in Pentecostal ideology that many believers view the subordination of women as part of the natural order. They feel that that subordination is sanctioned by God, as evidenced by the teachings of the Bible, and male pastors reiterate these beliefs in public sermons.

For these reasons, some women's acceptance of Pentecostal ideology appears paradoxical. Pentecostal doctrine, however, also dictates rigid behavioral norms for men, and this serves to reform male behavior in accordance with some of the needs and desires of women. Married women and their children, for example, benefit from an improvement in the material circumstances of their households because male resources previously spent on alcohol, cigarettes, gambling, and extramarital liaisons are directed back into the domestic unit.[8] Unmarried women who may receive financial support from male relatives—for instance, teenage girls from their fathers—can profit in a similar fashion. Domestic servants and other single women may also encounter more potentially "domesticated" mates among the male faithful than among the male population at large, and the restrictions on masculine behavior allow all women to interact with men in nonthreatening ways during the *cultos* and related church activities. Pentecostalism facilitates this interaction by stressing submissiveness and obedience, which are generally considered to be female characteristics, among both men and women because these qualities are essential to an enduring relationship with God (Brusco 1986). Men are thus forced to cultivate some traditionally "feminine" qualities.

As male sex-role behavior is modified, gender differences are also blurred by a sense of community instilled by the shared experience of the culto and nurtured by a particular kind of separatism characteristic of Bolivian Pentecostalism. Male and female believers perceive themselves as belonging to a new elite—the possessors of "the Truth"—as a result of the new understanding of themselves, the world, and life after death that they have obtained through the Pentecostal church. Catholics and other so-called idolaters do not have the same access, for they have chosen the wrong path to salvation. They have forsaken salvation by continuing to live in sin and worshiping meaningless idols. This understanding draws on a literal interpretation of the Bible, which, the Pentecostals believe, is the actual word of God. Such dogmatism heightens a sense of group

identity among Pentecostal converts by promising membership in a select group, one that will attain eternal salvation on Judgment Day when Christ returns to earth and lifts them up to heaven. It also facilitates the separation of Pentecostal believers from their preconversion lives and the contemporary lifestyles of nonbelievers.

Pentecostal women, then, link their hopes for a better life with the aspirations of men, and they do not directly challenge their subordination to men. In this way, Pentecostalism resembles the Housewives' Committee and the MNR Female Commands that subsumed unequal power relationships between men and women under the broader concerns of class-based or party organizations. Pentecostal women, however, benefit from the "new man"—who is less typically "male"—fostered by the Pentecostal movement.

✳ Pentecostalism and the Experience of Community

The emerging relationships between Pentecostal women and men and among women themselves unite members of the urban working class and help shape an experience of shared opposition to some of the prevailing norms of the dominant society. Through participation in the Pentecostal culto, and especially the moving experience of conversion, women are provided with what one convert described as "an island of peace" amidst the uncertainties of daily life. A sense of communal opposition to the dominant society unites culto participants in a number of ways. Even though Pentecostalism tends to attribute class, gender, and ethnic inequalities to the devil-inspired behavior of individuals, believers are aware of a clear-cut moral distinction between the rich and poor, as they try to lead model lives and pursue a straight and narrow path to salvation. They agree that sin and wealth are closely intertwined and associate the pursuit of wealth with worldly materialism and carnal desire, which preclude the possibility of salvation. Because the poor, who have very little, are less contaminated by the practices and possessions of the rich, they are the natural heirs to the kingdom of God. These beliefs have much in common with certain tendencies in the Catholic tradition (see Lancaster 1988:110–115). The comments of Zenobia Mendoza, a former domestic servant who works as a street vendor, about her ex-employer, who constantly complained of illness, reflect this understanding: "Why do you think these rich women are always getting sick? We women who sell

on the street with our barefoot children don't have the same problems as the rich with all their money and doctors. God probably makes them sick so that they have to spend their money."

Pentecostalism also challenges Catholicism because it represents a new form of religious worship and social organization that threatens the authority and control of Catholics. Conversion to Pentecostalism and other evangelical forms of Protestantism is not an issue in the middle- and upper-class neighborhoods of La Paz, where a conservative form of Catholicism is firmly entrenched. Residents of these neighborhoods, as well as the economically successful urban Aymara elite and Aymara intellectuals, view Pentecostalism as a pariah religion. Believers are ridiculed for their religious convictions, derided for not participating in the general revelry that characterizes so many festive occasions in La Paz, condemned for undermining indigenous practices and beliefs, and accused of being dupes of an imperialist plot designed to win the hearts and minds of Bolivians.

Pentecostals do indeed condemn aspects of indigenous Aymara culture, although they promote others. Certain practices and beliefs, such as chewing coca leaves and worshiping the Pachamama, or Earth Mother, are anathema to them. Yet the Aymara language is given new dignity in the culto because of the Pentecostals' emphasis on speaking in tongues. It is considered as valid as Spanish, or any other language, for communicating with the Lord. In addition, many Pentecostal pastors are native speakers of Aymara and give their sermons in this language when congregants are unable to understand Spanish.

Yet even as impoverished immigrant women flock to Pentecostal churches, their commitment is not always as great as their mentors desire. Religious identity must be thought of as a dynamic, continually evolving process that takes place over an individual's entire lifetime. Beliefs and practices are an inherently relational phenomenon. They not only form part of the way people conceptualize the supernatural and ensure a favorable association with it, but also express how men and women define themselves in relation to their experiences and to other people.

It is not surprising that there is considerable religious mobility in La Paz, whereby people shift loyalties over the course of their lifetimes.[9] An individual can be born and raised a Catholic, convert to evangelical Protestantism by joining the Assemblies of God, then move to the United Pentecostal Church, which offers a slightly different twist to the fundamentalist message, and finally revert to folk Catholicism. At any

point in the process, the person may also consult a *yatiri* (indigenous diviner and healer) about a variety of misfortunes.

Changing religious identities is an integral part of the tumultuous and contradictory process of social change in La Paz. It includes both conversion—a personal ideological transformation—and affiliation, which encompasses varying forms of membership or participation in a religious group (Green 1993). The outcome of this process of distancing and association is never determined once and for all. It is rather part of the ongoing encounters of daily life, where diverse individuals and contending groups confront the dislocations of social life in an impoverished city.

The emotional ecstasy of the conversion experience may not last forever, and affiliating with an organized religion is just one of a number of ways that people try to establish bonds in a crisis-ridden milieu. Many people even maintain more than one religious affiliation at the same time. Most have been baptized Catholics at birth, then converted to another religion, usually Pentecostalism, without completely forsaking their Catholic heritage.

Vacilia Choque is one such individual. She is a thirty-six-year-old Aymara market woman, who migrated to La Paz shortly after marrying at the age of seventeen. Choque's husband works as a part-time mason, while she sells clothing in the vast urban market known as Miamicito (Little Miami). Choque describes herself as a Catholic, having undergone a Catholic baptism in the rural community where she was born. Several years after settling in La Paz, she began to attend an evangelical Protestant church called Cristo es la Respuesta (Christ is the Answer). She was deeply moved by the message and attributes her recovery from a serious illness to the intervention of the Protestant God. According to Choque,

> I was in the hospital and cried and cried, pleading with the señor [God] to save me. Then one night—it must have been three o'clock in the morning—He called my name and said, "Don't cry. Your father is here. I am going to help you." And just like that, he cured me with his words. It was really tremendous.

Over ten years later, Choque still recalled the events of that night in vivid detail. She continued to attend the worship services at Cristo es la Respuesta, despite the opposition of her husband, who described the 137

church as "nonsense" and maintained that he would "go dancing to hell on Judgment Day [Cuando llegue Dios, yo voy a ser el que va al infierno, dice el. Yo quiero ir bailando, dice]." Yet Choque still defined herself as Catholic, even though she was uncertain where she stood and could not participate in folk Catholic fiestas because of the high cost of food, alcohol, and other ritual items that made reciprocity impossible for her. As she explained the apparent contradiction, "I am a Catholic because I have been baptized and everything, but I have not been receiving the [Catholic] message lately. Also, with everything so expensive I can't afford to go to fiestas and drink and dance. That's just how my life is."

In addition to people like Choque, who apparently hold contradictory beliefs at the same time, other people move between religious organizations over the course of their lives. Their participation reflects an ongoing process of association and distancing with their class peers, as they seek to address personal misfortunes, overcome the disintegrating effects of economic crisis on their lives, and, if possible, advance both socially and economically.

Margarita Ticona, for example, is a fifty-four-year-old widow who never converted to Protestantism but has had experience with three different religious organizations. She migrated to La Paz with her family in the early 1970s, after her late husband, a tin miner, became sick and could no longer work. The family could not survive on the husband's pension from the mining company, so Margarita began selling food on the street and working as a part-time laundress. Her husband died soon after the family resettled in La Paz, leaving Ticona with four children to raise.

Although Ticona had lived her entire life as a folk Catholic, now she began to listen more closely to the messages of the various religious practitioners who plied their trade on the streets of her neighborhood. One day a pastor from a Protestant church came to her home and offered a free meal to anyone who wished to attend worship services in his church. Ticona decided to send her fourteen-year-old daughter, who subsequently developed a regular association with the group. She was supportive of her daughter's involvement because she felt that the church exercised a strong moral influence over the young woman during a vulnerable time of life. Ticona herself decided to visit another evangelical congregation in the neighborhood after all the local mothers were invited to attend a Christmas meal in the church. She enjoyed the event and became a regular churchgoer for the next two years. "I went for the

fun of it," she explained, "but then I became more accustomed and got to know some of the other sisters. I also like to listen to the pastor, they played beautiful music, and the brothers don't drink. They also offered little lunches to people in this area."

Despite the manifest benefits, eventually Ticona grew disillusioned with the church and withdrew. Evangelicals were really hypocrites, she explained, citing a particular case to prove her point. "My landlady is a sister, for example, but she is really bad. She gets mad at everything and constantly complains that I don't pay the rent. But what does she want? Sometimes there is no money. They [the evangelicals] say that every brother [and sister] should help a poor person, but no, nothing. They just complain. This is why I no longer believe in them." Ticona currently describes herself as a Catholic but her understanding of God is not bound by Catholic dogma. "Everyone talks of God," she says, "but I don't give any of them much importance now. But in my imagination I believe in God. When people say that he is our father, I believe that it is true. I don't go to the churches, though. I just pray in my home."

Margarita Ticona's story illustrates how hard-pressed members of the lower class change their religious affiliations as a result of their struggles to survive. Her changing loyalties reflect her search for practical solutions to her problems. Yet in Ticona's case, she found neither solutions nor support, only a few free lunches and many hypocrites. Her experiment with evangelical Protestantism has ended in disillusionment, at least for now.

Contrary to conventional assumptions, then, tumultuous social changes have less prompted impoverished women and men to develop firm loyalties to new groups, than to embark on a series of religious experiments whose outcome remains unclear. As the ties that bind poor Bolivians to one another are fractured and established institutions fail to adequately address their suffering, people increasingly face the world alone and are forced to create personal solutions to their problems. The ideology of many new religious organizations, particularly the most successful Pentecostal ones, emphasize individualism and self-sacrifice as a means of personal improvement.

Yet while the Pentecostals and other religious fundamentalists are uniting with one another, they are not linking their organizations to the political and economic agendas of class-based organizations that seek to change state policy and the status quo. The concept of solidarity that has been so crucial to the labor movement, albeit in a masculine sense, is

absent among Christian fundamentalists. They tend to separate themselves from their class peers, whom they often view as morally inferior. This establishes the basis for new divisions between fundamentalists and nonfundamentalists and between men and women in urban barrios, even as the distinctions that separate rich and poor grow more pronounced.

Despite the inroads made by evangelical Protestantism, Bolivian peasants and the working class have long understood the necessity of challenging power, and they have done so very effectively on many occasions. Joining new religious groups has not provided Bolivians with lasting solutions to the current crisis of capitalism in their country. Although religious fundamentalism draws its strength from a claim to universal truth and provides individuals with a concrete program for change, its suitability for Bolivians is not so obvious to many disillusioned converts.

CONCLUSION

When market woman Claudia Morales took time out from her hectic schedule to reflect on a three-year stint as a domestic worker, she spoke passionately about a brief, but unforgettable, period in her life. "For me, the work was not good," she said, "because the señoras always exploit the polleras. They say, 'Ah, these indias with so many polleras, how ugly.' I suffered a lot with them." Morales' feelings of abuse might easily be echoed by women in New York, Johannesburg, San Francisco, or Guatemala City (see, for example, Colen 1989; Cock 1980; Glenn 1986; Menchú 1983), because the exploitation of domestic workers is not a characteristic that is specific to La Paz. Yet Morales' reference to herself and other women like her as "the polleras" reflects one particular way that class is culturally expressed by some poor women in La Paz.

Domestic service is rooted in inequality, and its most enduring feature is that servants are drawn from groups considered inferior by those in power. Indeed, various forms of oppression are combined in the occupation. It is considered women's work with few exceptions, and the women

who carry out paid household labor invariably represent a subordinate race, class, ethnic group, or nationality. These various forms of subordination, however, do not merely exist side by side. They are interlocking phenomena that are continually tested, challenged, and reformulated in the ongoing encounters of daily life, where they are mutually constituted and constitutive.

Beliefs about gender, class, and ethnicity crystallize into categories and acquire specific meanings as individuals contend with each other for access to resources. In this ongoing struggle, the particular interpretations of more powerful groups may acquire power, eclipse others, and begin to propagate themselves throughout society, thus concealing for a time different understandings. They may even come to be understood as "common sense" by individuals from diverse backgrounds. Yet hegemonic notions of class, gender, and ethnicity are themselves dynamic. They are never inclusive of everyone and are therefore continually reshaped on the terrain of social and political struggle.

Over the more than half a century covered by this study, Bolivian society experienced moments of relative stability and flashes of convulsive change. A persistent contest to frame the nature of social life and construct a hegemonic image of society took place on a number of fronts. In the remote tin-mining communities of the highlands, miners constantly challenged the power of the tin barons and later the Bolivian state. They forged a class solidarity through the enactment of collective rituals that gave meaning to their daily struggle for survival in a harsh, inhospitable environment. This enabled them to maintain a sense of self-worth and strengthened a shared engagement in mineral production (see Nash 1989).

Their struggles shared center stage for most of the twentieth century with those of the peasant producers of the altiplano and Cochabamba Valley. Peasant demands for land, equitable working conditions, and human dignity constantly disrupted the ability of dominant groups to impose self-serving notions of social life. Protests, road blockades, land invasions, and other direct action tactics not only challenged unjust social relationships and sometimes even overturned them, but also constantly shifted the terrain of ideological struggle into new areas. Peasant militants who invaded haciendas in the aftermath of the 1952 revolution justified their actions by claiming that "land is for those who work it," which defied elite conceptions of private property. More contemporary peasant mobilizations in the coca-growing region of Chapare have op-

142

posed U.S. drug policy and the Bolivian government's capitulation to Washington's dictates (Healy 1992). Indeed, the militancy of Bolivian peasants and miners is renowned, even in Latin America, where revolutions and grass-roots insurgencies have played a key part in shaping contemporary history.

Domestic workers are the wives and daughters of peasants and miners, but unlike some of their male class peers, they are never depicted as the courageous standard-bearers of the impoverished masses. Because they work in the isolation of private homes and carry out tasks that are considered women's work, servants, it is believed, are not part of the broader class struggles that shape society. The labor movement has therefore virtually ignored them.

Even though paid household labor is not a key sector of the national economy, it is one of the few forms of waged labor available to immigrant women, and thousands of employers depend upon servants to carry out the domestic tasks that they so abhor. Domestic service brings women from diverse backgrounds together, and it is an important arena in which hegemonic beliefs are contested. As servants and employers seek to modify, impose, and accommodate their competing agendas, the meaning of femininity, servitude, and even civilization itself is renewed and reenacted. Servants also contest dominant conceptions of femininity in their leisure activities and in the streets, plazas, and working-class neighborhoods of the city.

Although the young domestic workers central to my account are not the victors in these ongoing encounters, they are never completely assimilated into the bourgeois ideal of the "perfect woman." The critical question is how the relative balance of forces creates conditions that are favorable or unfavorable to particular interpretations of social relationships. Although servants and employers experience certain conditions of existence, there are always cross-cutting interests that condition the manner in which they understand themselves and relate to others. These interests may even be contradictory. Live-in domestic workers, for example, are both dependent on and exploited by female employers. Hence the lines of solidarity and resistance cannot be taken for granted. They must be created in the course of interactions with employers, fellow servants, and others in both the city and the countryside. This process is characterized by conflict, accommodation, reinterpretation, confusion, and sometimes even resistance.

During the two decades that preceded the 1952 Bolivian revolution, 143

the power of the white ruling class structured the contours of female domestic service and powerfully influenced prevailing beliefs about who Bolivian men and women should be. White women were expected to dedicate themselves to the home, and the presence of servants was essential for them to be "ladies" in the fullest sense. Yet even though they assumed responsibility for managing household workers and domestic tasks, their control of the home was often nominal. White mistresses answered ultimately to a male household head who could contradict their orders at any time. The women often resented male dominance, and some were remarkably independent, tough, and assertive when men were not available to fulfill their customary obligations. Few, however, questioned the social relations that shaped their subordination to men. Most chose to enjoy the benefits of female class privilege and to develop a sense of dignity as ancillaries to powerful men.

Aymara women had no such choice. During the first half of the twentieth century, the expansion of the haciendas pushed them out of rural communities and into urban domestic service. Indigenous beliefs about gender complementarity were undermined in the rigidly hierarchical confines of elite households. Domestic workers found themselves obliged to negotiate tension-ridden relationships with employers in the language of paternalism. In exchange for room, board, and assistance during times of illness or misfortune, mistresses expected loyalty, obedience, and hard work from them. Yet the manner in which these expectations actually worked out in practice varied enormously. Live-out servants enjoyed greater independence than live-in workers and were better positioned to challenge the demands of mistresses. Sometimes, too, employers assumed little responsibility for the welfare of servants.

As servants and employers struggled for ways to strike a tenuous balance in their dealings with each other, the entire edifice of Bolivian society was disintegrating into crisis. The Chaco War, heightened labor militancy, and growing rural unrest posed new challenges to the status quo. The disquiet touched domestic service, especially when a group of cooks influenced by anarcho-syndicalism organized a union and challenged many of the basic tenets of servant-employer relations.

The rising social discontent marked the decline of the old order and ushered in the 1952 revolution. Although the revolution did not directly affect female domestic service, it did radically alter Bolivian society and signaled the beginning of a new era, one in which superior social class no longer corresponded with moral supremacy and being white. Paceños ex-

perienced new patterns of upward and downward mobility, as fallen oligarchs, newly rich entrepreneurs, and aspiring bureaucrats contended with each other and with an empowered popular movement for the power to shape a new hegemony. Female domestic service was also transformed in this process. Multi-servant households declined, unpaid labor was abolished, and specialization within domestic service diminished.

The new social order emerged under the growing political and economic dominance of the United States. In La Paz, female domestic service played an important part in the competition of diverse groups to forge a modern society. Prosperous, white mistresses not only used servants to create a comfortable lifestyle, but also to elaborate an orderly, virtuous home that distinguished their families from the perceived chaos and miasma of the immigrant neighborhoods. They then used the freedom that servants provided from housework to elaborate the symbols of class privilege in a variety of social settings and to clarify the differences between good taste, garish consumerism, and modernity.

The cholas paceñas were less successful in using the home as a weapon in the class struggle. They had always been involved in family businesses and had never undertaken the task of transforming their dwellings into citadels of feminine virtue. Indeed, their homes and businesses frequently occupied the same premises, and the distinction between a "public" and a "private" sphere was not always easy to discern. These women used servants less as adjuncts in the pursuit of bourgeois feminine self-realization than as assistants in their small-scale enterprises.

Young Aymara immigrants were critical of the white ladies and chola women alike, but in the aftermath of the revolution they still had few economic alternatives to domestic service. The deterioration of subsistence agriculture and the growing commoditization of the rural economy eroded peasant livelihood, forcing thousands of rural dwellers to migrate to La Paz in search of waged employment. Live-in domestic service offered young women the possibility of earning a wage, and it also gave them a limited economic independence and the ability to assist needy relatives.

Becoming a servant, however, was an experience that few enjoyed. Most reported feeling lonely, isolated, and overworked, and because they were separated from their own families, many looked to female employers for the emotional nurturance that they craved. For many servants, to be treated "like another member of the family" was one of the most important criteria of a good job. Yet they could never really join employers' 145

families. In addition, they were subjected to an entirely new work routine that they neither controlled nor completely understood. Not surprisingly, the contradictions of this extremely personal labor relation were profoundly troubling for them.

Domestic service also created vexing paradoxes for female employers, particularly middling and upper-class white women. The sexual harassment of domestic workers by employers' husbands and sons jeopardized class-based notions of morality that white women were supposed to uphold. Sometimes white employers tried to shield young workers from the sexual advances of men by locking them in rooms at night or offering advice about men, which underscored their own subordination within the household. At other times, they quietly assented to male behavior by looking the other way. They could do so because many did not believe that Aymara women had the same needs as themselves.

By the late 1980s, social and economic changes were pulling middling and upper-class women in a number of directions. Unlike their mothers' generation, many young white women who came of age in the late 1960s and 1970s enjoyed access to higher education. Some of these women began to envision lives for themselves that extended beyond the home and beneficent work to include professional careers. Yet by the end of the 1970s, the onset of a prolonged crisis eroded the previous gains of women and men from various middling groups, and obliged women, with or without professional qualifications, to seek waged employment. At the same time, rising divorce rates led to an increase in female-headed households among these groups.

As mounting economic turmoil restricted the range of opportunities available to middling white women, some found themselves struggling to maintain positions as unwaged housewives, while others, particularly single mothers, had to work harder to preserve a respectable lifestyle. Those who could pursue a professional career celebrated the opportunity for greater social and economic independence, often scoffing at the long-suffering mothers of an earlier generation. As the experiences of middling white women grew more diverse, the dominant beliefs and practices of womanhood became more controversial. Most women, however, still adhered to certain basic beliefs about feminine domesticity. They continued to assert the primacy of motherhood and the creation of a home, and they conformed to prevailing expectations of appropriate feminine dress, speech, and demeanor. Yet their ability to do so was con-

stantly upset by independent-minded servants, who forced them to negotiate the demands of economic necessity, personal self-realization, and dominant notions of femininity in ways that were not entirely of their own choosing.

Middling housewives, who wanted to remain within the home, could not compete with foreigners and the upper class for experienced servants. They had to contend with green immigrants, who knew nothing about bourgeois housekeeping, had short-term commitments to the work, and resented the constant supervision of mistresses. To maintain the appearance of gentility, these employers constructed elaborate divisions between mental and manual labor, but such distinctions were frequently subverted by servants, who departed without notice or were intentionally careless. Consequently, middling housewives often found themselves far more involved with domestic tasks than befit a true lady.

Wage-earning employers faced different problems. They often did not have time to supervise recalcitrant servants or assume the burden of housework if a domestic worker quit, and they were thus forced to concede a certain amount of control to servants. Yet giving mistrusted outsiders unsupervised access to their homes and young children was profoundly unsettling. It raised doubts about their identities as mothers, women, and family providers that had to be negotiated with servants in the shifting context of waged employment, declining standards of living, and beliefs about feminine propriety. In this process of negotiation and contestation, all employers continued to control household workers through the wage nexus and used the labor of Aymara women to underwrite their own lifestyle.

Although dominant gender beliefs have changed as more white women enter the labor force, the lives of young Aymara immigrants present the most significant alternative to the status quo. These women do not intend to spend their lives servicing the needs of other households. They hope to achieve greater economic prosperity and social mobility, but their dreams of a better life are continually frustrated by class, gender, and ethnic barriers. Urban wage labor allows young, unmarried women to establish new social relationships in the city and to satisfy some of their cravings for consumer commodities, especially clothing. At the same time, however, young women are aware of their precarious economic position and do not readily abandon ties to kinfolk. The conflicting demands of family members, their own desires for upward mobility,

and changing attitudes about themselves and the countryside, which are increasingly influenced by dominant groups in the city, create new ambivalencies for them.

Female fashion is one realm in which these contradictions are displayed and where immigrant women create an alternative femininity that challenges dominant views of the perfect woman. This emergent urban Aymara femininity is itself contradictory, having arisen from years of dealings among peasants, urban immigrants, the chola paceñas, and white women. Many of the accoutrements of contemporary Aymara women's wardrobe originated with Spanish colonial women, but they now symbolize female Aymara gender and ethnic pride. They are the contemporary symbols of a continuing historical process, one in which new cultural forms are not only created, but older styles also become separated from their original setting and infused with new significance.

While evolving patterns of Aymara fashion set young immigrant women apart from white society and more prosperous chola women, the relationships that they create with young men further distinguish them from their middling and upper-class counterparts. Domestic workers are relatively free to meet and establish relationships with young men during their free time because they are removed from the direct control of family members. Their freewheeling sociality scandalizes employers, who feel that such behavior violates the standards of appropriate feminine decorum. At the same time, however, the freedom enjoyed by young women may also render them vulnerable to male deceit and abandonment.

Young women who become pregnant and bear children without the support of male companions face serious difficulties earning a living that is adequate to support themselves and their children. Moreover, even when men provide financial support to women and children, the economic crisis has undermined their role as providers. The earnings of women and children are increasingly important for the maintenance of poor households under the prevailing conditions of debt-induced austerity in La Paz. This, in turn, has made the construction of gender more controversial for men, who may manipulate the meanings of masculinity and femininity in order to regain some of their lost authority in the household.

What it means to be a woman in La Paz, then, is continually reshaped among and between different social classes and ethnic groups. Because the subaltern forms of femininity created by Aymara women pose an alternative to dominant concepts of feminine morality and beauty, they

are constantly manipulated, marginalized, and appropriated by dominant groups, who have a vested interest in conserving the symbols of their power.

Representations of Aymara and immigrant women are manipulated in a number of ways by the popular media, tourist agencies, and employers themselves to convey particular sentiments. Representations of innocent Indian girls in a pastoral countryside coexist with others that depict rural people as degraded barbarians. These contradictory conceptualizations selectively draw on beliefs about the past, but they acquire specific meaning in the contemporary encounters between dominant and subordinate groups in the city. They are deployed at different times to deflect a variety of challenges to the symbols of the status quo.

Employers also control servants in ways that not only discipline immigrant women as workers but impose particular notions of femininity on them. They dictate standards of personal hygiene and manipulate the dress of young women to suit their own need for acculturated servants who conform to dominant notions of plebeian womanhood. Employers also discriminate between the worthy and the unworthy poor. The "worthy" poor woman is isolated from a social support network and is thus eligible for upper-class charity, while the "unworthy" poor woman, who is perceived as loud, boisterous, and sexually irresponsible, is spurned. Employers, however, are unable to completely constrain the gregarious lives of domestic workers or refashion immigrant women into docile attendants. Many therefore turn to the Catholic Church and other organizations for assistance.

For their part, servants do not have strong organizations that support workers' rights and shape their intense feelings of indignation into a critical analysis of domestic service. Class consciousness thus emerges among them in an ambiguous, confining manner. Lived experiences are understood in contradictory ways because of the simultaneous processes of distancing and incorporation that are so characteristic of servant-employer relations and the immigrant ordeal in La Paz. Servants' interpretations of experience often remain structures of feeling that are perceived to be personal rather than collective (Williams 1977), and are only rarely articulated into specific concepts or explanations of servitude.

A number of factors have precluded the crystallization of a lucid class consciousness, one in which the feelings of resentment and exploitation that are already present in servants' practical consciousness are elaborated into a systematic indictment of the status quo. In addition to the

precarious dependencies that characterize mistress-servant relations, the male leadership of the labor movement fails to appreciate the far-reaching importance of "women's work." This has impeded the incorporation of domestic workers into the struggles of organized labor and left servants to languish in the isolation of an imagined "private sphere."

The severe economic dislocations of the 1980s only aggravated this process. Low international prices for tin and IMF-backed fiscal austerity measures severely weakened the labor movement, as thousands of people lost their jobs. While the unemployed turned increasingly to various "informal" economic activities, such as street selling, cocaine production, and domestic service, the labor movement did not produce a comprehensive strategy that was sensitive to the gender, ethnic, and occupational diversity of the working class. Many immigrant women, who were disillusioned with the labor movement or isolated from it, found the teachings of evangelical Protestantism to resonate more with their life experiences.

The profusion of Christian fundamentalist sects that have sprouted up in La Paz over the last two decades speaks powerfully to a pervasive sense of desperation felt by immigrants. Rather than addressing issues of power, inequality, racism, and sexism, however, the sects seek to reshape the nature of social debate around personal and religious issues. They offer converts, who must increasingly confront the city alone, a practical plan for living that, they claim, will ultimately lead to eternal salvation. This plan varies from one group to another but usually includes hard work, social and sexual abstinence, loyalty to a patriarchal vision of the nuclear family, and, of course, unquestioning faith in the Protestant God.

Evangelical Protestantism—especially Pentecostalism—is particularly appealing to immigrant women in La Paz because it offers an institutional setting to meet people and develop contacts. Unlike their male counterparts, who enjoy a homosocial world of leisure-time activities that includes sports, bars, immigrant associations, political parties, and unions, women's activities are more restricted to the domestic sphere. Participation in frequent religious gatherings is one of the few socially sanctioned ways that women can develop and reaffirm new social relationships. Worship services also provide a setting in which women feel that they can take control of their lives. It thus seems paradoxical that women must also deal with a religious ideology that endorses the natural inferiority of women.

At the same time, however, aggressive male behavior is discouraged in the collective setting of the Pentecostal *culto*, and women find it easier to relate to the "new" man who has been domesticated by the sects. Together, men and women experience a heightened sense of group identity that is fostered by a religious ideology that emphasizes a clear-cut distinction between believers and infidels. Pastors argue that true believers understand the "truth" and will be saved on Judgment Day, while others will be condemned to damnation. Such beliefs distance converts from non-believers and help shape a shared sense of community, while simultaneously separating believers from other members of the working class.

Yet much to the consternation of religious leaders, the commitment of immigrant women to the tenets of evangelical Protestantism is not always as deep as they want. There is considerable religious mobility among immigrant women and men. Religious identities evolve over the lifetimes of particular individuals and often change as people negotiate the disruptions of social life in continuously evolving ways. In this process, individuals define social identities as they relate to and separate from others.

Rather than developing lasting loyalties to new groups, immigrant women are still searching for answers to the predicaments that continually confound their lives. Although the leaders of many Protestant sects have closed off the possibility of confronting inequality as it is lived every day by thousands of poor people, immigrant women remain open-minded. As they move through religious organizations, experiment with unionization, confront different employers, and grapple with conflicting ideologies, they understand their life experiences, past and present, in new ways. How they address their problems in the future is impossible to predict, but we have certainly not heard the last from them.

INTRODUCTION

1. "Indio" has been reappropriated to a limited degree by an *indianist* movement in La Paz that is led by urban Aymara intellectuals (Albó 1987).

2. There is a large literature on the manner in which gender and ethnicity are created and expressed in the context of unequal power relationships. For gender, see, for example, Gailey (1987); Stansell (1987); Davidoff and Hall (1987); Peiss (1985). For ethnicity, see, for example, Bourgois (1989); Wolf (1982:354–384); Sider (1987); and Di Leonardo (1984).

3. For the discussion of public and private spheres, see Rosaldo (1974, 1980) for the original formulation of the concepts in anthropology, and Yanagisako (1979), Rogers (1978), Rapp (1979), and Strathern (1984) for critical evaluations of them.

4. Feminist discussion of production and reproduction draws on Engels's original formulation. Leacock (1972) was one of the first feminist anthropologists to appreciate Engels's analysis. See also Vogel (1983), Meillasoux (1981), Harris and Young (1981), Benería and Sen (1981), and Edholm, Harris, and Young (1977).

5. I use the term *status* in the Weberian sense: "Every typical component of the life fate of men [and women] that is determined by a specific, positive or negative, social estimation of honor. This honor may be connected with a quality shared by a plurality." See Gerth and Mills 1946:187.

6. Cholita is the feminine diminutive of chola.

1. SEÑORAS AND SIRVIENTAS

1. "Condecoración a empleadas domésticas," *La Razón*, May 29, 1948 and "Se premió la lealtad y trabajo a quince servidores domésticas," *La Razón*, 1950.

2. Archivo de La Paz (ALP), Censo Demográfico de 1950, Ciudad de la Paz, Dirección General de Estadística y Censos.

3. Despite the transformations that have continually reshaped domestic service relationships, the continuities with the past are striking. See, for example, Glave (1988) and Zulawski (1990).

4. ALP, Distrito Judicial La Paz, 1927, Caja 1576. See also THOA 1986b.

5. ALP, Distrito Judicial La Paz, 1927, Caja 1576.

6. See Stevens (1973) and Wilson (1984) for explanations of similar beliefs in Mexico and Peru, respectively.

7. See Poole's article (1988) on upper-class women in nineteenth-century Lima, Peru. Poole describes how women used veiling, a common practice of the period, to escape the scrutiny of relatives and publicly assert their sexuality.

8. ALP, Distrito Judicial La Paz, 1933, Caja 1632.

9. ALP, Distrito Judicial La Paz, 1937, Caja 1680.

10. These activities were noted by Olivia Harris in the 1970s (Harris 1978) and are still practiced today in many parts of the altiplano.

11. ALP, Distrito Judicial La Paz, 1936, Caja 1665.

12. ALP, Distrito Judicial La Paz, 1937, Caja 1693.

13. *Casera* refers to an individual who regularly buys from or sells to another person. Sellers, for example, typically provide the highest-quality products at the best prices to those customers who regularly purchase from them. Buyers, for their part, depend upon continuous loyalty to a particular seller to obtain high-quality goods.

14. See Graham (1988) for a useful discussion of paternalism in the servant-employer relationships of nineteenth-century Rio de Janeiro.

15. ALP, Distrito Judicial La Paz, 1937, Caja 1683.

16. ALP, Distrito Judicial La Paz, 1932, Caja 1619.

17. When other means failed, the impoverished parents of criadas turned to the courts for assistance. The available documentation contains several cases of litigation between parents and employers. One ploy commonly used by employers to maintain control over the children was to demand reimbursement for food and lodging. The resulting amount was often beyond the reach of a peasant household, particularly if a child had been in service for a number of years, thus leaving the child an indentured servant.

18. *Mitanis* were peasants completing a stipulated period of obligatory labor service (*mitanaje*) to the landlord. For peasant women, the labor was typically carried out in the landlord's urban residence.

19. ALP, Distrito Judicial La Paz, 1935, Caja 1655.

20. "Se Debe Exigir Carnet Sanitario a la Servidumbre," *La Fragua*, April 27, 1936.

21. "Sección doméstica de la policía de seguridad," *La Fragua*, April 26, 1936.

22. "Military socialism" essentially meant a populist and reformist government led alternately by Colonels David Toro and Germán Busch. A number of leftist and anarcho-syndicalist groups made important strides in this period, but so, too, did civilian groups associated with a modified fascist position, who were closely tied to the regimes (Klein 1982:201).

23. Graham (1988) examines employers' ambivalence to state regulation of domestic service in nineteenth-century Rio de Janeiro.

24. "Se inaugura el 10 de marzo próximo en La Paz una escuela doméstica," *La Tribuna*, April 5, 1950.

25. "Citaciones: Sindicato de Culinarias y Ramas Similares," *La Calle*, August 23, 1936.

2. MAINTAINING APPEARANCES: DOMESTIC SERVICE
AND CHANGING CLASS RELATIONS, 1952–1980

1. I use the term *middling* to describe middle-level government bureaucrats, professionals of various sorts, shop owners, petty merchants, and military personnel who are much too socially and economically heterogeneous to constitute a "middle class."

2. Gerson and Peiss (1985) provide a useful discussion of the concept of boundaries. They emphasize the permeability of boundaries in the context of changing social relations, stressing the importance of domination and negotiation in the process of change.

3. There is a great deal of literature on the Bolivian revolution and its legacy. See, for example, Eckstein (1979); Malloy and Thorn (1971); Lagos (1994); Heath, Erasmus, and Buechler (1969); Healy (1982); and McEwen (1975).

4. See Roseberry (1989a) for a discussion of similar processes in the Venezuelan context.

5. Contraband goods were sold in a large outdoor market that expanded during the 1970s to encompass several city blocks. Popularly known as "Miamicito," or "Little Miami," the market provided everything from Johnny Walker whiskey, food processors, and stereo components to toothpaste, dish detergent, and scouring pads. Merchants smuggled the items from intermediate points in Peru, Chile, Brazil, and sometimes brought them directly from the United States. They then sold the goods for prices substantially below those on display in shops in the city center.

6. See William Roseberry (1989a) for a further discussion of this phenomenon.

7. *El Diario*, March 1, 1970.

8. *El Diario*, March 4, 1970, p. 4.

9. In March 1970, for example, four "hippies" were arrested by the La Paz police after they were discovered naked and smoking marijuana in a room filled with psychedelic decorations. Two of the perpetrators were North Americans. Psychiatric treatment was recommended for all four (*El Diario*, March 1970).

10. See Hall and Jefferson (1976) for an analysis of this process among British youth. Even though British teenagers had more access to consumer commodities than their Bolivian counterparts, the democratizing role of consumerism was limited by the constant development of new styles and practices that identified individuals with particular groups.

11. See Graham (1988) for a discussion of employers' fears of contagion in nineteenth-century Rio de Janeiro. Black servants lived in the filthiest, most disease-ridden parts of the city. Yet they entered the homes of the upper class every day, raising fears among employers that contagious diseases would not be confined to the world of servants. This realization had profound implications for the manner in which employers struggled to control servants and regulate their activities.

12. See Fox-Genovese (1988) and Davidoff and Hall (1987) for an interesting discussion of similar gender conventions among white women in the antebellum American South and early nineteenth-century England, respectively.

13. See Maria Lagos (1993) for a good discussion of the class and ethnic dynamics of a similar event—the celebration of the Virgin of Urkupiña—in Cochabamba.

3. FROM THE COUNTRYSIDE TO THE CITY: AYMARA WOMEN,
MIGRATION, AND WORK IN LA PAZ

1. Aymaras have been forced to engage in wage labor since the colonial period. The importance of wage labor for the family economy varies from one historical period to another and is conditioned by changing political, economic, and social factors.

2. These illicit drug-processing centers grew throughout the 1980s in response to rising North American and European demand. The cocaine economy represented the only niche in

the world economy in which Bolivia could successfully compete. Yet U.S. repression against the drug traffic increased during this period, even though the Reagan and Bush administrations constantly touted trade liberalization and deeper world economic integration for Third World countries. Paradoxically, the Chapare and Santa Cruz, which were at the center of the U.S. war on drugs, were precisely those areas that U.S. aid opened for economic development in the 1950s and 1960s.

3. See Roseberry (1989b).

4. See Portes (1989) for a discussion of patterns of urbanization in Latin America during the crisis years of the 1980s.

5. See Crummet (1987) and Radcliffe (1985) for further discussion of gender in the migratory process. Although there are no specific studies dealing with the Bolivian altiplano, the Peruvian communities studied by Radcliffe confront similar circumstances as those found in the Bolivian altiplano.

6. See Sandoval, Albó, and Greaves (1987) for a discussion of gender and land tenure in the communities of the Bolivian altiplano.

7. Carmen Diana Deere (1990) provides an interesting discussion of family instability among the Cajamarcan peasantry.

8. See Deere's pioneering article (1977) on the changing division of labor between peasant men and women for more discussion of this point.

9. Salteñas are spicy meat pies that are very popular among paceños of all social backgrounds.

10. I personally attended a Christmas Eve dinner that extended into the early hours of Christmas morning. When I left at 3:00 A.M. to go home, the servant was still washing dishes and serving late-night drinks and snacks to guests. See also Rigoberta Menchú's account of being a domestic servant in Guatemala City (1983).

11. See Young (1987) for a discussion of the myth of being part of the family.

12. See Rollins (1985) for an insightful discussion of "invisibility" in domestic service. Rollins, an African-American sociologist, worked as a servant for white families in the Boston area. There were times when Rollins became so invisible to her employers that she was able to pull out a note pad and take notes without arousing their curiosity.

13. Imilla is an Aymara word that means girl. It is used in a derogatory fashion by urban residents.

14. During my stay in Bolivia, I resided in one such building in central La Paz. The maid's chamber consisted of a windowless room behind the kitchen that was no bigger than a large closet.

15. For example, one man from an old, oligarchic family recounted his "wild days" as a teenager in La Paz to me. He described one occasion when he appeared in the doorway of the maid's room clad only in his underwear. He then chuckled as he told how the woman screamed and drove him away.

16. See Laurel Bossen's discussion (1988) of middle-class wives and servants in Guatemala City for an elaboration of the importance of marriage in structuring the relative positions of wives and servants in households.

4. EMPLOYERS AND THE WAGE NEXUS

1. See Williams (1977:115–127) for a discussion of the selectivity of tradition. Hobsbawn and Ranger (1983) also demonstrates the importance of inventing traditions for the maintenance of a dominant cultural order.

2. The Compadre Palenque hosts a popular television talk show in La Paz.

3. The informants for this study included a number of professionals: two dentists, two journalists, three business managers, and one university professor.

4. Kelly (1991) reports that single mothers face similar contradictions in the Spanish Galician community that she studied.

5. Most prosperous paceño households are equipped with both 110- and 220-volt outlets.

6. See Colen (1990) for a discussion of the problems that arise around "mothering" between white New York City mistresses and West Indian nannies. Also, see Susser's (1991) analysis of the changing class structure of New York City households and the consequences for the manner in which children are raised in different settings.

7. *Casera* is a term used to describe a market vendor who regularly provides a buyer with high-quality produce at reasonable prices.

5. CITY PLEASURES

1. See Williams (1973b:57–60) for further elaboration on the development of the concept of civilization.

2. I am indebted to Gerald Sider for this point. See Sider (1987).

3. Margo Smith (1973) has argued that domestic service is a channel of upward mobility for poor women. She subsequently qualified this position (1989) and called for more research on the economic trajectories of former servants.

4. Sandóval, Albó, and Greaves (1987) found that only 10 percent of the domestic workers that they surveyed in the 1970s had access to land. Sixty-three percent, however, hoped to acquire land at some time in their lives.

5. See Kathy Peiss's discussion (1985) of working-class women in turn-of-the-century New York City for a very interesting discussion of how class and gender shaped leisure activities.

6. See Thompson (1978) for further discussion of the dialectical antagonisms, adjustments, and accommodations that shape cultural production.

7. A concern for stylishness and fashion came out repeatedly in my interviews with domestic workers. On two occasions I also visited rural communities on the altiplano and discussed female rural-urban migration with local people. Several of these informants described in detail the airs put on by young female migrants during visits to the communities and the clothing that they displayed on these occasions.

8. The clothing prices reflect the situation in La Paz during the late 1980s.

9. A *presterio* is a large party characterized by much drinking and dancing. The *preste*, or sponsor, hosts the event and pays for the festivities.

10. For this point, I am indebted to Christine Stansell (1987), who develops it for nineteenth-century working-class women in New York City.

11. Personal communication, 1993.

12. Nash (1979:315) makes a similar observation for the Bolivian mining community of San Jose. The emergence of various avowedly "Indian" political parties has done little to address gender issues between Aymara men and women. These parties, which are dominated by men, paint a rosy picture of male-female relationships among Aymaras based on a romanticized notion of "complementarity," derived from an idealized pre-colonial past.

6. BEYOND THE SERVANT PROBLEM: EMPLOYERS AND THE CREATION OF PLEBEIAN WOMANHOOD

1. Indeed, the way in which peasants cooperated with the miners was one of the most terrifying images (to whites) of the 1986 march and one of the main reasons why the army stopped it on the outskirts of the city (Nash 1992).

2. Tom Abercrombie (1990) discusses contradictory representations of Indians within the context of the Oruro carnival and relates them to the process of nation building, whereby a white minority tries to incorporate a suppressed majority into one nation. See also Albó's discussion (1987) of the ideology of the Katarista peasant movement in contemporary Bolivia.

3. Most of these soap operas are produced in Brazil, Argentina, and Mexico. Examples of two popular soap operas are *Rosa de Lejos*, produced in Argentina, and *A Escrava*, produced in Brazil. In *Rosa de Lejos*, a domestic servant studies fashion design, marries a good man, and eventually becomes a high-fashion designer in Paris. In *A Escrava*, a domestic slave on a Brazilian plantation falls in love and marries the plantation owner. The *fotonovelas* (pictures with captions) have also traditionally represented domestic service as an avenue of upward mobility for young women. Yet Flora's study (1989) of fotonovelas in Mexico, Colombia, Venezuela, and Chile suggests a new trend that depicts the exploitative sexual and economic relationships of domestic service, particularly emphasizing male violence against women.

4. For more discussion of this point, see Nelkin and Gilman (1988).

5. Stansell (1987) develops this same point about upper-class women in antebellum New York City.

6. In 1987, the order had plans to build a school for servants behind its elegant Sopocachi headquarters and to expand its training program by recruiting more participants.

7. For further elaboration on the notion of structures of feeling, see Raymond Williams (1977:128–135).

8. Miners, who are predominantly male, are constantly depicted as playing a heroic role in the broader struggles of the Bolivian working class. Yet servants, who are primarily female, are perceived as childish and outside of the major processes shaping contemporary Bolivian society.

7. UNION MAIDS AND PROTESTANT SISTERS: WOMEN AND MOVEMENTS FOR SOCIAL CHANGE

1. Leftist peasant and working-class women have tended to associate "feminism" with white, middle-class women in Europe and North America and, to a lesser extent, Bolivian women who come from a similar class background. Because of enormous class and cultural differences, they do not harbor any feelings of sisterhood toward these women, and it should therefore come as no surprise that feminism, as it is popularly understood, holds very little appeal to them. This does not imply, however, that poor women have no sense of their particular problems as women. As León (1990) shows, women of the Bartolina Sisa Federation of Peasant Women have slowly been trying to articulate their demands as women within the broader context of the male-dominated peasant movement.

2. I thank Ineke Dibbits of TAHIPAMU for making me aware of the presence of servants in the homes of labor leaders (personal communication, June 23, 1992).

3. The term "evangelical Protestant" refers to a theological conservative who stresses personal salvation, evangelism, and a literal interpretation of the Bible. Although in the United States Mormons and Jehovah's Witnesses are not included in this definition, Bolivians tend to lump all non-Catholic Christians together under the term "evangelico."

4. About 30 percent of the population in Guatemala now considers itself evangelical (Stoll, personal communication, 1992), while the number of Brazilian Catholics has declined from 90 percent to 75 percent of the total population because of the inroads made by evangelical Protestantism ("Pope Urges Brazilians to Resist Mirage of Evangelists," *New York Times*, October 14, 1991).

5. Bamet (1986) describes similar processes for Ecuador.

6. In the 1970s, nearly 80 percent (716) of all priests were foreigners (Barrett 1982:181–182), and although this figure dropped somewhat during the years of the most repressive military rule under Generals Banzer (1971–1978) and Garcia Mesa (1980–1982), it remained high. See also Lernoux (1980:143).

7. This church resembled many others like it. The core membership consisted of approximately thirty-five adults, but individual worship services could attract up to eighty people.

Sometimes men and women were present in equal numbers, but women more commonly outnumbered men, often by as much as three to one. The majority of women were neither married nor involved in a stable union.

8. Many of the conversion accounts that I heard from men focused on alcohol abuse in their preconversion lives and their subsequent transformations into more responsible fathers and husbands.

9. I have borrowed the term *religious mobility* from Murphee (1969) to describe the process of shifting religious affiliation.

Abercrombie, Thomas. 1990. "Mothers and Mistresses of the Bolivian Nation: Memory and Desire in a Postcolonial Pagent." Unpublished manuscript.

Albó, Xavier. 1987. "From MNRista to Kataristas to Katari." In Steve Stern, ed., *Resistance, Rebellion, and Consciousness in the Andean Peasant World: 18th to 20th Centuries*, pp. 379–419. Madison: University of Wisconsin Press.

Albó, Xavier, Tomás Greaves, and Godofredo Sandóval. 1981. *Chukiyawu: La Cara Aymara de La Paz*, vol. 1. El Paso a la Ciudad. Cuadernos de Investigación no. 20. La Paz: CIPCA.

Albó, Xavier, Tomás Greaves, and Godofredo Sandóval. 1983. *Chukiyawu: La Cara Aymara de La Paz*, vol. 3. Cabalgando Entre Dos Mundos. Cuadernos de Investigación no. 24. La Paz: CIPCA.

Albó, Xavier, and Mauricio Mamani. 1976. *Esposos, Suegros, y Padrinos entre los Aymaras*. Cuaderno de Investigacion no. 1. La Paz: CIPCA.

Albó, Xavier, and Matías Preiswerk. 1986. *Los señores del gran poder*. La Paz: Centro de Teología Popular.

Antezana, Luis H. 1983. "Sistema y Proceso Ideológicos en Bolivia (1935–1979)." In René Zavaleta Mercado, ed., *Bolivia, Hoy*. Mexico City: Siglo Veintiuno Editores.

Araníbar, Jaime, et al. 1984. "Migración y empleo en la ciudad de La Paz." Ministério de Trabajo y Desarrollo Laboral. Série Resultados no. 9. La Paz: Ministério de Trabajo y Desarrollo Laboral.

Ardaya, Gloria. 1985. "The Barzolas and the Housewives Committee." In June Nash and

BIBLIOGRAPHY

Helen Safá, eds., *Women and Change in Latin America*. South Hadley, Mass.: Bergin and Garvey.

Arze Aguirre, René Danilo. 1987. *Guerra y Conflictos Sociales: El Caso Rural Boliviano durante la Campaña de Chaco*. La Paz: CERES.

Bamet, Tomás. 1986. *¿Salvación o Dominación? Las sectas religiosas en el Ecuador*. Quito, Ecuador: Editorial El Conejo.

Barragán, Rossana. 1991. "Entre Polleras, Ñañacas, y Lliqllas: Los Mestizos y Cholas y la Emergencia de la Tercera República." Unpublished ms.

Barrett, David, ed. 1982. *World Christian Encyclopedia*. Nairobi: Oxford University Press.

Barrios de Chungara, Domitila. 1978. *Let Me Speak: The Autobiography of a Bolivian Mining Woman*. Edited by Moema Vieser. New York: Monthly Review Press.

Benería, Lourdes, and Martha Roldan. 1987. *The Crossroads of Class and Gender: Industrial Homework, Subcontracting, and Household Dynamics in Mexico*. Chicago: University of Chicago Press.

Benería, Lourdes, and Gita Sen. 1981. "Accumulation, Reproduction, and Women's Role in Economic Development: Boserup Revisited." *Signs* 7(2):279–298.

Bossen, Laurel. 1988. "Wives and Servants: Women in Middle-Class Households, Guatemala City." In George Gmelch and Walter P. Zenner, eds., *Urban Life: Readings in Urban Anthropology*, 2d ed. Prospect Heights, Ill.: Waveland Press.

Bourgois, Phillip. 1989. *Ethnicity at Work: Divided Labor on a Central American Banana Plantation*. Baltimore: Johns Hopkins University Press.

Brusco, Elizabeth. 1986. "The Household Basis of Evangelical Religion and the Reformation of Machismo in Colombia." Ph.D. dissertation, City University of New York.

Buechler, Hans, and Judith-Marie Buechler. 1992. *Manufacturing Against the Odds*. Boulder, Colo.: Westview Press.

Bunster, Ximena, and Elsa Chaney. 1989. *Sellers and Servants*. Granby, Mass.: Bergin and Garvey.

Calderón, Fernando. 1983. *La política en las calles*. La Paz: CERES.

Canavesi de Sahonero, M. Lissette. 1987. *El Traje de la Chola Paceña*. La Paz: Amigos del Libro.

Censo Demográfico. 1950. Ciudad de La Paz. Dirección General de Estadísticas y Censos. La Paz, Bolivia.

Chaney, Elsa, and Mary Garcia Castro, eds. 1989. *Muchachas No More: Household Workers in Latin America and the Caribbean*. Philadelphia: Temple University Press.

Cock, Jacqueline. 1980. *Maids and Madams*. Johannesburg: Raven Press.

Colen, Shellee. 1989. "'Just a Little Respect:' West Indian Domestic Workers in New York City." In Chaney and Castro, eds., *Muchachas No More*, pp. 171–196.

Colen, Shellee. 1990. "'Housekeeping' for the Green Card: West Indian Household Workers, the State, and Stratified Reproduction in New York." In Sanjek and Colen, eds. *At Work in Homes*, pp. 89–118.

Collins, Jane. 1984. "The Household and Relations of Production in Southern Peru." *Comparative Studies in Society and History* 28(4):651–671.

Comaroff, Jean, and John Comaroff. 1992. *Of Revelation and Revolution: Christianity, Colonialism, and Consciousness in South Africa*. Chicago: University of Chicago Press.

Crummet, Maria de los Angeles. 1987. "Rural Women and Migration in Latin America." In Carmen Diana Deere and Magdalena Leons de Leal, eds., *Rural Women and State Policy: Feminist Perspectives on Latin American Agricultural Development*. Boulder, Colo.: Westview Press.

Davidoff, Leonore, and Catherine Hall. 1987. *Family Fortunes: Men and Women of the English Middle Class, 1780–1850*. Chicago: University of Chicago Press.

Deere, Carmen Diana. 1977. "Changing Social Relations of Production and Peruvian Peasant Women's Work." *Latin American Perspectives* 4(12–13):58–69.

Deere, Carmen Diana. 1990. *Household and Class Relations: Peasants and Landlords in Northern Peru*. Berkeley: University of California Press.

Di Leonardo, Micaela. 1984. *The Varieties of Ethnic Experience: Kinship, Class, and Gender among Cailfornia Italian-Americans*. Ithaca, N.Y.: Cornell University Press.

Di Leonardo, Micaela. 1991. "Introduction: Gender, Culture and Political Economy: Feminist Anthropology in Historical Perspective." In Micaela Di Leonardo, ed., *Gender at the Crossroads of Knowledge: Feminist Anthropology in the Postmodern Era*, pp. 1–50. Berkeley: University of California Press.

Dunkerley, James. 1984. *Rebellion in the Veins: Political Struggle in Bolivia, 1952–1982*. London: Verso.

Eckstein, Susan. 1979. "El Capitalismo Mundial y la Revolución Agraria en Bolivia." *Revista Mexicana de Sociologia* 61:458–478.

Edholm, Felicity, Olivia Harris, and Kate Young. 1977. "Conceptualising Women." *Critique of Anthropology* 3(9/10):101–130.

Engels, Fredrich. 1972 [1884]. *The Origin of the Family, Private Property and the State*. New York: Pathfinder Press.

Flora, Cornelia Butler. 1989. "Domestic Service in the Latin American Fotonovela." In Chaney and Castro, eds., *Muchachas No More*, pp. 143–149.

Fox-Genovese, Elizabeth. 1988. *Within the Plantation Household: Black and White Women of the Old South*. Chapel Hill: University of North Carolina Press.

Gailey, Christine. 1987. *Kinship to Kingship: Gender Hierarchy and State Formation in the Tongan Islands*. Austin: University of Texas Press.

Gaitskell, Deborah, Judy Kimble, Moira Maconacnie, and Elaine Unterhalter. 1984. "Class, Race and Gender: Domestic Workers in South Africa." *Review of African Political Economy* 27/28:86–108.

Gal, Susan. 1991. "Between Speech and Silence." In Micaela Di Leonardo, ed., *Gender at the Crossroads of Knowledge: Feminism in the Postmodern Era*, pp. 175–203. Berkeley: University of California Press.

Gerson, Judith, and Kathy Peiss. 1985. "Boundaries, Negotiation, Consciousness: Reconceptualizing Gender Relations." *Social Problems* 32(4):317–331.

Gill, Lesley. 1987. *Peasants, Entrepreneurs and Social Change: Frontier Development in Lowland Bolivia*. Boulder, Colo.: Westview Press.

Gill, Lesley. 1990. "'Like a Veil to Cover Them': Women and the Pentecostal Movement in La Paz." *American Ethnologist* 17(4):708–721.

Gilligan, Carol. 1982. *In A Different Voice*. Cambridge, Mass.: Harvard University Press.

Glave, Luis Miguel. 1988. "Mujer Indígena, Trabajo Doméstico y Cambio Social en el Virrenato Peruano del Siglo XVII: La Ciudad de La Paz y el Sur Andino en 1684." *Bulletin de L'institute Francais D'etudes Andines* 16(3–4).

Girth, H. H., and C. Wright Mills, eds. 1946. *From Max Weber: Essays in Sociology*. New York: Oxford University Press.

Glenn, Evelyn Nakano. 1986. *Issei, Nisei, War Bride: Three Generations of Japanese-American Women in Domestic Service*. Philadelphia: Temple University Press.

Gould, Jeffrey. 1990. *To Lead as Equals: Rural Protest and Political Consciousness in Chinandega, Nicaragua, 1912–1979*. Chapel Hill: University of North Carolina Press.

Graham, Sandra Lauderdale. 1988. *House and Street: The Domestic World of Servants and Masters in Nineteenth-Century Rio de Janeiro*. Cambridge: Cambridge University Press.

Gramsci, Antonio. 1971. *Selections from the Prison Notebooks*. New York: International Publishers.

Green, Linda. 1993. "Shifting Boundaries: Mayan Widows and Evangelicals." In David Stoll and Jean Gerrard, eds., *Rethinking Pentecostalism*, pp. 180–198. Philadelphia: Temple University Press.

Hall, Jacqueline D. 1986. "Disorderly Women: Gender and Labor Militancy in the Appalachian South." *Journal of American History* 73(2):354–382.

Hall, Stuart. 1980. "Cultural Studies at the Centre: Some Problematics and Problems." In Stuart Hall, D.Hobson, A. Lowe, and P. Willis, eds., *Culture, Media and Language*, pp. 15–47. London: Hutchinson.

Hall, Stuart. 1981. "Notes on Deconstructing the Popular." In Raphael Samuels, ed., *People's History and Socialist Theory*, pp. 227–240. London: Routledge and Kegan Paul.

Hall, Stuart, and Tony Jefferson, eds. 1975. *Resistance Through Rituals: Youth Subcultures in Post-War Britain*. London: Unwin Hyman.

Hansen, Karen. 1989. *Distant Companions: Servants and Employers in Zambia, 1900–1985*. Ithaca: Cornell University Press.

Hansen, Karen. 1991. "Introduction: Domesticity in Africa." In Karen Tranberg Hansen, ed. *African Encounters with Domesticity*, pp. 1–36. New Brunswick, N.J.: Rutgers University Press.

Harris, Olivia. 1978. "Complementarity and Conflict: An Andean View of Male and Female." In J. LaFontaine, ed., *Sex and Age as Principles of Social Differentiation*. London: Tavistock.

Harris, Olivia, and Kate Young. 1981. "Engendered Structures: Some Problems in the Analysis of Reproduction." In J. Kahn and J. Llobera, eds., *The Anthropology of Pre-capitalist Societies*, pp. 109–147. London: Macmillan.

Healy, Kevin. 1982. *Caciques y Patrones*. Cochabamba: El Buitre.

Healy, Kevin. 1992. "Coca, the State and the Peasantry in Bolivia." *Journal of Interamerican Studies and World Affairs* 30 (Summer/Fall):105–126.

Heath, Dwight, Charles Erasmus, and Hans Buechler, eds. 1969. *Land Reform and Social Revolution in Bolivia*. New York: Praeger.

Hobsbawn, Eric, and Terance Ranger, eds. 1983. *The Invention of Tradition*. Cambridge: Cambridge University Press.

Jelin, Elizabeth. 1977. "Migration and Labor Force Participation of Latin American Women: The Domestic Servants in Cities." *Signs* 3:129–41.

Keesing, Roger. 1985. "Kwaio Women Speak: The Micropolitics of Autobiography in a Solomon Island Society." *American Anthropologist* 87(1):27–39.

Kelly, Heidi. 1991. "Unwed Mothers and Household Reputation in a Spanish Galician Community." *American Ethnologist* 18(3):565–580.

Klein, Herbert S. 1982. *Bolivia: Evolution of a Multi-Ethnic Society*. New York: Oxford University Press.

Knudson, Jerry W. 1986. *Bolivia: Press and Revolution, 1932–1964*. London: University of America Press.

Lagos, Maria. 1994. *Autonomy and Power: The Dynamics of Class and Culture in Rural Bolivia*. Philadelphia: University of Pennsylvania Press.

Lagos, Maria. 1993. "We Have to Learn to Ask: Cultural Hegemony, Diverse Experiences and Antagonistic Meanings." *American Ethnologist* 20(1):52–71.

Lamphere, Louise. 1987. *From Working Daughters to Working Mothers: Immigrant Women in a New England Industrial Community*. Ithaca: Cornell University Press.

Lancaster, Roger. 1988. *Thanks to God and the Revolution: Popular Religion and Class Consciousness in the New Nicaragua*. New York: Columbia University Press.

Leacock, Eleanor. 1972. "Introduction." In Engel, *Origin of the Family*, pp. 7–68.

Lehm, Zulema, and Silvia Rivera. 1988. *Los Artesanos Libertarios y la Ética de Trabajo*. La Paz: Gramma.

León, Rosario. 1990. "Bartolina Sisa: The Peasant Women's Organization in Bolivia." In Elizabeth Jelin, ed., *Women and Social Change in Latin America*, pp. 135–150. London: Zed Books.

Lernoux, Peggy. 1980. *Cry of the People: United States Involvement in the Rise of Facism, Torture,*

and Murder and the Persecution of the Catholic Church in Latin America. Garden City, N.Y.: Doubleday.

Lernoux, Peggy. 1989. "Opus Dei and the 'Perfect Society.' " The Nation (April 10):469, 482–487.

Malloy, James, and Richard Thorn, eds. 1971. Beyond the Revolution: Bolivia Since 1952. Pittsburgh: University of Pittsburgh Press.

McEwen, William J. 1975. Changing Rural Society: A Study of Communities in Bolivia. New York: Oxford University Press.

Meillassoux, Claude. 1981. Maidens, Meal and Money. Cambridge: Cambridge University Press.

Medinaceli, Ximena. 1989. Alterando la Rutina: Mujeres en las Ciudades de Bolivia, 1920–1930. La Paz: CIDEM.

Menchú, Rigoberta. 1983. I, Rigoberta Menchu. Edited by Elizabeth Burgos. London: Verso.

Murphee, M. W. 1969. Christianity and the Shona. London School of Economics Monograph on Social Anthropology no. 36. London: Athlone Press.

Nash, June. 1975. "Resistance as Protest: Women in the Struggle of Bolivian Tin-Mining Communities." In Ruby Rohrlich-Leavitt, ed., Women Cross-Culturally, Change and Challenge, pp. 261–274. Hague: Mouton.

Nash, June. 1979. We Eat the Mines and the Mines Eat Us. New York: Columbia University Press.

Nash, June. 1989. "Cultural Resistance and Class Consciousness in Bolivian Tin-Mining Communities." In Susan Eckstein, ed., Power and Popular Protest: Latin American Social Movements, pp. 182–202. Berkeley: University of California Press.

Nash, June. 1992. "Interpreting Social Movements: Bolivian Resistance to Economic Conditions Imposed by the International Monetary Fund." American Ethnologist 19(2):275–293.

Nelkin, Dorothy, and Sander Gilman. 1988. "Placing Blame for Devastating Disease." Social Research 55(3):361–378.

Paredes Candia, Antonio. 1982. De la Tradición Paceña. La Paz: Librería Editorial Popular.

Peiss, Kathy. 1985. Cheap Amusements: Working Women and Leisure in Turn-of-the-Century New York. Philadelphia: Temple University Press.

Poole, Deborah A. 1988. "A One-Eyed Gaze: Gender in Nineteenth-Century Illustration of Peru." Dialectical Anthropology 13(4):333–364.

Portes, Alejandro. 1989. "Latin American Urbanization during the Years of Crisis." Latin American Research Review 3(24):7–44.

Radcliffe, Sarah. 1985. "Migración Femenina de Comunidades Campesinas." Allpanchis (Lima) 21(25):81–122.

Rapp, Rayna. 1979. "Anthropology: A Review Essay." Signs 4(3):497–513.

Rogers, Susan Carol. 1978. "Woman's Place: A Critical Review of Anthropological Theory." Comparative Studies in Society and History 20:123–162.

Rollins, Judith. 1985. Between Women: Domestics and Their Employers. Philadelphia: Temple University Press.

Rosaldo, Michelle Z. 1974. "Women, Culture and Society: A Theoretical Overview." In Michelle Zimbalist Rosaldo and Louise Lamphere, eds., Women, Culture and Society. Stanford: Stanford University Press.

Rosaldo, Michelle Z. 1980. "The Use and Abuse of Anthropology: Reflections on Feminism and Cross-Cultural Understanding." Signs 5(3):389–417.

Roseberry, William. 1989a. "Americanization in the Americas." In William Roseberry, ed., Anthropologies and Histories: Essays in Culture, History and Political Economy, pp. 80–124. New Brunswick, N.J.: Rutgers University Press.

Roseberry, William. 1989b. "Images of the Peasant in the Consciousness of the Venezuelan Proletariat." In William Roseberry, ed., Anthropologies and Histories: Essays in Culture, History and Political Economy, pp. 55–79. New Brunswick, N.J.: Rutgers University Press.

165

Sacks, Karen. 1989. "Toward a Unified Theory of Class, Race and Gender." *American Ethnologist* 16(3):534–550.

Sandoval, Godofredo, Xavier Albó, and Tomás Greaves. 1987. *Chukiyawu: La Cara Aymara de La Paz*, vol. 4 Nuevos Lazos con el Campo. Cuadernos de Investigación CIPCA no. 29. La Paz: CIPCA.

Sanjek, Roger, and Shellee Colen, eds. 1990. *At Work In Homes: Household Workers in World Perspective*. American Ethnological Series no. 3. Washington, D.C.: American Anthropological Association.

Seligman, Linda. 1989. "To Be In Between: The Cholas as Market Women." *Comparative Studies in Society and History* 31(4):694–721.

Sider, Gerald. 1980. "The Ties that Bind: Culture and Agriculture, Property and Propriety in the Newfoundland Village Fishery." *Social History* 5(1):1–39.

Sider, Gerald. 1987. "When Parrots Learn to Talk, and Why They Can't: Domination, Deception, and Self-Deception in Indian-White Relations." *Comparative Studies in Society and History* 29(1):3–23.

Simson, Rennie. 1983. "The Afro-American Female: The Historical Context of the Construction of Sexual Identity." In Ann Snitow, Christine Stansell, and Sharon Thompson, eds., *Powers of Desire: The Politics of Sexuality*, pp. 229–235. New York: Monthly Review Press.

Smith, Margo L. 1973. "Domestic Service as a Channel of Upward Mobility for the Lower-Class Woman: The Lima Case." In Ann Pescatello, ed., *Female and Male in Latin America*, pp. 191–207. Pittsburgh: University of Pittsburgh Press.

Smith, Margo L. 1989. "Where is Maria Now? Former Domestic Workers in Peru." In Chaney and Castro, eds. *Muchachas No More*, pp. 127–142.

Stansell, Christine. 1987. *City of Women: Sex and Class in New York, 1789–1860*. Urbana: University of Illinois Press.

Stevens, Evelyn. 1973. "Marianismo: The Other Face of Machismo in Latin America." In Ann Pescatello, ed., *Female and Male in Latin America*, pp. 89–101. Pittsburgh: University of Pittsburgh Press.

Strathern, Marilyn. 1984. "Domesticity and the Denigration of Women." In D. O'Brian and S. Tiffany, eds., *Rethinking Women's Roles: Perspectives from the Pacific*, pp. 13–31. Berkeley: University of California Press.

Stoll, David. 1990. *Is Latin America Turning Protestant: The Politics of Evangelical Growth*. Berkeley: University of California Press.

Susser, Ida. 1991. "The Separation of Mothers and Children." In J. Mollenkopf and M. Castells, eds., *The Dual City*, pp. 207–224. New York: Sage.

Taussig, Michael, and Anna Rubbo. 1983. "Up Off Their Knees: Servanthood in Southwest Colombia." *Latin American Perspectives* 10(4):2–23.

TAHIPAMU (Taller de Historia y Participación de la Mujer). 1986. *Polleras Libertarias: Federación Obrera Femenina, 1927–1964*. La Paz: TAHIPAMU.

TAHIPAMU. 1989. *Agitadoras de Buen Gusto: Historia del Sindicato de Culinarias (1935–1958)*. La Paz: TAHIPAMU-HISBOL.

THOA (Taller de Historia Oral Andino). 1986a. *Los Constructores de la Ciudad: Tradiciones de Lucha y de Trabajo del Sindicato Central de Constructores y Albañiles, 1908–1980*. La Paz: THOA.

THOA. 1986b. *El Indio Santos Marka T'ula: Cacique Principal de los Ayllus de Qallapa y Apoderado General de las Comuidades Originarias de la Republica*. La Paz: THOA.

Thompson, E. P. 1967. "Time, Work-Discipline, and Industrial Capitalism." *Past and Present* 38:56–97.

Thompson, E. P. 1978. "Eighteenth-Century English Society: Class Struggle Without Class?" *Social History* 3(2):133–166.

Trevor-Roper, Hugh. 1983. "The Invention of Tradition: The Highland Tradition of Scotland."

In Eric Hobsbawm and Terance Ranger, eds., *The Invention of Tradition*, pp. 15–42. Cambridge: Cambridge University Press.

Vogel, Lise. 1983. *Marxism and the Oppression of Women*. London: Pluto Press.

Williams, Raymond. 1973a. *The Country and the City*. New York: Oxford University Press.

Williams, Raymond. 1973b. *Keywords: A Vocabulary of Culture and Society*. London: Oxford University Press.

Williams, Raymond. 1977. *Marxism and Literature*. Oxford: Oxford University Press.

Wilson, Fiona. 1984. "Marriage, Property, and the Position of Women in the Peruvian Central Andes." In R. T. Smith, ed., *Kinship, Ideology and Practice in Latin America*, pp. 297–326. Chapel Hill: University of North Carolina Press.

Wolf, Eric. 1982. *Europe and the People Without History*. Berkeley: University of California Press.

Yanagisako, Sylvia. 1979. "Family and Household: The Analysis of Domestic Groups." *Annual Review of Anthropology* 8:161–205.

Young, Grace Esther. 1987. "The Myth of Being 'Like a Daughter.' " *Latin American Perspectives* 14(3):365–380.

Zondag, Cornelius H. 1966. *The Bolivian Economy, 1952–1965: The Revolution and Its Aftermath*. New York: Praeger.

Zulawski, Ann. 1990. "Social Differentiation, Gender, and Ethnicity: Urban Indian Women in Colonial Bolivia, 1640–1725." *Latin American Research Review* 25(2):93–113.

INDEX

Designer: Linda Secondari
Text: Goudy O.S.
Compositor: The Composing Room of Michigan, Inc.
Printer: Book Crafters
Binder: Book Crafters